D0754557

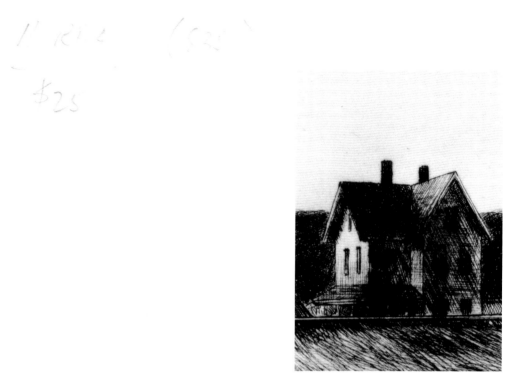

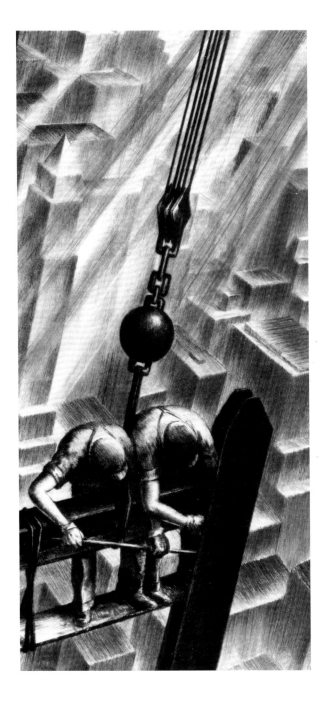

Graphic Excursions: American Prints in Black and White, 1900–1950

SELECTIONS FROM THE COLLECTION OF REBA AND DAVE WILLIAMS

Essays by Karen F. Beall and David W. Kiehl

David R. Godine, Publisher, Inc. in association with The American Federation of Arts

First published in 1991 by David R. Godine,
Publisher, Inc., 300 Massachusetts Avenue, Boston,
Massachusetts 02115, in association with The
American Federation of Arts, 41 E. 65 Street,
New York, New York 10021.

Library of Congress Cataloging-in-Publication Data
Graphic excursions—American prints in black and
white, 1900–1950 : selections from the collection
of Reba and Dave Williams / essays by Karen F.
Beall and David W. Kiehl.
 p. cm
Published in conjunction with an exhibition
organized and circulated by the American
Federation of Arts at the Weatherspoon Art
Gallery, University of North Carolina, Greensboro,
North Carolina, Apr. 6–June 1, 1991, and others.
ISBN: 0-87923-902-6 — ISBN: 0-87923-909-3 (pbk)
1. Prints, American—Exhibitions. 2. Prints—20th
century—United States—Exhibitions. 3. Williams,
Dave, 1932– —Art collections—Exhibitions.
4. Williams, Reba—Art collections—Exhibitions.
5. Prints—Private collections—United States—
Exhibitions. I. Williams, Reba. II. Williams,
Dave, 1932– . III. Beall, Karen F. IV. Kiehl,
David W. V. American Federation of Arts.
VI. Weatherspoon Art Gallery.
NE508.G74 1991
769.973'074'73—dc20 91-81

Publication Coordinator: Michaelyn Mitchell
Designer: Greer Allen
Editor: Debra Edelstein
Photographer: Dwight Primiano
Composition: DEKR Corporation
Printer: Franklin Graphics
Binder: Horowitz/Rae

Printed in the United States of America

Halftitle page: *Detail from* Edward Hopper,
American Landscape (no. 11); frontispiece: *Detail
from* Samuel L. Margolies, *Men of Steel* (no. 76)

Contents

Acknowledgments

It is a privilege to pen the acknowledgments for *Graphic Excursions* because this publication and *American Prints in Black and White, 1900–1950: Selections from the Collection of Reba and Dave Williams*, the traveling exhibition that it accompanies, illuminate a print collection of exceptional quality. The AFA is delighted to have been instrumental in bringing it to the attention of a national audience.

First and foremost, we wish to acknowledge the generosity of Reba and Dave Williams, a collecting couple in whom one finds unceasing dedication matched by aesthetic acumen. Numbering close to three thousand, their collection is singular both for its breadth and depth. We are particularly pleased that the selection represented here includes not only works by well-known artists but a considerable number of very fine lesser-known artists.

We are grateful to have enlisted the talents of Karen F. Beall, a research associate at Carleton College and former curator of prints at the Library of Congress, and David W. Kiehl, associate curator of prints and photographs at the Metropolitan Museum of Art. Their essays provide an important context for an understanding and appreciation of the 110 prints illustrated in this publication. We also acknowledge the considerable efforts of Margaret W. Doole, who prepared the artist biographies, as well as AFA staff members Robert Workman, administrator for exhibitions, and P. Andrew Spahr, senior exhibition coordinator, who collaborated on the selection of the works.

Other staff members whose participation has been crucial include J. David Farmer, director of exhibitions; Michaelyn Mitchell, head of publications; Deborah Notkin, publications assistant; Andrea Farnick, associate registrar; and Jillian W. Slonim, director of public information.

We also want to acknowledge Dwight Primiano, who is responsible for the photography, and Dave Williams's assistants, Marie Rossi, Joanne O'Donnell, and Brian Morrissey, all of whom have been helpful throughout the course of the project.

Last, we salute the eight museums that will be presenting the exhibition: the Weatherspoon Art Gallery, the Columbus Museum, the Newark Museum, the MacDonald Stewart Art Center, the Glenbow Museum, the Brunnier Gallery and Museum, the Heckscher Museum, and the Dallas Museum of Art.

Serena Rattazzi
Director
The American Federation of Arts

Preface

During the past decade Reba and Dave Williams have amassed a collection of prints that attests to the rich diversity of American art of the twentieth century. It is not static and, in their eyes, not complete. As it grows, so does their understanding of American art and artists in this century. It is an avocation that has become a preoccupation, a learning process that in turn has been shared with others.

This publication presents 110 prints from their collection, many of which are images by American master printmakers—Bellows, Hopper, Marin, Sloan, Arms, and others. But the Williamses have for the most part collected works by artists little known nationally that unquestionably hold their own when juxtaposed with recognized masterworks. This serves as a reminder that our nation has produced scores of artists whose work is equal in quality, technique, and content to that of the more familiar names. It therefore offers us an opportunity to look with fresh eyes at a vibrant part of our artistic heritage.

All of the pieces are black and white; so it is neither a complete study of American printmaking during the first half of the century nor a full representation of the Williams Collection, which contains many fine color silkscreen and woodblock prints. Represented here are intaglios, relief prints, and lithographs, which we hope will spark in the viewer an invigorated appreciation of American art and printmaking in this century.

David W. Kiehl

"I Hear America Singing": Modes of Expression in American Prints

David W. Kiehl

I hear America singing, the varied carols I hear,
Those of mechanics, each one singing his as it
* should be blithe and strong,*
The carpenter singing his as he measures his
* plank or beam,*
The mason singing his as he makes ready for
* work, or leaves off work,*
The boatman singing, what belongs to him in his
* boat, the deckhand singing on the steamboat*
* deck,*
The shoemaker singing as he sits on his bench,
* the hatter singing as he stands,*
The wood-cutter's song, the ploughboy's on his
* way in the morning, or at noon intermission or*
* at sundown,*
The delicious singing of the mother, or of the
* young wife at work, or of the young girl sewing,*
* or washing,*
Each singing what belongs to him or her and to
* none else,*
The day what belongs to the day—at night the
* party of young fellows, robust, friendly,*
Singing with open mouths their strong melodious
* songs.*

Walt Whitman, from *Leaves of Grass*, 1860

The American frontier disappeared in the nineteenth century, and images of the unspoiled wilderness were replaced by both fearful and welcoming visions of industrial progress. But the railroad in the landscape did more than transform the land: it created a new frontier spirit, in which hope and promise were embodied in the man-made structures rising on the plains and in the cities. As the wilderness was fenced into national parks and enshrined as places of pilgrimage, artists began to celebrate the grain elevators, mills, factories, and skyscrapers that created new horizons. Charles Sheeler explored the geometry of the industrial complex with the same fervor that Thomas Moran felt exploring the wonders of Yellowstone in the 1880s. For John Marin, the Woolworth Building and the Brooklyn Bridge were as expressive of the spirit of the American nation as Thomas Cole's views of the Adirondacks in the 1830s and 1840s. Depictions of the rural and urban landscape in American art of the first half of the twentieth century were often paeans to the vitality of the new relationship between man and nature: men and women at work, at play, at large in the world they had built.

At the turn of the century a group of artists in New York City began to see in their teeming and bustling city the new frontier of America. The pioneers were the native-born and the immigrant, the poor and the rich, the beautiful and the ordinary—people depicted in all their diversity and without idealization.

8

In 1905, one year after moving to New York, John Sloan made a series of ten etchings, *New York City Life*, that shocked critics and collectors alike. The shock was the subject: "life," ordinary people in the ordinary routines of daily existence. These intense yet seemingly casual images owe much to the discipline of direct observation the artist had gained in his years of work as an illustrator. But behind this lies a legacy of insight gleaned from the study of one of the great artists of the previous century, Honoré Daumier. Daumier's images were not mere caricatures satirizing the attitudes of his day. Instead, he had a timeless understanding of human nature, of man's foibles and passions, and of daily life. From Daumier, Sloan learned to focus on the significant gesture or expression and on that point of interaction that says more than mere words could ever achieve. Daumier's bold, almost calligraphic style, dissecting human nature and often touched by wit, infused the prints of John Sloan, whether in the isolated, telling gesture of a woman turning out the light (no. 1) or a scene on a crowded urban street (no. 2).

Sloan was not alone in admiring Daumier's timeless style of delineating humanity. The French artist influenced many artists active in the first half of the century. His work certainly informs the prints of Reginald Marsh—whether of a crowded Coney Island beach, the tattooed lounger on the Bowery, or the burlesque (no. 34). His influence can be found in the prints of the so-called Union Square group—the tired shoppers of Kenneth Hayes Miller (no. 26). And it certainly is behind the pointed humor of Grant Wood's *Shrine Quartet* (no. 83).

These depictions of modern life also constituted a political, social, and economic commentary that challenged the social order and attacked the gentility of the established, academic art world. It found expression in such publications as *The Masses*, a progressive, cooperative journal that was illustrated by such artists as Sloan, George Bellows (no. 10), and Henry Glintenkamp (no. 24). The new political activism also led to the formation, in the mid-1930s, of the American Artists Congress, which recognized that, in a variety of styles and media, artists could articulate the concerns of the American people, could realize Walt Whitman's vision of the American mechanic, carpenter, shoemaker, and "young wife at work . . . singing with open mouths their strong melodious songs."

Printmakers heeded the call and produced a rich array of images depicting Americans at work on the land and in the cities. They ranged in style from the realistic to the abstract and in tone from Whitman's celebratory register to the more somber notes of human despair (see, for example, Joe Jones, *Sacking Grain*, no. 48; Thomas Hart Benton, *Departure of the Joads*, no. 78; and Leon Golub, *Workers*, no. 104). In her haunting *Miner's Head* (no. 28), Blanche Grambs uses layers of deeply etched, gritty aquatint to capture the depression she saw in the mining community she

visited on a field trip with other members of the Art Students League. The work shows the influence of Georges Rouault, especially his emotionally charged images of human misery and martyrdom. But a more complex influence—evident as well in Jackson Pollock's *Coal Miners—West Virginia* (no. 62) and Lucienne Bloch's *Land of Plenty* (no. 59)—is that of the muralists and printmakers of Mexico.

By 1930 the big three—Diego Rivera, David Alfaro Siqueiros, and José Clemente Orozco—were in America, refugees from the latest change in the turbulent, political climate of Mexico. Indeed, the artists had actively supported the revolutionary fervor that characterized Mexico in the late teens and early twenties and that led to the ousting of an elitist oligarchy that had controlled the government for decades. The artists, especially Siqueiros, published illustrated broadsheet newspapers urging a democratic reform for all the people. They also painted murals in public buildings at workman's wages for the new government. These murals created a visual record of the history and aspirations of the Mexican people and successfully melded subject and form into vigorous artistic statements. The Mexican movement had an especially strong influence on the forms and subjects of art produced under the auspices of the WPA, and the mural's hieratic complexity and social commentary are evident in Howard Cook's *Fiesta* (no. 41), Will Barnet's *Conflict (Vigilantes)* (no. 45), Edgar Dorsey Taylor's *The UVX, Jerome* (no. 51), and Florence Kent Hunter's *Decoration for Home Relief Bureau* (no. 61). But it is the intense, very expressive vigor of the depictions of social conditions and the everyday lives of the common citizen that best demonstrate the impact of the Mexican movement on American printmakers.

Those citizens were often at work in the new industrialized landscape, represented by both the encroachment of machinery on the old way of rural life (Doris Lee, *Helicopter*, no. 103) and the construction of the modern city (James E. Allen, *The Connectors*, no. 44; Samuel L. Margolies, *Men of Steel*, no. 76; Ida Abelman, *Construction*, no. 77). The forms of industrialization and the energy of urban life led printmakers to modernist, abstract styles, influenced by the innovations in Europe.

The prints of Joseph Pennell, an influential teacher at the Art Students League and founder of the Philadelphia Society of Etchers, may seem stylistically conservative today, but he successfully adapted the emphases of the late work of James McNeill Whistler, with whom he studied in England, to the burgeoning metropoli and industrial complexes of his native land. The Whistlerian vistas of Venice and London were exchanged for towering skyscrapers, smoke-belching factories, and hulking mineheads. Pennell brought Whistler into the new century through his calligraphic use of line to grasp essential details that define a subject but do not distract the eye, and through his atmospheric use of light and dark to draw the eye to the focus of the composition.

In 1904, the year after Whistler's death, Pennell visited New York. His astonishment on seeing the soaring skyscrapers and the canyoned streets of lower Manhattan informs the etchings and lithographs that follow: the eye zooms down streets and scales the towers in image after image, each dominated by a shimmering, insistent line. In later images, he added atmosphere and mood. He captured the brilliant whiteness of the Standard Oil Building under construction, breaking out among the shadowed forms of its neighbors with bold, slashing strokes of etched line and drypoint; and

in night-shrouded vistas of man-made structures of Manhattan, as seen from across its bordering rivers. His fascination with the American city extended to the industrial complexes on its outskirts. In *The Big Mill* (no. 4) the receding parallels of multiple tracks sweep the eye into the composition, a commanding series of nearly identical industrial structures. It is a man-conceived, man-centered world.

Pennell's influence can be seen in the work of many printmakers in the early decades of this century who were anxious to break away from the shackles of a nineteenth-century pictorialism and the tired structures of Etching Revival. In adventuresome hands his solutions, even combined with other stylistic influences, could result in an invigorated image celebrating the city and industry. For example, Gerald Geerlings found magic in the dramatic architecture of Chicago (*Grand Canal America*, no. 42) and in the complex world backstage at the theater. John Marin freed Pennell's calligraphic line in a series of etchings of the Brooklyn Bridge and the Woolworth Building (no. 3). His line shimmers and vibrates; it has been taken apart, analyzed, and then reassembled. It is Pennell coupled with the analysis of Picasso and Braque.

Like Marin, Abraham Walkowitz adapted a cubist-derived style to American subjects. In a series of interpretive drawings of New York, he refigured the city, breaking the solidity of structures into a series of geometric or linear planes that encapsulate his vision of the city's movement, weight, and vitality. In *New York of the Future* (no. 20), one of the few prints in this group, Walkowitz shattered the vista of buildings into a series of planar shapes cascading somewhat oppressively on the fast-moving populace below. He was not alone in his fascination with the scale and energy of the modern city—and with both the beauty and threat it engenders—as images from artists as diverse as Adriaan Lubbers (*South Ferry*, no. 25), Adolf Dehn (*New York Night*, no. 31), and I. Iver Rose (*City Streets*, no. 50) indicate.

The geometry of skyscrapers and the abstract patterns of urban structures attracted artists like Ernest Fiene, Samuel L. Margolies, and Armin Landeck. In his image of the newly completed *Empire State Building* (no. 32), Fiene stresses the geometric mass of the building towering above its neighbors. The framing device and unusual perspective emphasize the direct and deliberate approach. In Margolies's *Men of Steel* (no. 76), the upward thrust of the building under construction is reinforced by the oblique angle of the image and the dizzying array of fine diagonal lines. The parallelograms of structural steel overlay a complex pattern of cubes and triangles that represent the city below. The preparatory drawings and early states of the print, in the Metropolitan Museum of Art, document the progressive additions of realist detail to the underlying geometry of the composition. Landeck's architectural training is apparent in the superb draftsmanship and realistic abstraction of his *View of New York* (no. 39). It is a slice of the city that captures the architectonic rhythm of flat roofs, sculpted skyscrapers, and dramatic changes in scale and light.

The dynamism of the modern city was most evident in its transportation networks, and following the futurists' celebration of the speed of trains and automobiles, painters like Max Weber and Joseph Stella depicted the technological system that defined the rhythms of modern American life. Stella's *Brooklyn Bridge*, 1922, the fifth image in his series *New York Interpreted*, is a clear antecedent to Jolan Gross Bettelheim's lithograph of a

bridge, whose steel cables and energetic structure sweep travelers into the city (no. 86). More abstractly, Stuart Davis, in *Sixth Avenue El* (no. 36), and Frederick Whiteman, in *Elevated* (no. 69), address the structures the city's trains engender. And in Claire Mahl Moore's *Modern Times* (no. 90), the train speeding from skyscraper to tunnel is the lifeline of the city the hand of man has built.

Man had also built a new economic system, for which the factories and machinery stood as powerful emblems. Louis Lozowick's paean to an industrial, geometric America addresses the importance to the artist of the altered economic and physical landscape:

The dominant trend in America of today is towards an industrialization and standardization which require precise adjustment of structure to function which dictate an economic utilization of processes and materials and thereby foster in man a spirit of objectivity excluding all emotional aberration and accustom his vision to shapes and colors not paralleled in nature.

The dominant trend in America of today, beneath all the apparent chaos and confusion, is towards order and organization which find their outward sign and symbol in the rigid geometry of the American city: in the verticals of its smoke stacks, in the parallels of its car tracks, the squares of its streets, the cubes of its factories, the arc of its bridges, the cylinders of its gas tanks.[1]

In images invested with a monumentality once reserved for cathedrals and castles—symbols of the old social order—and for mountain peaks—symbols of the natural order—artists paid homage to the technological world. Werner Drewes, in *Grain Elevator No. 3* (no. 18); Isaac Friedlander, in *Fractionating Tower* (no. 33); William S. Schwartz, in *Gas Factory* (no. 21); Abe Ajay, in *Heavy Industry* (no. 84); and Lozowick himself in *Coal Pockets #2* (no. 16) brought European abstract and expressionist styles to bear on the new American icons.

But the images most American viewers recall are the pristine precisionist works of Charles Sheeler, whose vision of the Ford Motor Company's River Rouge plant gave us a new pastoralism. Sheeler, according to art historian Dominic Ricciotti, understood the irony in Henry Ford's locating the factory in a rural setting outside Detroit; he recognized that "the one man who was radically changing urban-industrial America with the private automobile turned his back on the cities to embrace the virtues of the land." The artist's response, Ricciotti notes, was to invoke the "classical landscape tradition while simultaneously emphasizing its transformation by a contemporary machine aesthetic." Ricciotti's reading of the famous painting *American Landscape*, 1930, applies equally to Sheeler's lithograph *Industrial Series #1* (no. 22) and is worth quoting at length:

The river and railroad occupy the characteristic foreground plane of classical landscape painting, while the apparatus at the right [at left in the print] serves as the requisite coulisse *or "wing." Factory structures and coal heaps, in place of the usual classical architecture or groups of trees, occupy the rising middle ground; and the smokestack approximates the distant focal point normally created by a mountain peak. . . . In* American Landscape, *Sheeler succeeded in harmonizing the man-made world of technology with nature, by recourse to those artifices imposed on nature in a more humanistic age.*

1 Louis Lozowick, "The Americanization of Art," in *Machine Age Exposition* (New York: Little Review, May 1927).

It is an idealized vision: with his sharp contrasts of light and shadow, crisp shapes and simplified volumes, and suppression of extraneous detail, Sheeler presents a "technological utopia" without grime or confusion.[2]

Others saw a less benign industrial presence. Harry Sternberg's *Forest of Flame* (no. 81) suggests that both mankind and the natural world have become subservient to the fire-breathing engines of man's creation. Men nourish the mills with materials taken from the earth, which receives in return the polluting smoke and wastes. In Howard Cook's *Engine Room* (no. 29) and Ross Braught's *Road Roller* (no. 35) man is literally dwarfed by the hulking machines, delineated with an abstraction and intensity of light and dark that is almost menacing. The new economic order this technology represents dictated "an economic utilization" of men as well as of "processes and materials." While Lozowick celebrated the "order and organization" brought by industrialization, Henry Billings, in his *Men and Machines* (no. 93), uses the precise, architectonic style Lozowick endorsed to create a portrait of a worker as the machine with which he works. And in *Another Day* (no. 63) Joseph Vogel reminds us that men dominated by the "industrialization and standardization" Lozowick applauds may indeed "exclude all emotional aberration" and become the alienated, spectral work force that never haunts the Arcadia Sheeler created.

It is a reminder that the vibrant world American ingenuity built can be both a playground for boaters (Jan Matulka, *Evening in Central Park*, no. 14) and dancers (Lou Barlow, *Jitterbugs*, no. 85) and sailors on leave (Paul Cadmus, *Shore Leave*, no. 55), and a boisterous, violent place (Will Barnet, *Conflict* [*Vigilantes*], no. 45) in which some men lead lives of quiet desperation (Raphael Soyer, *The Mission*, no. 43). The symbiotic relationship between man and the world he creates has many facets, and for every artist who celebrates man's power and energy as embodied in the new built environment, another sees that with power comes the powerless. The printmakers represented in the Williams Collection did indeed sing out the "various carols" Walt Whitman said he heard, and did so in a medley of styles that revitalized American art in the first half of the twentieth century.

2 Dominic Ricciotti, "City Railways/Modernist Visions," in *The Railroad in American Art*, edited by Susan Danly and Leo Marx (Cambridge: The MIT Press, 1988), pp. 140, 141–43.

The American Printmaker Comes of Age

Karen F. Beall

During the last decades of the nineteenth century, an etching revival, based on that in Europe, reached the art-buying public in the United States. Print clubs were established to support artists, and collectors and American artists abroad became increasingly interested in printmaking as an important form of artistic expression. Lithography came to be accepted on a par with intaglio and relief techniques, and tremendous technical developments occurred in color printing. These developments attracted a new audience for prints.

Between 1900 and 1920 American art saw an erratic but lively activity that drew upon the American experience but also placed the art in an international context. Publications appeared on American art: Loredo Taft's *The History of American Sculpture* (1903), Charles Henry Caffin's *American Masters of Painting* (1902) and *American Masters of Sculpture* (1903), Samuel Ishams's *History of American Painting* (1905), and Royal Cortissoz's biographies of Saint-Gaudens and La Farge (1907 and 1909, respectively). Frank Jewett Mather, Royal Cortissoz, Guy Pène du Bois, and James Gibbons Huneker were among writers hired by newspapers and journals as art critics and editors. In 1909 the American Federation of Arts was established to promote and disseminate the values of art in American life. All this reflected a growing audience.

In the 1930s silkscreen became accepted as an artistic medium, and images in many techniques were often designed to carry when seen across a room. The Museum of Modern Art had opened in 1929, and in 1931 the Whitney Museum of American Art, the first museum devoted to American work, opened its doors. Opportunities to view prints multiplied, and the artists as well as institutions began educational campaigns. Federal support of the arts enabled many to keep working and even to expand from one medium to another by making available workshops and materials. Clearly, there was at least quasi-official recognition of the value of the arts in American society.

The American Abstract Artists Group was formed in 1936 (the year in which the Museum of Modern Art mounted *Cubism and Abstract Art*) and held annual exhibitions in some ways analogous to those held at Alfred Stieglitz's "291" gallery twenty years earlier. Among a number of print exhibitions of the late 1930s was *America Today*, which included a hundred WPA pieces that were shown simultaneously in thirty cities around the country. In December 1942 the Metropolitan Museum of Art in New York broke its practice of not exhibiting work by living Americans and mounted *Artists for Victory* to support the war effort. The increased role prints were playing in the 1940s in American society is evident from the proliferation of serious printmakers in college and university art departments across the country and the introduction of professional workshops such as Atelier 17 in New York City. By the end of the decade gallery walls were awash with printed images.

Public awareness of prints was maintained during the 1950s as schools remained the center for much

printmaking, with technical experimentation continuing and individualism valued. American printmakers had a newly found self-confidence on the world stage, and prints moved from a secondary position behind painting and sculpture and grew to a scale capable of holding its own with works in other media. After 1960 printmaking exploded in an unprecedented way with the establishment of large workshops, where artists in other media could collaborate with master printers.

In artistic terms, the United States was still provincial at the turn of the century; fifty years later it was the center of the art world, with New York its capital. Those were decades of tremendous growth and change for the nation and its art, and the rich panorama of American printmaking in this era is represented in this publication. Looking back from 1990, one finds a world of tradition and a world in change, a world that moves from innocence to awakening, a world more of black and white than of gray (if gray may stand for introspection).

The 110 prints in this publication are mostly small, close studies making gentle inquiries rather than deep probes into their time. They are unselfconscious, unpretentious, unaffected, even unsuspecting works of art, despite all that was going on in European art during these decades.

And what was going on in Europe was a rather frantic series of artistic revolutions: fauvism, cubism, German expressionism, and surrealism all tumbled over each other with enthusiasm created only by those most interested in being avant-garde

artists. American artists noted and absorbed these European currents but were not themselves among the vanguard. American modernism occurred suddenly and without the decades of preparation that enabled European artists to fully exploit these new tendencies. The American works seem at times to be more a series of stylized images echoing the European works. Even when American artists do borrow avant-garde manners and techniques, their works show a naive purity and lack the display seen in European art: the latest styles are utilized but the works are not avant-garde.

Elements of form and style dominate fauvist and cubist images, and subject matter, so consistently important for Americans, is of little concern to the Europeans. And even when subject matter does become important, as in the works of German expressionists and the surrealists, it does not come from the perceivable, contemporary scene but probes other worlds of personal, inner visions. In contrast, American printmakers are always talking about their own physical environment even when they follow their European mentors and alter colors, fragment objects, and reorganize parts in a kaleidoscopic manner.

Three concurrent trends dominate American art early in this century: the academic, following accepted standards of style, the social realist, and the emerging modernist.

The period from 1900 to World War I was a time of tremendous growth and social change in the United States. Developing technologies made

travel easier, which led to an enormous influx of immigrants into the country and of people into the cities. Urban life, with its energy and noises, tall buildings, cramped spaces, and crowded sidewalks, became a primary focus in the nation's art.

The earliest prints in this publication capture the social, political, and economic issues confronting urban dwellers. John Sloan's etching *Turning Out the Light* (1905, no. 1), from his then controversial *New York City Life* series, and his lithograph *Sixth Avenue and 30th St.* (1908, no. 2) combine elements of illustration and caricature in well-drawn, compassionate images of ordinary moments in time. Sloan was a member of The Eight (Eight Independent Painters), a group of rebel artists whose imagery revolved around urban life and was dubbed "ashcan" by critics. Despite harsh criticism, Sloan achieved surprising financial success and ranks among the most significant printmakers in the early decades of this century. He worked as an illustrator as well as the art editor for the socialist reform magazine *The Masses*, and his work has a reportorial quality that depicts people and settings with concern and with an energetic, descriptive line that defines without laboring his subjects.

His colleague George Bellows focuses more on middle- and upper-class life, and his images, while equally descriptive, are more deliberate. He depends more on tones and masses than on line and to this end utilizes the medium of lithography very well. In *Tennis Tournament* (1920, no. 10), he presents a fashionable gathering at a sporting event, but often his images comment on social conditions.

Although interested in many of the same themes as Sloan, Reginald Marsh generally depicts people in crowds, and his prints are bitter and satirical comments on the times with such diverse themes as *Bread Line* (1929) and *Gaiety Burlesk* (1930, no. 34). While Sloan indicates background with sufficient but not abundant detail, Marsh creates a rather complete setting for his people, and his work is more anecdotal.

Also interested in the city, though less in people, was Joseph Pennell, a prolific draftsman and printmaker and an influential teacher. With his images of city, construction, and industry, his focus was more on the power and implications of the "machine age." His awe and respect for the capabilities of man and machine resulted in images more academic than those of his contemporaries, as in his Wonder of Work prints and the *Panama Canal* lithographs (1912) that document the cutting and building of the canal and its locks. *The Big Mill* of 1915 (no. 4) depicts a different view of industry. Although Pennell made London his home base for thirty years, his greatest impact followed his permanent return to America. The native Philadelphian settled in Brooklyn and taught at the Art Students League, where he greatly expanded the intaglio area and established a lithography studio, probably the first in an American art school.[1]

Like Pennell, who had studied with Whistler, many American printmakers had roots in nineteenth-century impressionism. This can be seen in William Meyerowitz's etching *November 11, 1918—Fifth Avenue* (1918, no. 8), a celebration at the end of World War I composed from an impressionist vantage point much like Camille Pissarro's Parisian views. Other American artists employed impressionist stylistic elements, for example,

1 *One Hundred Prints by 100 Artists of the Art Students League of New York, 1875–1975*, foreword by Judith Goldman (New York: Associated American Artists, 1975), p. 16.

Childe Hassam, whose interest in the fleeting moment and the breakdown of form into the play of light and shade are evident in many of his prints.

While these artists were concerned with creating American images in relatively traditional styles, there were also untraditional forces in the American scene. The presence of these forces is most strongly identifiable in works by artists involved with Alfred Stieglitz's "291" gallery and in the Armory Show, where stylistic innovation is valued over subject.

The Armory Show of 1913 is generally acknowledged to be pivotal in the history of American art and the development of "modernist" styles in this country. It consisted of a diverse group of European and American works, including some prints. But for five years preceding the show, photographer and dealer Alfred Stieglitz had been exhibiting modernist works by European artists and by Americans in Europe influenced by fauvism, cubism, futurism, and German expressionism. The return of these artists to America before World War I helped to make New York City a world art center.

Individualism was fostered at "291," and the Stieglitz group basically believed that art should reveal a subject as well as a feeling about the subject. Among the Americans shown there before the Armory Show and represented in this publication were John Marin (see nos. 3, 17), Max Weber (see no. 23), Abraham Walkowitz (see no. 20), and Arthur B. Davies (see no. 6). Marin's *Woolworth* of 1913 (no. 3) reflects his European experience of 1905–9 and 1910–11 in its modernist interpretation of New York City. The building's mass takes on a life of its own in swaying rhythms, and the artist creates a highly dynamic image reflecting the intensity of urban life. The dynamism of the city also interested Weber (as it did Walkowitz) at the same time that the dynamism of factories, mills, and construction sites interested Pennell.

Max Weber knew Matisse in Paris (he was in Europe between 1906 and 1909) and was a leading advocate of modernist trends. In 1910 he made a set of color woodcuts that combine influences from European modern art and primitive art, and he was the first modernist to use lithography (after about 1916). The 1928 print *Repose* (no. 23) reflects an interest in Picasso's work. The Newark Museum gave Weber a one-man show—the first for an American modernist—in 1913.

Arthur B. Davies, another leader of the time, was among the most important figures in the American modernist movement. His fundamental role in organizing the Armory Show of 1913 places him at a central point in introducing modernist ways to America; interestingly, it also serves as a major contrast to his own more representational and dreamlike images. Though the drypoint *Figure in Glass* (1918, no. 6) is quite obviously cubist-derived, many of his prints are much more lyrical. Despite the distinctions between these artists and the leading artists in Europe, many formed a vital link between Europe and America.

Among others who made prints influenced by new European styles were the sculptors John Storrs and William Zorach. Storrs's 1918 woodcut *Coming from the Bath* (no. 9) relates to his simple columnar sculptural forms and prefigures his later association with the development of the art deco style. The artist's stamp of a framed face in the lower right corner of the sheet is derived from art nouveau.

Zorach's *Mountain Stream* (1917, no. 5) is a more complex image with curvilinear patterns. His work

was affected by various European styles, and it was his familiarity with the woodcuts of Gauguin and the German expressionists that led him to print-making.

The period between 1900 and World War I was turbulent and also hopeful, but the war interrupted artistic activity and broke up old circles. In the period that followed, the distinction between European and American attitudes was less clear; for example, there was a return to more figurative work in the art of Picasso, Braque, and Léger in Europe as well as in that of many American artists. The 1920s came in with an economic boom and closed with the stock market crash, depicted in James N. Rosenberg's *November 13, Mad House 1929* (1929, no. 27), which was influenced by second-wave expressionist art and film.

During the 1920s some artists continued their relatively conservative approaches, but others were caught up in the new European trends. This can be seen in John Marin's 1925 etching *Down Town N.Y.,* (no. 17), a semi-abstract work quite in contrast to his earlier *Woolworth* (1913, no. 3).

One of America's leading painters, etchers, and illustrators, Edward Hopper, responded with lonely, haunted, realist scenes. If one compares Bellows's *Tennis Tournament* (1920, no. 10) and its focus on subject with Hopper's *American Landscape* (no. 11) of the same year, in which the viewer reads areas as large masses, the Hopper image has greater compositional unity. The Hopper is quietly aggressive in composition and technique, with its nineteenth-century farmhouse seen across the strongly horizontal railroad tracks, which cut across and out of the picture. Bellows is concerned mainly with subject; Hopper is making a work of art. In his words, "I find, in working, always the disturbing intrusion of elements not a part of my most interested vision, and the inevitable obliteration and replacement of this vision by the work itself as it proceeds."[2]

Hopper learned etching from his friend Martin Lewis, a master of intaglio techniques. Both artists used the oblique vantage point, but Hopper reveals concerns more universal than Lewis's fleeting moments. Lewis's prints are also more elaborate technically, and he is more interested in the juxtaposition of lights and darks for dramatic effect, as in *The Arc Welders* (1937, no. 70). Lewis is often anecdotal; Hopper is not.

Other important early modernists in America were Stuart Davis (see no. 36), Jan Matulka (see no. 14), and Walter Francis Kuhn (see nos. 12, 15). At the age of nineteen, Davis had exhibited at the Armory Show and was particularly affected by that exhibition. He was subsequently strongly influenced by Matulka and Léger, and he shared, with the latter, an interest in contemporary industrial and commercial imagery. Davis continued his modernist work into the 1930s, when he became associated with the American Scene artists because his images relate to American society and were readily understood. It was not until the 1940s that his work became totally abstract.

Matulka was an influential teacher at the Art Students League in New York. An immigrant from Czechoslovakia familiar with avant-garde trends in Europe, he worked in a wide range of styles. His prints are sometimes cubist, sometimes precisionist, sometimes realist, as in the ca. 1925 *Evening in Central Park* (no. 14), which presents a genre scene that records without comment. In this print

2 *Artists on Art. From the XIV to the XX Century,* compiled and edited by Robert Goldwater and Marco Treves (New York: Pantheon Books, Inc., 1958), p. 471.

the artist chooses a spotlight effect to illuminate his subject sympathetically.

Kuhn, an organizer of the Armory Show and a multifaceted individual, created paintings that tend to contradict his zealous promotion of modernist trends. His interest in abstraction, however, is brought out more by his prints, such as *Country Road* (1925, no. 15), than his paintings. Like others, he studied in Europe (Paris and Munich) during the early years of the century and was profoundly affected by post-impressionist and expressionist art. He was a cartoonist, architect, designer, and teacher. Also strongly influenced by European movements was Arshile Gorky, whose *Painter and Model* (1931, no. 37) reflects a debt to surrealism. Gorky's surrealist interest was to be instrumental in the origins of abstract expressionism in the 1940s.

Expressionist influences are also evident in Birger Sandzen's woodcut *Lake in the Rockies* (1921, no. 13), in which his objects are given life through the use of energetic line, and Henry Glintenkamp's overtly political wood engraving *Voters Puppets* (1929, no. 24), which uses dramatic contrast in scale among the figures. In the latter work obvious social activism and the lack of subtlety politicizes to a degree rarely found even in work by artists interested in social concerns, such as the regionalists John Steuart Curry (see no. 30) and Adolf Dehn (see no. 31).

Another focus of a large number of artists of the late 1920s and, particularly, the 1930s was the American Scene. In the early 1930s unemployment ran rampant and the nation was in turmoil. The depression brought with it a wave of attention to American subjects transmitting American ideals; it was a period of rationalization and a national need for self-identity. People sought a clear view of themselves and their country, and artists across the country provided it, particularly in New York and the Midwest. American Scene art was a democratic art that treated familiar subjects and images. Its two major components were the regionalists and the "passing scene" artists.

We often think of the regionalists as the artistic epitome of the time. They include artists who concentrated both on the rural and the urban environment. The rural regionalists—Grant Wood (see nos. 82, 83), John Steuart Curry (see no. 30), Thomas Hart Benton (see no. 78), among others—portrayed a harmony between people and their setting. They tended to be apolitical and more interested in folk tales than current events, more interested in developing a personal style for presenting things in a generalized way than in identifying specific people or places. (Exceptions may be found in the work of Everett Gee Jackson, whose *The Fishing Barge* [ca. 1935, no. 47] reveals an interest in modernist devices, and Otis Dozier, whose *Grasshopper and Farmer* [1938, no. 72] carries the message of nature over man.) For example, John Steuart Curry was most accepting of midwestern values; his work was more idealizing than probing. And Thomas Hart Benton's 1939 print *Departure of the Joads* (no. 78), showing migrant workers leaving drought-stricken Oklahoma, was commissioned by Twentieth Century Fox when it made a film based on John Steinbeck's novel *The Grapes of Wrath*. An early adherent of synchromism, a cubist offshoot, Benton had traveled to Europe before World War I and was initially affected by the avant-garde. He began service in the United States Navy in 1918 and there became interested in the American sailor and American "types." Grant Wood had also been exposed to European movements, but other rural regionalists simply used the subjects at

hand to create images without any thought to possible alternatives. For the most part, the rural regionalists looked at their world without the effects or hardships brought about by the depression.

The urban regionalists—among them Kenneth Hayes Miller (see no. 26), Reginald Marsh (see no. 34), Adolf Dehn (see no. 31), Isabel Bishop, and Peggy Bacon—were based in major cities, mostly New York, and their work often has a bite absent in the rural images, except some by Grant Wood. The barns, silos, and grain elevators of the rural images found their counterpart in the skyscrapers and tenements of the urban ones. Though their art was not politically motivated, the urban artists were interested in an accuracy of detail that did not concern their rural counterparts, whose more naive style was used to dramatize events and places. Both groups, and the social realists, who focused on suffering, shared a denunciation of modernist and abstract art.

The American Scene movement was very strong, and it was aided in bringing art to the people by the Federal Art Project of the Works Progress Administration. The WPA was organized on a regional basis, so much of the art produced had a regional flavor and reached a public never touched by the European avant-garde art or early modernist work in America. With affordable prints, a new audience for art developed, and more people started to acquire them for their walls. Traditional attitudes that prints were intimate works to be hand held began to give way to the notion that they could be designed to hold their own on walls with works in other media. This idea came to full fruition only after 1950 but had its roots in the 1930s, particularly in lithographs influenced by the Mexican muralists, who came and worked in the United States at this time.

Of course not all artists interested in the American Scene were regionalists. For example, many works by Hopper, Charles Sheeler (see no. 22), and Charles Burchfield (see no. 107), with their greater interest in form than subject, fall outside that scope. The social realists were also beyond regionalism because of their national interest in social and political events; their art often focused on the injustices and inequalities in life.

This other facet of the American Scene included such artists as Robert Riggs (see no. 67), Kyra Markham (see no. 68), and Kenneth Hayes Miller (see no. 26). These are the "passing scene" artists. In contrast to the regionalists, they seem to take a smaller bite of the environment for their work, are less idealizing in their approach to their subject, and are recorders of a more specific place and time. Miller's greatest importance lies in the fact that he was among the most influential teachers in American printmaking history, awakening in his students (and others) an interest in the variety of subject matter available in their most immediate surroundings; he is linked to a number of artists in this publication. *Fourth of July* by Kyra Markham (no. 68), a WPA print from 1937, brings together fireworks and a church to evoke the belief that God and country are related—a common theme among artists during this period of national self-consciousness.

Though the depression, radical politics, and the approach of World War II all contribute to our view of the period as socially conscious, many artists worked without regard for these conditions. For example, Edward Hopper continued along an established path, and Stuart Davis kept his art separate from these issues, retaining a simplified cubist aspect in his images. John Marin and John Storrs also worked without reference to the social turmoil of the 1930s.

At the same time other artists engaged a different and rather crisp style somewhat related to cubism and abstraction that treated urban and industrial subjects and depicted the American Scene in a different way. Precisionism, basically realist in nature with a reduction of forms to their basic geometric elements (as with cubism but without the multiple viewpoints), was a style that had taken hold during the 1920s and continued into the 1930s. It was the machine age, with the attendant distillation of forms to their most essential lines or shapes, that interested these artists. Charles Sheeler is best known for his precisionist works; and *Industrial Series #1* (1928, no. 22), one of his few lithographs, clearly shows his reductive approach and interest in the geometry of his surroundings. Other artists took similar subjects and treated them in various ways. Louis Lozowick (see no. 16) simplified forms and created strong and often monumental images combining line with strong light and dark accents. In *Road Roller* (1931, no. 35) Ross Braught simplifies and enlarges a piece of machinery until the image almost becomes an abstract shape. Howard Cook's *Engine Room* (1930, no. 29) is a statement on the power of machinery, while Charles W. Dahlgreen's *A Note in Pattern* (ca. 1933, no. 40) remains an elegant, tonal piece on a quieter note.

Joseph Vogel's *Another Day* (ca. 1936–39, no. 63), is one of the few machine-age prints with the social overtones often found in American Scene work. Although the monumentality of the industrial site dominates, the posture of the men going to work suggests dissatisfaction and perhaps represents the psychological toll of industrialization. Jackson Pollock, who was to become the most dramatic exponent of abstract expressionism in the early 1950s, hints at the plight of miners in his

rather surprising print *Coal Miners—West Virginia*, from about 1936 (no. 62). This piece is related in its theme and bold style to works by the Mexican muralists.

Possibly the ultimate celebration of the machine age is Gerald Geerling's *Grand Canal America* of 1933 (no. 42), which captures the idea of power and industry at the Chicago World's Fair, an international celebration of the new age and the latest technology with the theme "A Century of Progress." The print won first prize in a contest sponsored by the fair.

The depression years saw a number of significant changes in printmaking. The medium of lithography, long thought of as a commercial process despite important strides made by Joseph Pennell, George Bellows, and others, became a widely used and recognized medium of expression particularly among artists influenced by the Mexican social realists. The Federal Arts Project printmaking workshop program gave great impetus to graphic artists and created a larger audience. For example, the Contemporary Print Group and Associated American Artists were formed in 1933 and 1934, respectively, and new commercial galleries not only sold prints but also published and distributed large edition works at reasonable prices. Artists and dealers acknowledged a relationship between sales and comprehensible images. With silkscreen and lithography taking their places alongside intaglio and relief methods, a wide range of work was available to a growing audience.

Toward the end of the 1930s, with the approach of World War II, another immigrant wave came to the United States. Although artistic production in general was curtailed because of wartime priorities, intaglio printmaking experienced unprecedented growth with the arrival of Stanley William

Hayter and his Atelier 17. Hayter's studio had functioned in Paris between 1928 and 1938, attracting an impressive array of artists in other media from across Europe (including Picasso, Joan Miró, Marc Chagall, Jacques Lipchitz), and a few from the United States (including David Smith [see no. 109] and John Ferren [see no. 56]). Among the many American artists and printmakers who worked in the New York atelier were Fred Becker (see no. 64), Sue Fuller (see no. 97), and James R. Goetz (see no. 98). Jacques Lipchitz, Gabor Peterdi, and Mauricio Lasansky were among the immigrant artists who worked there, and Lipchitz's *Theseus* (1943, no. 96) is one of only two prints shown here to deal with a classical theme (the other is George "Pop" Hart's *Dance of Centaurs* [1926, no. 19]). Alice Trumbull Mason (see no. 101), an often overlooked but very talented abstract artist, worked with Arshile Gorky after her return from a trip to Europe in the late 1920s. Years later she turned to printmaking and was at Atelier 17, where she was innovative in her use of different materials to give interesting textural effects to her softground prints. Another abstract artist who worked with Hayter and whose work gained acceptance at home and abroad was Alfred Russell (see no. 99).

Hayter, sometimes criticized for fostering imitators because of his strong influence and abstract surrealist style, was a catalyst: the atmosphere in the shop encouraged cooperative efforts, the combining of techniques in the search for new forms of expression, and a sharing of information. The significance of the atelier as a meeting place for refugee European artists and American students cannot be overestimated, and the radical experimentation that occurred there was important to the development of the abstract expressionist style, which was soon to dominate all others and place New York at the center of the postwar art world.

Aside from the work at Atelier 17, it is hard to find a focus in printmaking in the 1940s. Some of the artists working then are best known for their work from the 1930s, such as Doris Lee (see no. 103) for her regionalist images and Henry Billings for his interest in machines and precisionist style (see no. 93). Rockwell Kent had wide exposure during the 1920s and 1930s with his illustrations and wood engravings (see no. 102); and by 1947, the date of *U.S. Navy Series, U.S.S. Haddo* (no. 100), John Taylor Arms had been acclaimed as a virtuoso printmaker for more than a quarter century.

The period had its own "regionalist" artists, such as Alexandre Hogue (see no. 94), who spent a great part of his life in Texas and whose themes were from the American West. Gene Kloss, who was born and educated in California but has spent part of each year in New Mexico since 1930, is particularly known for her Rembrandtesque use of lights and darks in images of the American Southwest (see no. 105).

The 1950s was to be a decade of individualism, and the technical experimentation of the previous decades offered new possibilities and challenges to

printmakers. Academic institutions were now the center of printmaking. Modernist forms had become standard vocabulary, and prints increasingly grew in scale, taking their place alongside works in other media. Prints had moved to a more central position in American art.

At the turn of the twentieth century, American printmaking was largely tradition-bound and tentative; by mid-century a flowering had occurred and with this proliferation came acceptance as well as a national self-confidence. "Important" art was redefined to include printmaking and there was widespread recognition and appreciation for the specific qualities only possible in prints due to the technical challenges involved in their making. Not only had prints moved to a central position in America; they gained international attention just as this country came to the forefront in the world of art.

It is difficult to define the American muse. Some artists have been given less attention than they might deserve because they were expatriates; what we call American art is the result of a complex interchange that took place during the early decades of the century. Certainly a great strength of American art and American prints is diversity.

The Williams Collection of prints is broad in scope and through it one finds the many strains in American printmaking. Some of the pieces presented are of a genre deemed "forgettable" in the period following World War II, when America experienced a tremendous acceptance of "new art"

and we had our own avant-garde. Happily, with historical perspective, we allow works in all their diversity to mingle on our walls and in our museums. The Williams Collection is evidence that we have accepted ourselves.

Selected Bibliography

Adams, Clinton. *American Lithographers 1900–1960: The Artists and Their Printers.* Albuquerque: The University of New Mexico Press, 1983.

American Graphics 1880–1940. Introduction by Alan Fern. Catalogue by Ellen S. Jacobowitz and George H. Marcus. Philadelphia: Philadelphia Museum of Art, 1982.

The American Scene: Urban and Rural Regionalists of the '30s and '40s. Introduction by Mariea Caudill. Minneapolis: University Gallery, University of Minnesota, 1976.

Field, Richard S., and Sara D. Baughman, Debra N. Mancoff, Lora S. Urbanelli, and Rebecca Zurier. *American Prints 1900–1950.* New Haven: Yale University Art Gallery, 1983.

Johnson, Una E. *American Prints and Printmakers: A Chronicle of over 400 Artists and Their Prints from 1900 to the Present.* Illustrated. New York: Doubleday, 1980.

One Hundred Prints by 100 Artists of the Art Students League of New York, 1875–1975. Introduction by Sylvan Cole, Jr. Foreword by Judith Goldman. New York: Associated American Artists, 1975.

Watrous, James. *A Century of American Printmaking, 1880–1980.* Madison: The University of Wisconsin Press, 1984.

Catalogue

I

J O H N S L O A N (1871–1951)

Turning Out the Light, 1905

Etching

Sheet: 12⅝ x 14⅜ in.

Image: 4¹³⁄₁₆ x 6¹³⁄₁₆ in.

Signed below plate, right: "John Sloan"; signed in plate, lower left: "John Sloan 1905"

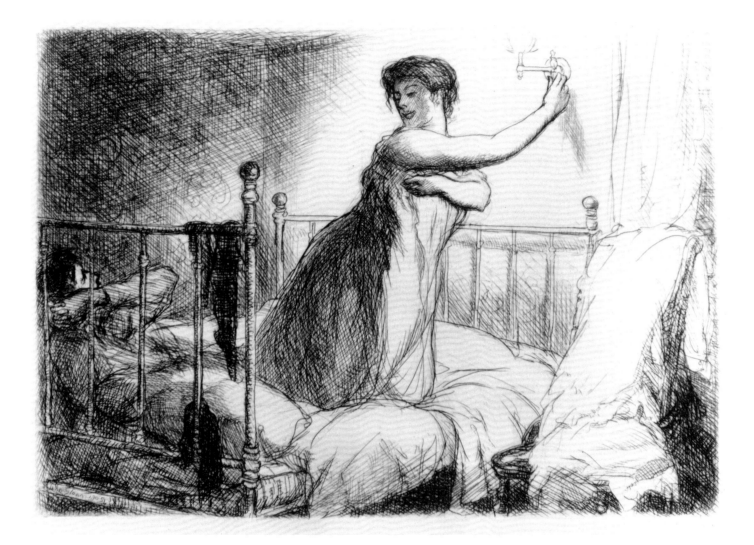

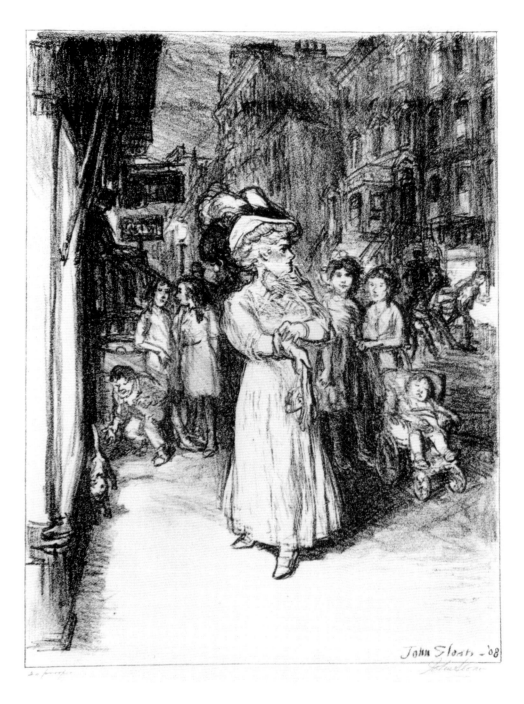

2

JOHN SLOAN (1871–1951)
Sixth Avenue and 30th St., 1908
Lithograph
Sheet: 19 x 14⅞ in.
Image: 14³⁄₁₆ x 11 in.
Signed below image, right: "John Sloan"; inscribed
below image, left: "20 proof"; signed in stone,
lower right: "John Sloan—'08"; inscribed on sheet,
lower left: "JS Imp"; inscribed on sheet, lower
center: "Sixth Avenue and 30th St."

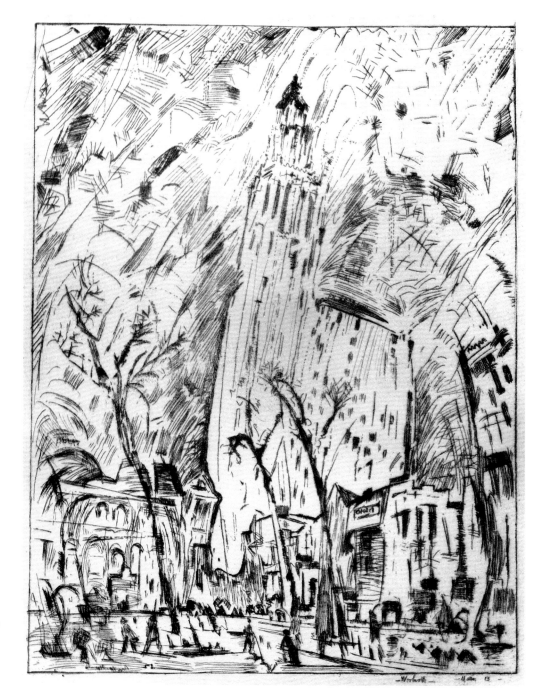

3

JOHN MARIN (1870–1953)

Woolworth, 1913

Etching

Sheet: 15¼ x 12½ in.

Image: 10⅞ x 8⅜ in.

Signed below plate, right: "John Marin";
signed in plate, lower right: "—Marin 13—";
inscribed in plate, lower right: "—Woolworth—"

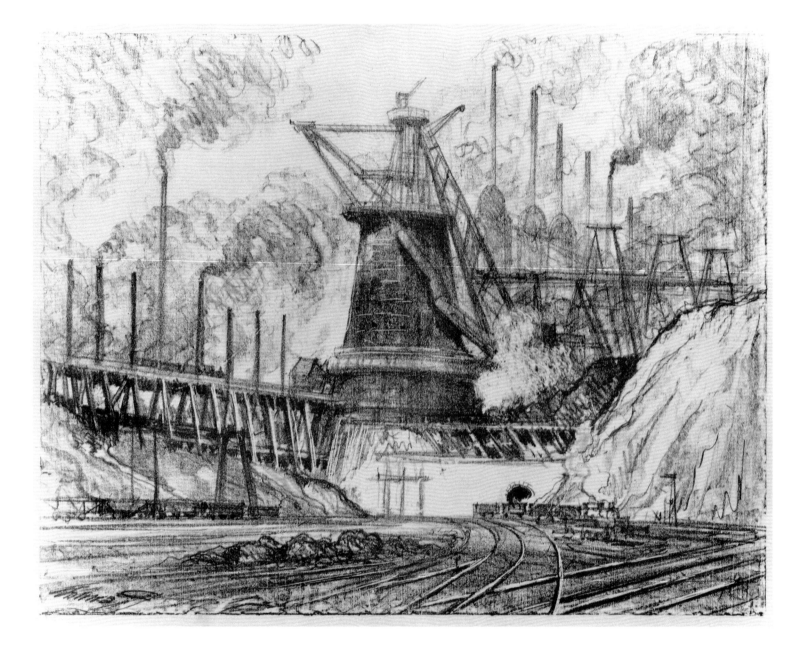

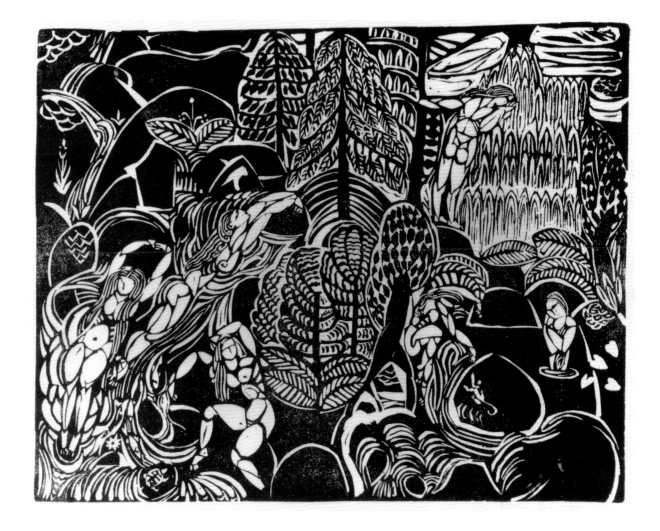

4
JOSEPH PENNELL (1860–1926)
The Big Mill, 1915
Lithograph
Sheet: 18½ x 24¾ in.
Image: 17⁷⁄₁₆ x 22½ in.
Signed in stone, in mirror image, lower left: "Pennell"; inscribed
on verso, lower left: "The Big Mill, Gary, Indiana, 1915/ W. 405.
Edition of 25"

5
WILLIAM ZORACH (1887–1967)
Mountain Stream, 1917
Woodcut
Sheet: 12¼ x 16½ in.
Image: 10¾ x 14 in.
Signed below image, right: "William Zorach 1917"

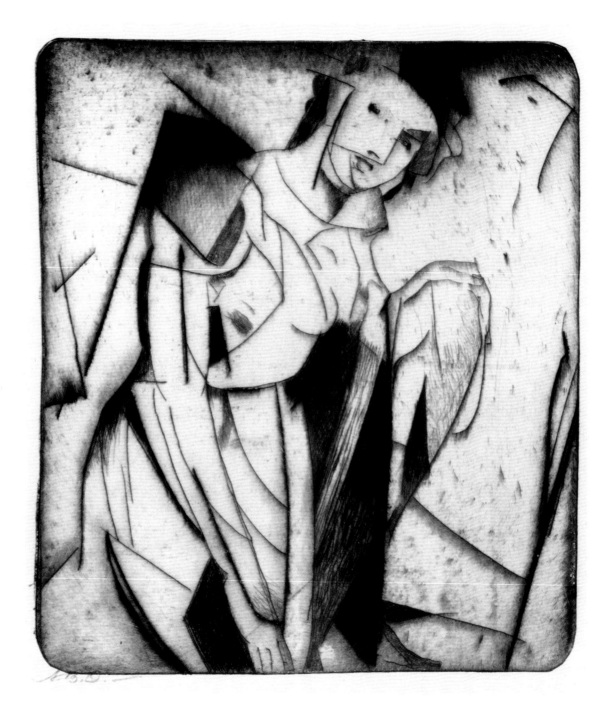

6

ARTHUR B. DAVIES
(1862–1928)
Figure in Glass, 1918
Drypoint
Sheet: 11¾ x 8½ in.
Image: 6⅜ x 5⅝ in.
Signed below plate, left: "A. B. D."

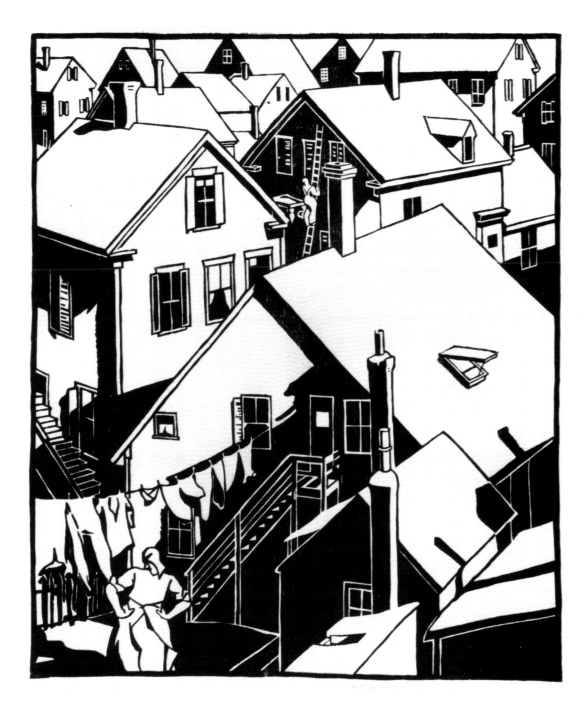

7

MILDRED McMILLEN
(1884–ca. 1940)
Provincetown Housetops, 1918
Woodcut
Sheet: 20¼ x 17¾ in.
Image: 17¼ x 14⅝ in.
Signed below image, right of center:
"Mildred McMillen 1918"

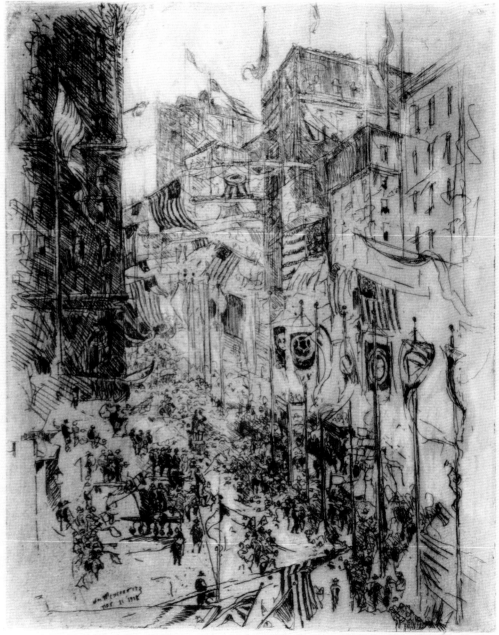

8

WILLIAM MEYEROWITZ
(1898–1981)
November 11, 1918—Fifth Avenue, 1918
Etching
Sheet: 12⅝ x 9⁷⁄₁₆ in.
Image: 9⅞ x 8 in.
Signed below plate, right: "Wm Meyerowitz";
signed in plate, lower left: "Wm Meyerowitz
Nov. 11 1918"

9
JOHN STORRS (1885–1956)

Coming from the Bath, 1918

Woodcut

Sheet: 31⅜ x 21¾ in.

Image: 30½ x 15¼ in.

Artist's stamp, lower right of plate: "John Storrs"

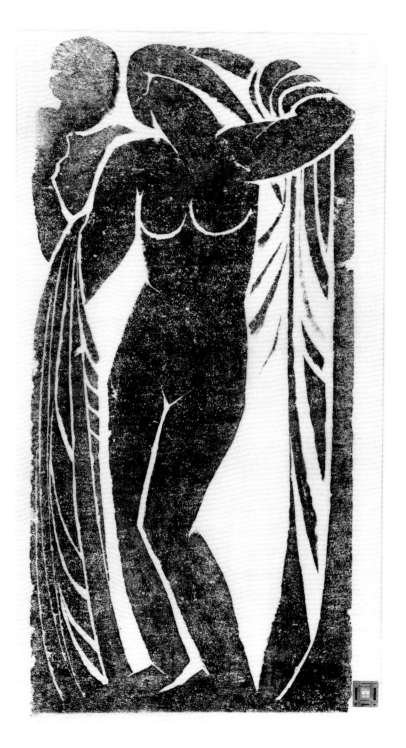

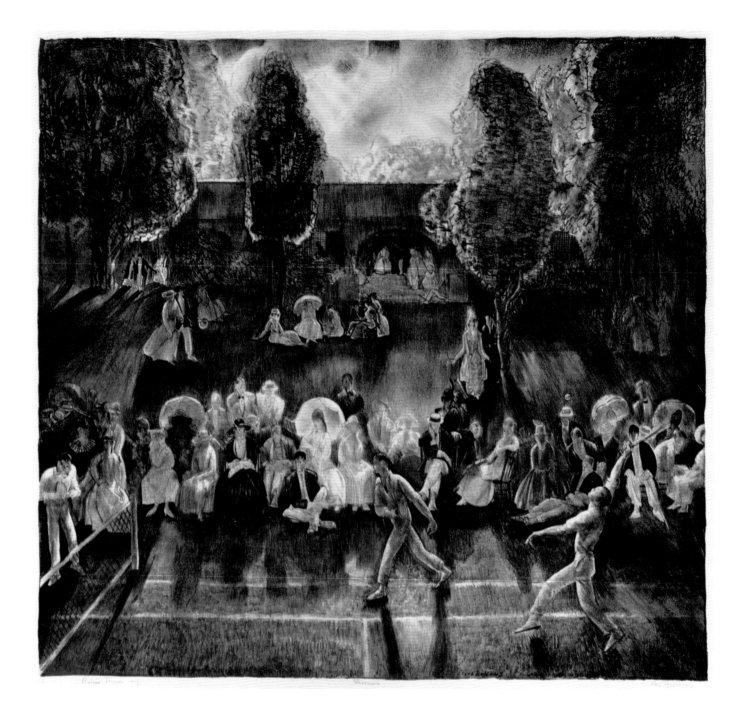

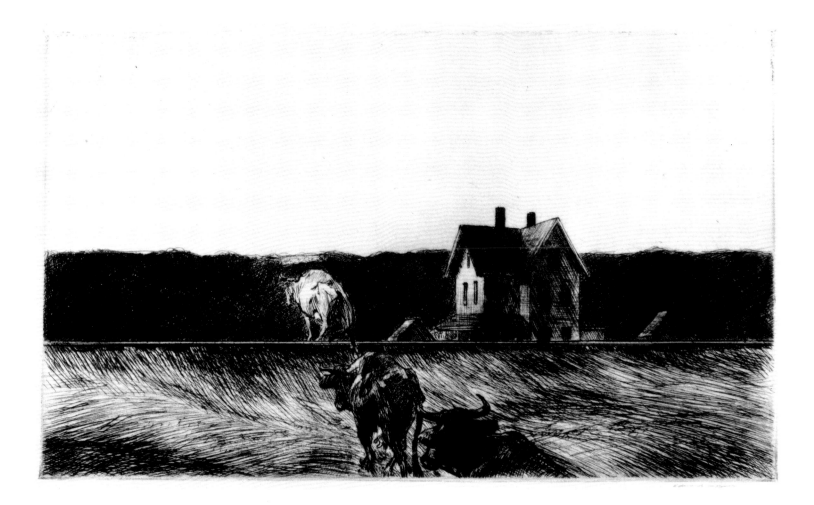

10
GEORGE BELLOWS (1882–1925)
Tennis Tournament, 1920
Lithograph
Sheet: 20½ x 21½ in.
Image: 18½ x 20 in.
Signed below image, right: "Geo Bellows"; inscribed below image,
left: "66 Bolton Brown imp."; inscribed below image, center:
"Tennis"; signed in stone, lower right of center: "Geo Bellows"

11
EDWARD HOPPER (1882–1967)
American Landscape, 1920
Etching
Sheet: 11½ x 16⅜ in.
Image: 7¼ x 12⅜ in.
Signed below plate, right: "Edward Hopper"

12

WALTER FRANCIS KUHN (1880–1949)
Floral Still Life, 1920
Woodcut
Sheet: 15⅛ x 11⅜ in.
Image: 10 x 6⅝ in.
Signed below image, right: "Walt Kuhn"; inscribed on sheet,
lower right: "Block Destroyed"

13

BIRGER SANDZEN

(1871–1954)

Lake in the Rockies, 1921

Woodcut

Sheet: 13⅞ x 11⅛ in.

Image: 11¹⁵⁄₁₆ x 9¹⁵⁄₁₆ in.

Signed below image, left: "Birger Sandzen";
inscribed below image, right: "Lake in the
Rockies"; signed in block, lower left: "B. S."

14

JAN MATULKA (1890–1972)

Evening in Central Park, ca. 1925

Lithograph

Sheet: 14⅞ x 22⅜ in. Image: 12⅜ x 18⅛ in. Signed below image, right: "Matulka"

15

WALTER FRANCIS KUHN (1880–1949)

Country Road, 1925

Lithograph Sheet: 9¼ x 12⅛ in. Image: 8⁹⁄₁₆ x 10⁵⁄₁₆ in.

Signed below image, right: "Walt Kuhn"; signed in stone, lower left: "Walt Kuhn"

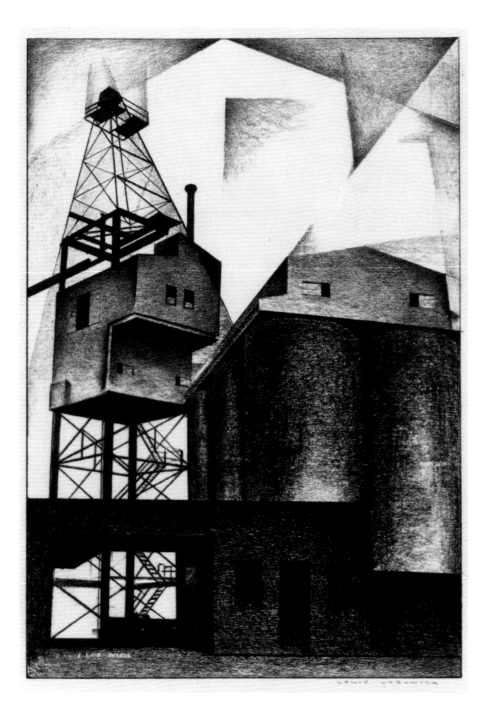

16

LOUIS LOZOWICK (1892–1973)
Coal Pockets #2, 1925
Lithograph
Sheet: 17¼ x 12¼ in.
Image: 11¾ x 8¼ in.
Signed below image, right: "Louis Lozowick"

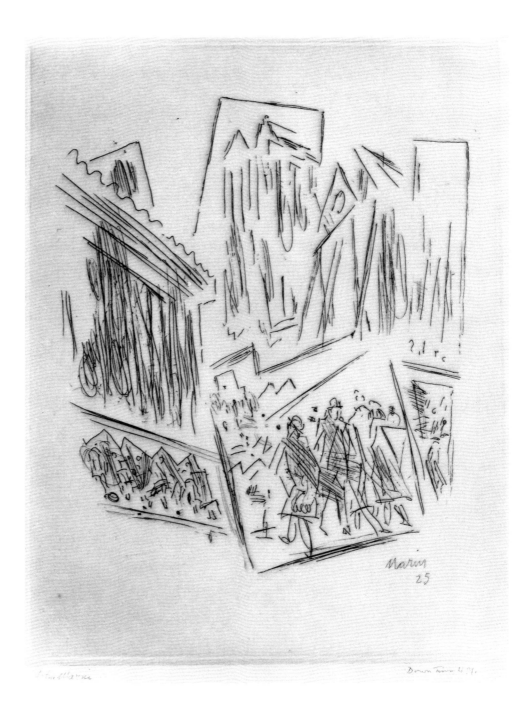

17

JOHN MARIN (1870–1953)
Down Town N.Y., 1925
Etching
Sheet: 13⁷⁄₁₆ x 11⅛ in.
Image: 8¾ x 6⅝ in.
Signed below plate, left: "John Marin";
inscribed below plate, right: "Down Town N.Y.";
signed in plate, lower right: "Marin 25"

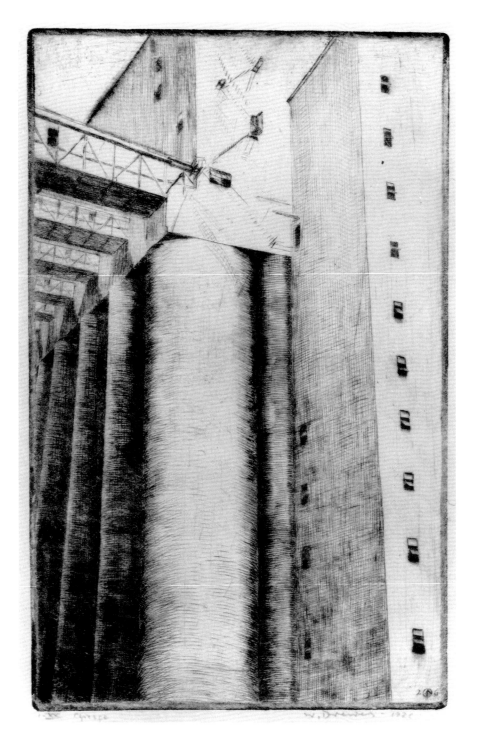

18
WERNER DREWES (1899–1985)
Grain Elevator No. 3, 1926
Etching
Sheet: 16 x 11 in.
Image: 12⅞ x 8¼ in.
Signed below plate, right: "W. Drewes—1926"; inscribed below
plate, left: "I–XX Epenage"; inscribed in plate, lower right:
"2 ⊕ 6"; inscribed on sheet, lower left: "No. 109/Grain
Elevator No. 3"

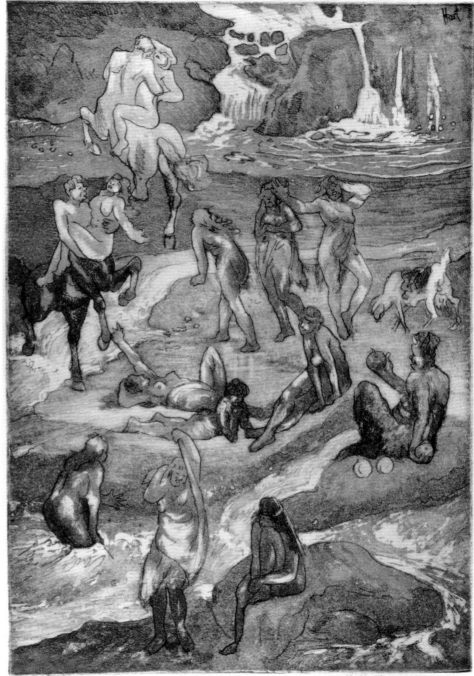

19

GEORGE "POP" HART

(1868–1933)

Dance of Centaurs, 1926

Etching and aquatint

Sheet: 14¹⁵/₁₆ x 10⅞ in.

Image: 12¾ x 9⅛ in.

Signed below plate, right: "Pop Hart"; inscribed
below plate, left: "Dance of Centaurs"; inscribed
on sheet, lower left: "18"; signed in plate,
lower right: "Hart"

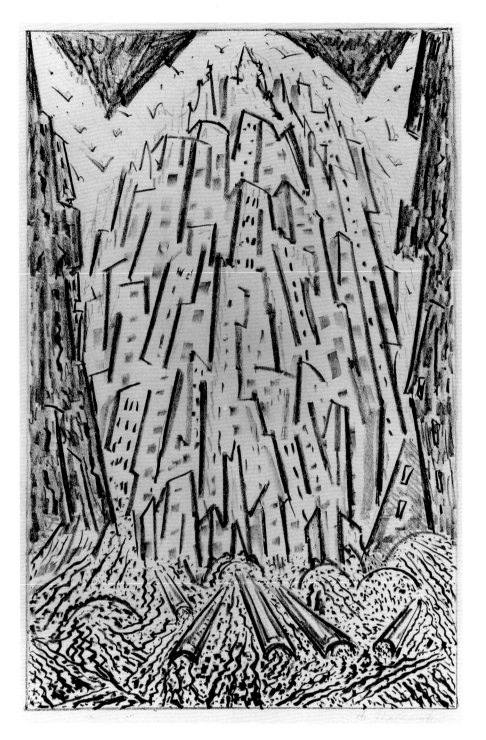

20

ABRAHAM WALKOWITZ (1880–1965)
New York of the Future, 1927
Lithograph
Sheet: 21½ x 15¾ in.
Image: 15½ x 10¼ in.
Signed below image, right: "A. Walkowitz"; inscribed on sheet,
lower right: "New York of the Future 14/11/27–10:00 (E)"

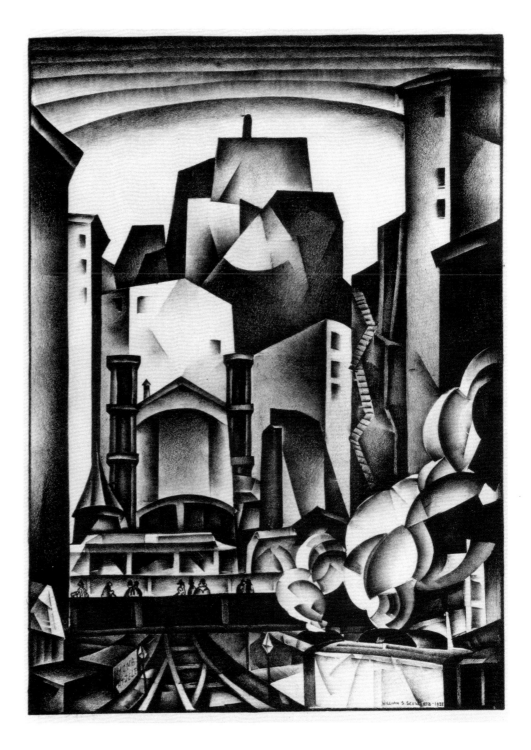

21

WILLIAM S. SCHWARTZ
(1896–1977)
Gas Factory, 1928
Lithograph
Sheet: 22⅜ x 17³⁄₁₆ in.
Image: 20⁹⁄₁₆ x 14½ in.
Signed below image, left: "William S. Schwartz";
signed in stone, lower right: "William S.
Schwartz–1928"

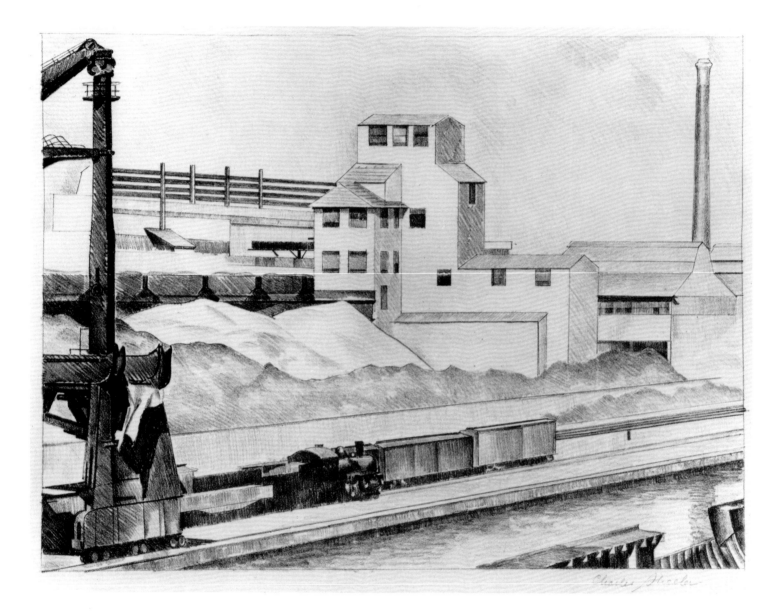

22

CHARLES SHEELER (1883–1965)
Industrial Series #1, 1928
Lithograph Sheet: 11¼ x 15⅞ in. Image: 8¹/₁₆ x 11⅛ in.
Signed below image, right: "Charles Sheeler"

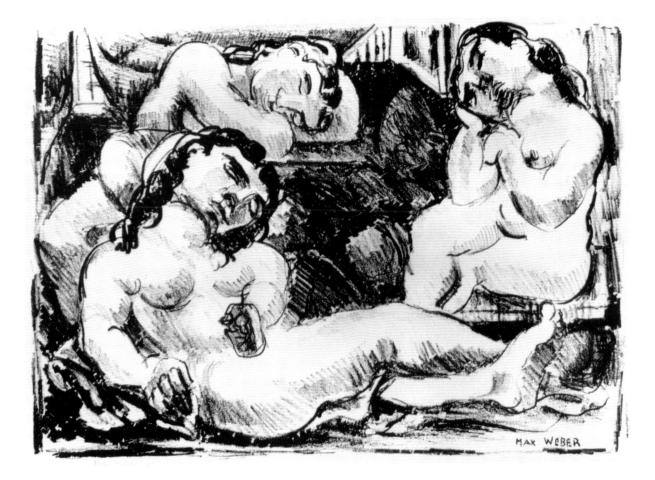

23

MAX WEBER (1881–1961)

Repose, 1928

Lithograph Sheet: 10 x 11⅞ in. Image: 6½ x 9⅜ in.

Signed below image, left: "Max Weber"; signed in stone, lower right:
"Max Weber"; signed on verso, lower right: "[artist's monogram encircled]"

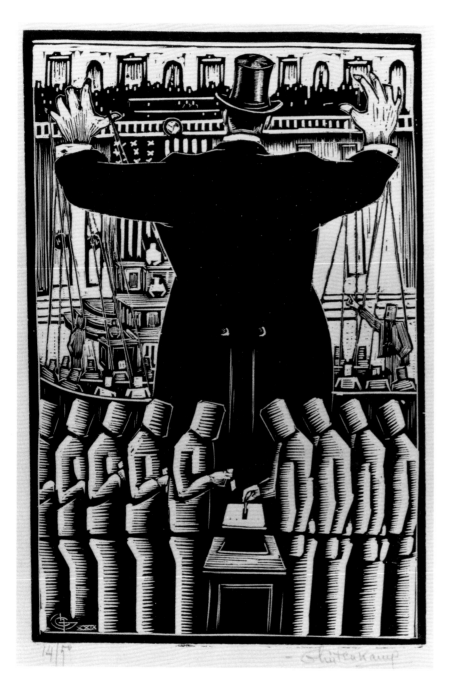

24

HENRY GLINTENKAMP (1887–1946)
Voters Puppets, 1929
Wood engraving
Sheet: 11⁹⁄₁₆ x 10¹⁄₁₆ in.
Image: 6½ x 4⅜ in.
Signed below image, right: "—Glintenkamp"; inscribed
below image, left: "14/50"; signed in block, lower left:
"[artist's monogram] XXIX"

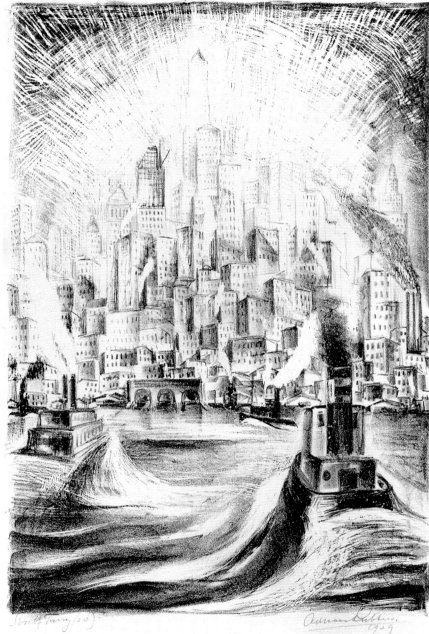

25

ADRIAAN LUBBERS (1892–1954)

South Ferry, 1929

Lithograph

Sheet: 20¼ x 14½ in.

Image: 14½ x 10½ in.

Signed below image, right: "Adriaan Lubbers. 1929";
inscribed below image, left: "South Ferry (20)";
stamped on sheet, lower right: "Benjamin West Society";
inscribed on sheet in ink, lower right: "590"

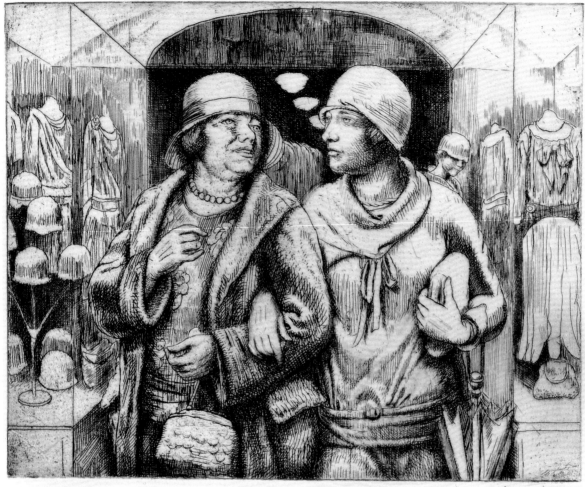

26

KENNETH HAYES MILLER (1897–1952)
Leaving the Shop, 1929
Etching
Sheet: 10 x 12⅞ in.
Image: 7⅞ x 9⅞ in.
Signed below plate, right: "Hayes Miller"

27

JAMES N. ROSENBERG (1874–1970)

November 13, Mad House, 1929, 1929

Lithograph

Sheet: 15⅞ x 11⁷⁄₁₆ in.

Image: 15¼ x 9½ in.

Signed below image, right: "James N. Rosenberg 1929"; inscribed below image, left: "Twenty five copies made of this"; inscribed below image, center: "To my friend Elmer Adler"; signed in stone, upper right of center: "JNR"

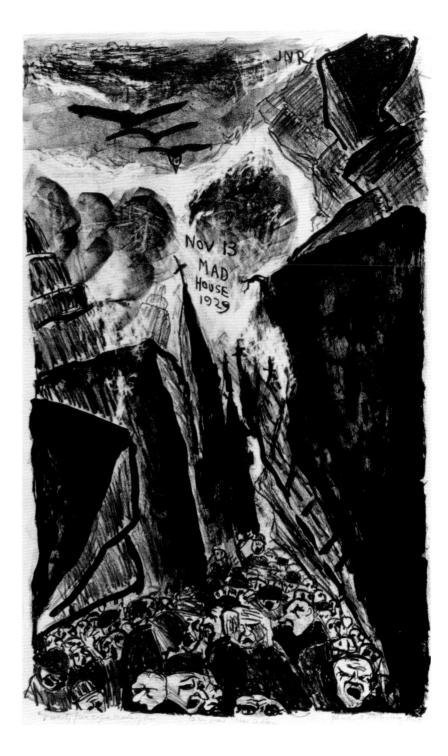

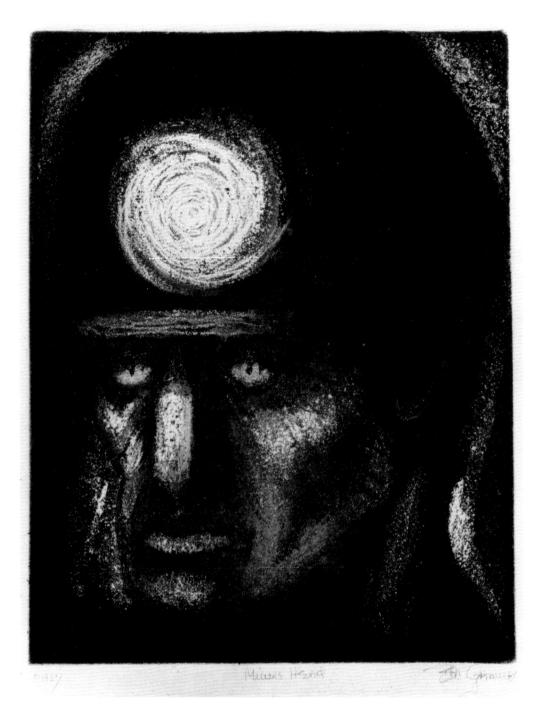

28
BLANCHE GRAMBS (b. 1916)
Miner's Head, ca. 1930s
Etching and aquatint
Sheet: 18½ x 14⅞ in.
Image: 14⅞ x 11¾ in.
Signed below plate, right: "BM Grambs";
inscribed below plate, left: "© 1937";
inscribed below plate, center: "Miners Head";
stamped on verso: "Federal Art Projects
NYC WPA"

29
HOWARD COOK (1901–80)
Engine Room, 1930
Lithograph
Sheet: 13¹¹⁄₁₆ x 15⅜ in.
Image: 10¹⁄₁₆ x 12⅛ in.
Signed below image, right: "Howard Cook
1930"; inscribed below image, left: "⑦⑤";
signed in plate; lower left: "Cook";
inscribed on sheet, lower left:
"Engine Room 1930"

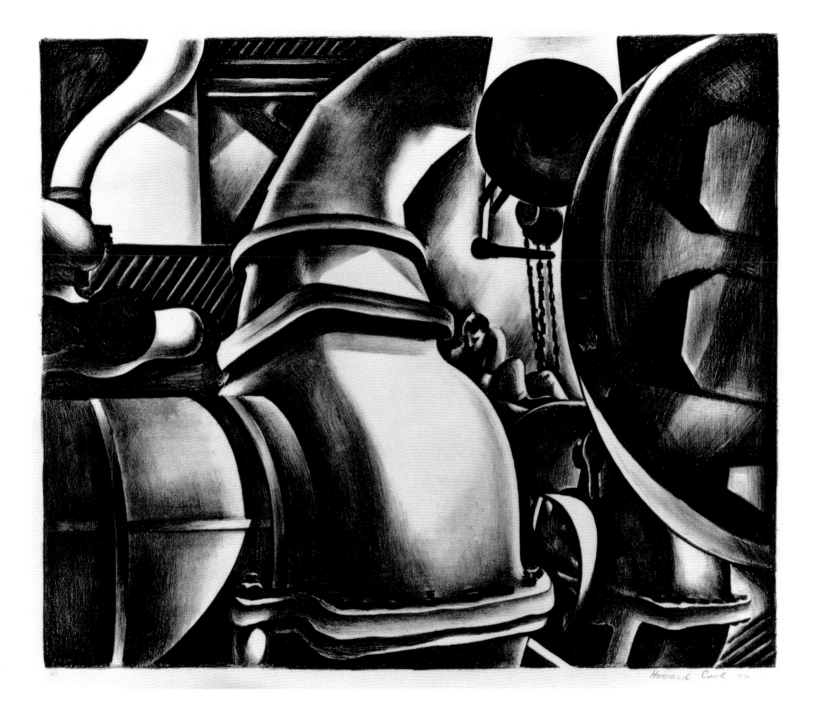

Howard Cook '30

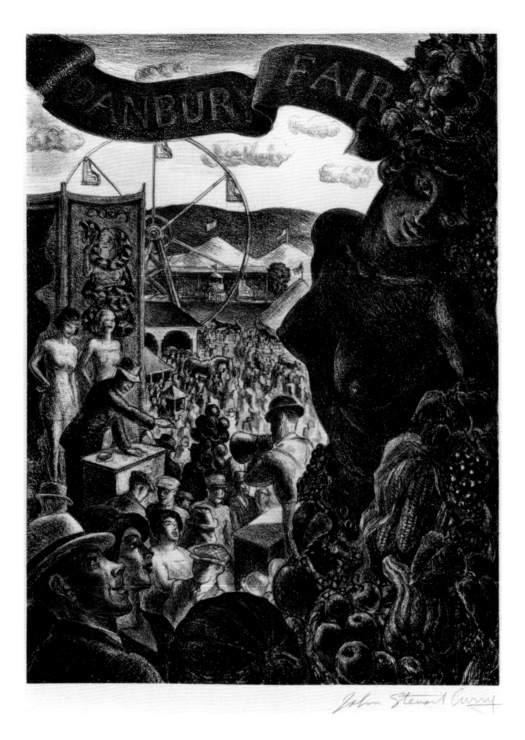

John Steuart Curry

30

JOHN STEUART CURRY
(1897–1946)
Danbury Fair, 1930
Lithograph
Sheet: 21½ x 15⅞ in.
Image: 13 x 9¾ in.
Signed below image, right: "John Steuart Curry";
inscribed below image, left: "yw.6. Miller Litho";
signed in stone, lower right: "[monogram] Curry EO"

31

ADOLF DEHN (1895–1968)
New York Night, 1930
Lithograph
Sheet: 28⁷⁄₁₆ x 19¹³⁄₁₆ in.
Image: 19⅛ x 13⅜ in.
Signed below image, right: "Adolf Dehn
1930"; inscribed below image, left: "10/30
New York Night"

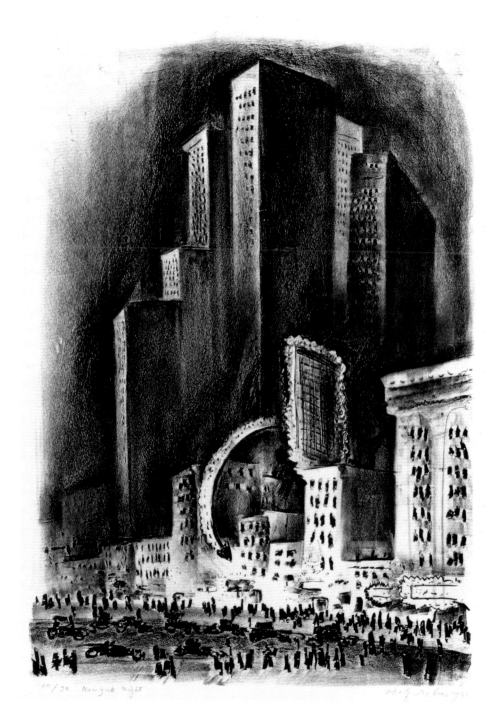

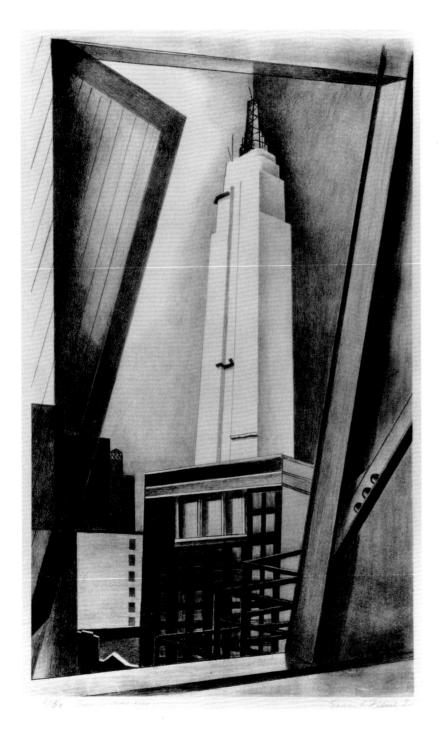

32

ERNEST FIENE (1894–1965)

Empire State Building, 1930

Lithograph

Sheet: 16 x 11⅝ in.

Image: 14⁵⁄₁₆ x 8¾ in.

Signed below image, right: "Ernest Fiene 30"; inscribed below image, left: "2/50 Empire Bld."; inscribed on sheet, lower right: "Empire State Bld."

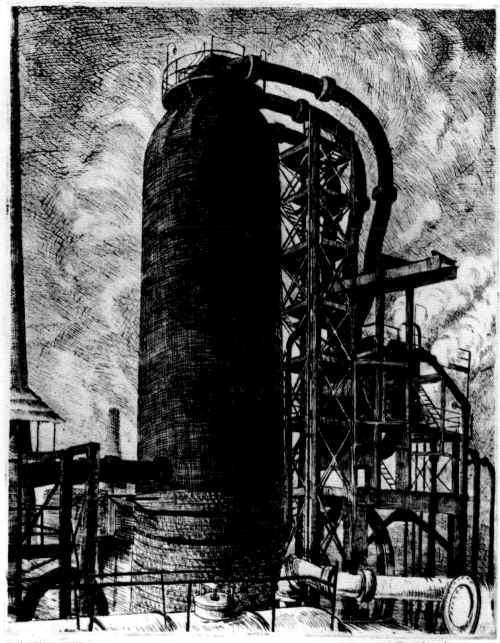

33
ISAAC FRIEDLANDER
(1890–1968)
Fractionating Tower, 1930
Etching
Sheet: 21¼ x 16 in.
Image: 17⅛ x 13¾ in.
Signed below plate, right: "I. Friedlander";
inscribed below plate, left: "Fractionating
Tower Standard Oil Refinery, Bayonne N.J."

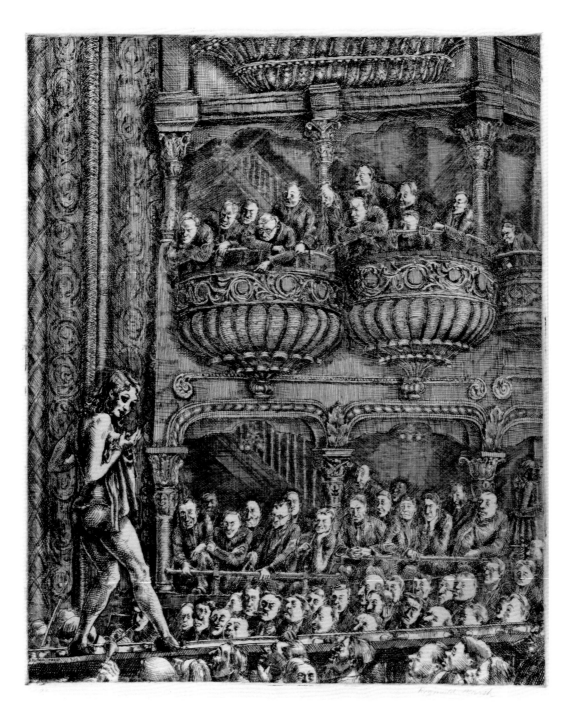

34
REGINALD MARSH
(1898–1954)
Gaiety Burlesk, 1930
Etching
Sheet: 13½ x 11 in.
Image: 11⅞ x 9⅞ in.
Signed below plate, right: "Reginald Marsh";
inscribed below plate, left: "#23"; signed
in plate, lower left: "REGINALD
MARSH 1930"

35

ROSS BRAUGHT (b. 1898)

Road Roller, 1931

Lithograph Sheet: 19 x 25 in. Image: 12⅛ x 18¾ in.

Signed below image, right: "Ross Braught 1931"; inscribed below image, left: "Road Roller (4) Ed of 10 numbered prints"

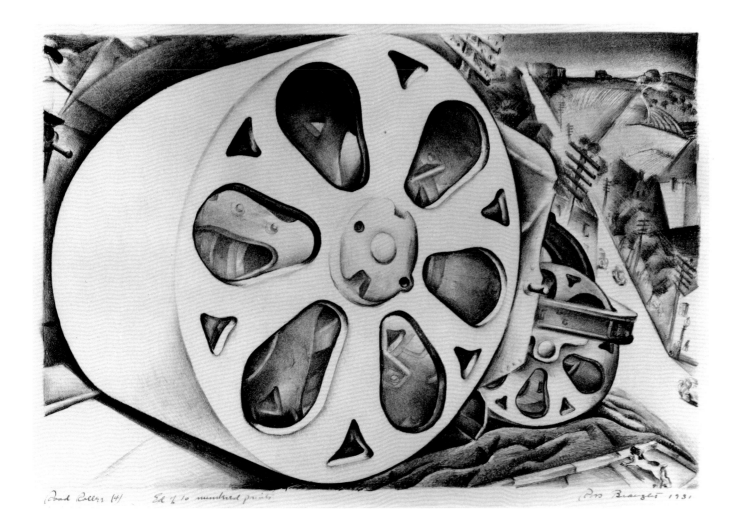

20/25 Stuart Davis

36
STUART DAVIS (1894–1964)
Sixth Avenue El, 1931
Lithograph Sheet: 17 x 23⅛ in. Image: 11⅞ x 17¹⁵⁄₁₆ in.
Signed below image, right: "Stuart Davis"; inscribed below image, left: "20/25"; signed in stone, right center: "Stuart Davis"

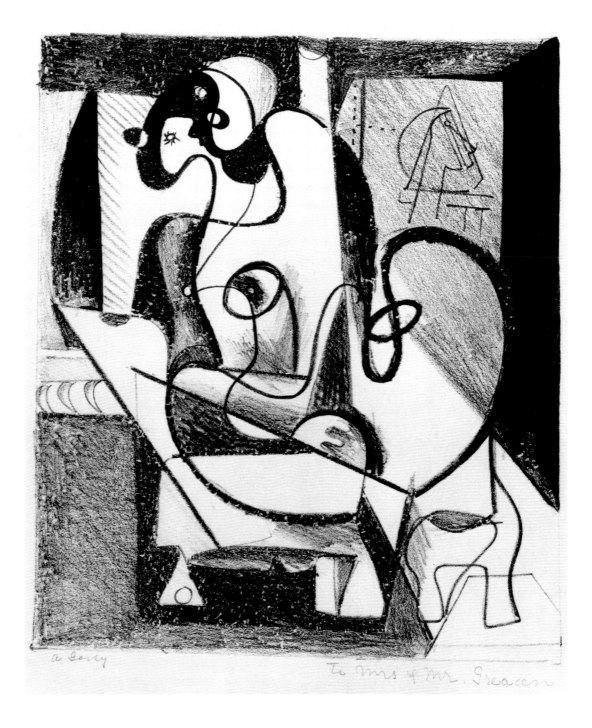

37
ARSHILE GORKY
(1904–48)
Painter and Model, 1931
Lithograph
Sheet: 20½ x 16 in.
Image: 11¼ x 9⅞ in.
Signed below image, left: "A. Gorky";
inscribed below image, right: "To Mrs.
& Mr. Greacen"

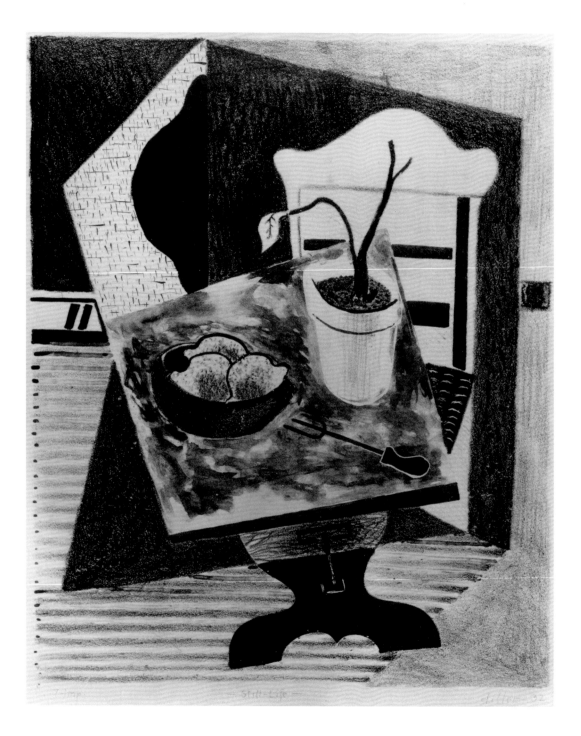

38
BURGOYNE DILLER
(1906–65)
Still Life, 1932
Lithograph
Sheet: 15¹⁵⁄₁₆ x 11⁷⁄₁₆ in.
Image: 11⅜ x 9⁷⁄₁₆ in.
Signed below image, right: "diller—32";
inscribed below image, left: "7–Imp";
inscribed below image, center:
"—Still-Life—"

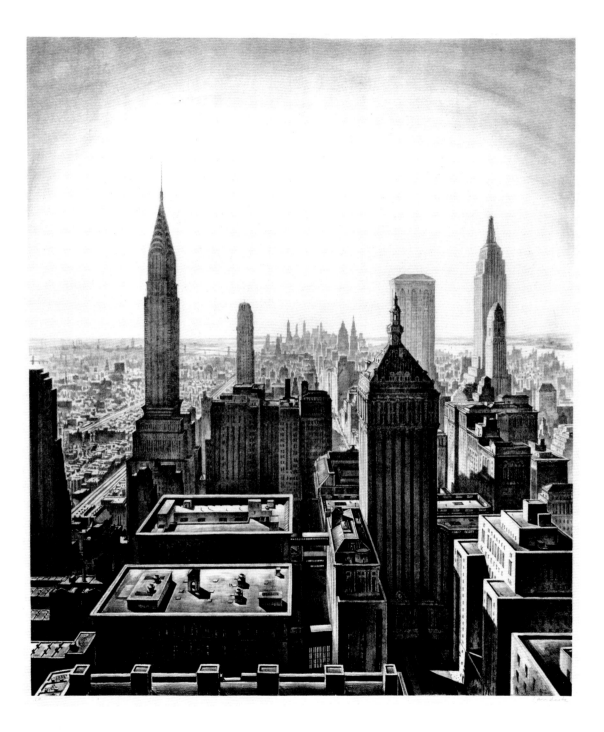

39
ARMIN LANDECK
(1905–84)
View of New York, 1932
Lithograph
Sheet: 32 x 26 in.
Image: 27⅛ x 23½ in.
Signed below image, right:
"Landeck"; inscribed below image,
left: "10"

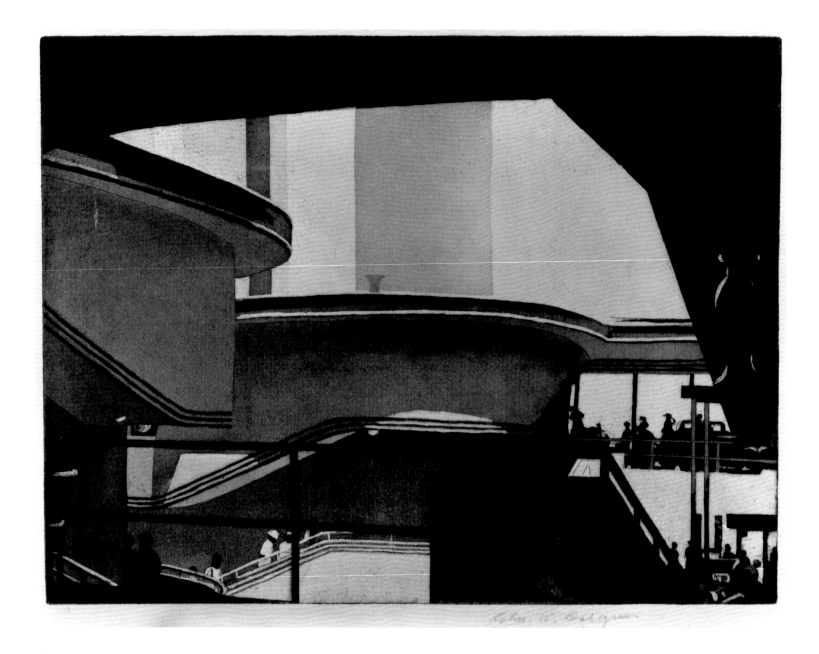

40

CHARLES W. DAHLGREEN (1864–1955)

A Note in Pattern, ca. 1933 Etching and aquatint Sheet: 9¹⁵⁄₁₆ x 12¹¹⁄₁₆ in. Image: 7¹⁵⁄₁₆ x 10¹¹⁄₁₆ in. Signed below plate, right of center: "Chas. W. Dahlgreen"

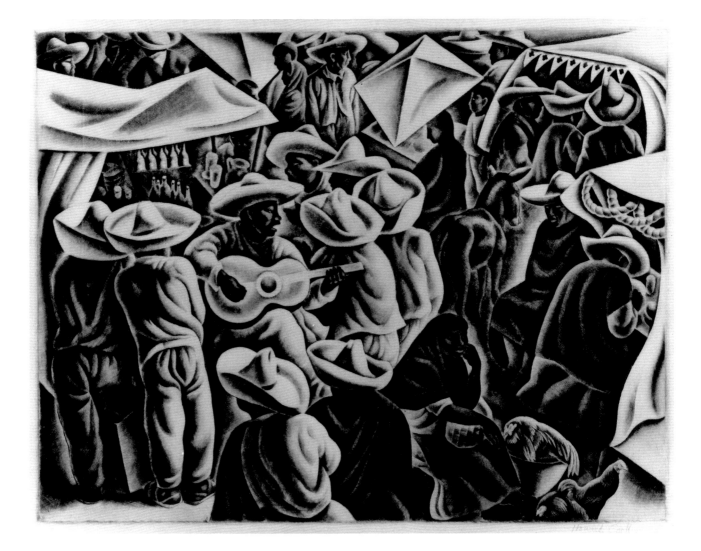

41

HOWARD COOK (1901–80)

Fiesta, 1933

Etching

Sheet: 12⅛ x 16⁹⁄₁₆ in.

Image: 10⅞ x 14⅜ in.

Signed below plate, right: "Howard Cook"

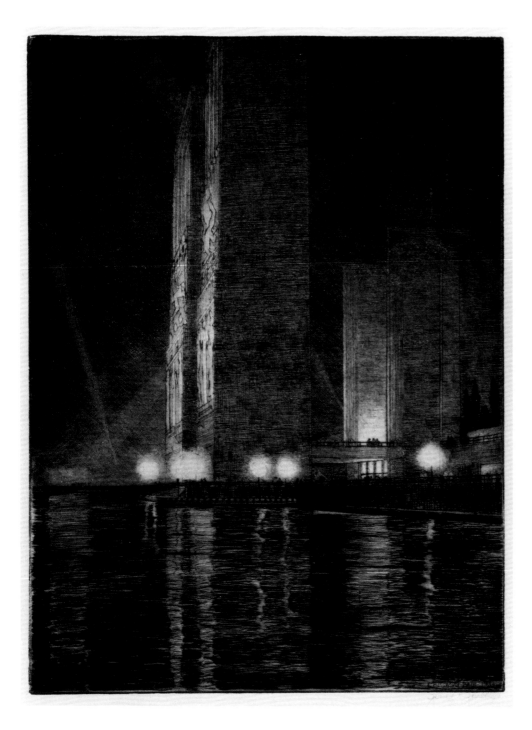

42

GERALD GEERLINGS (b. 1897)

Grand Canal America, 1933

Drypoint

Sheet: 15⅛ x 11⅛ in.

Image: 11⅞ x 8¹⁵⁄₁₆ in.

Signed below plate, right: "Gerald K. Geerlings";
inscribed in plate, right: "CHICAGO FAIR 1933";
imprint in sheet, lower left: "CHICAGO SOCIETY
OF ETCHERS"

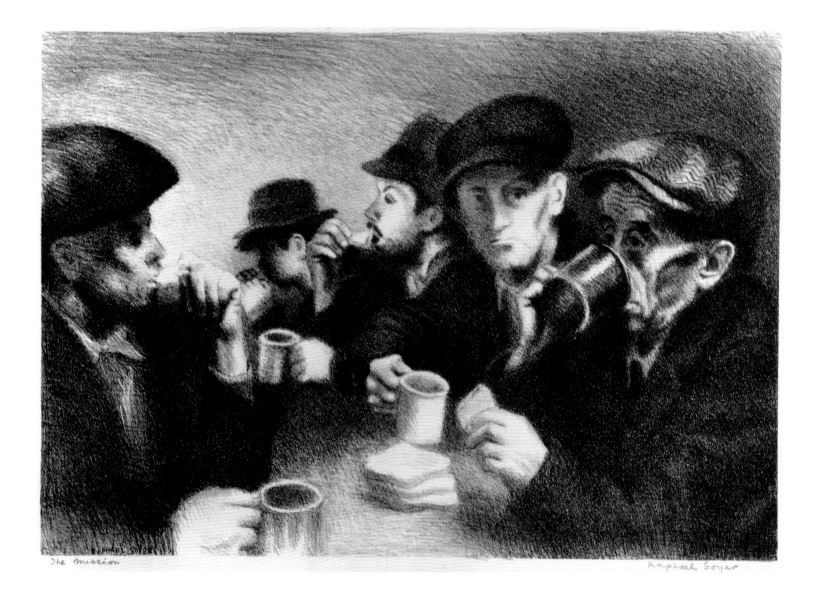

43

RAPHAEL SOYER (1899–1987)

The Mission, 1933

Lithograph Sheet: 15⅞ x 22⅞ in. Image: 12³⁄₁₆ x 17¾ in.

Signed below image, right: "Raphael Soyer"; inscribed below image, left: "The Mission"; signed in stone, lower left: "Raphael Soyer"

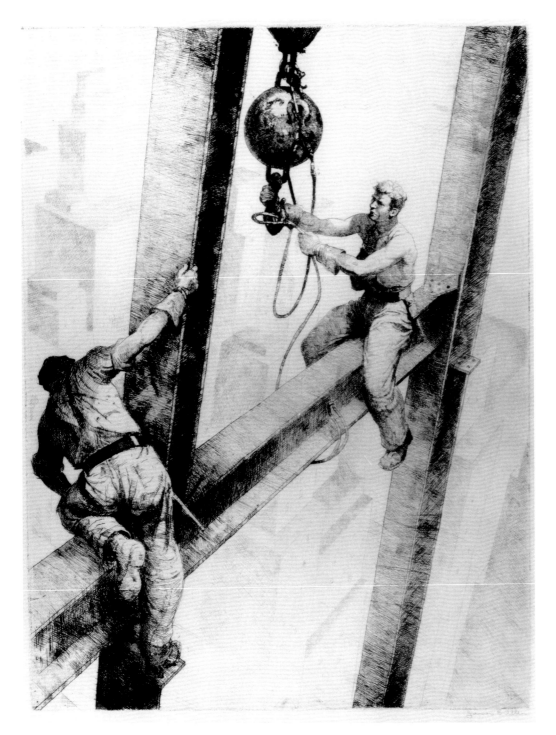

44

JAMES E. ALLEN (1894–1964)

The Connectors, 1934

Etching

Sheet: 16¾ x 13⅛ in.

Image: 13 x 10¹³⁄₁₆ in.

Signed below plate, right: "James E. Allen"

45

WILL BARNET (b. 1911)

Conflict (Vigilantes), 1934

Lithograph

Sheet: 17⅞ x 22⅝ in.

Image: 16⅜ x 19¼ in.

Signed below image, right: "Will Barnet";

inscribed below image, left: "Vigilantes"

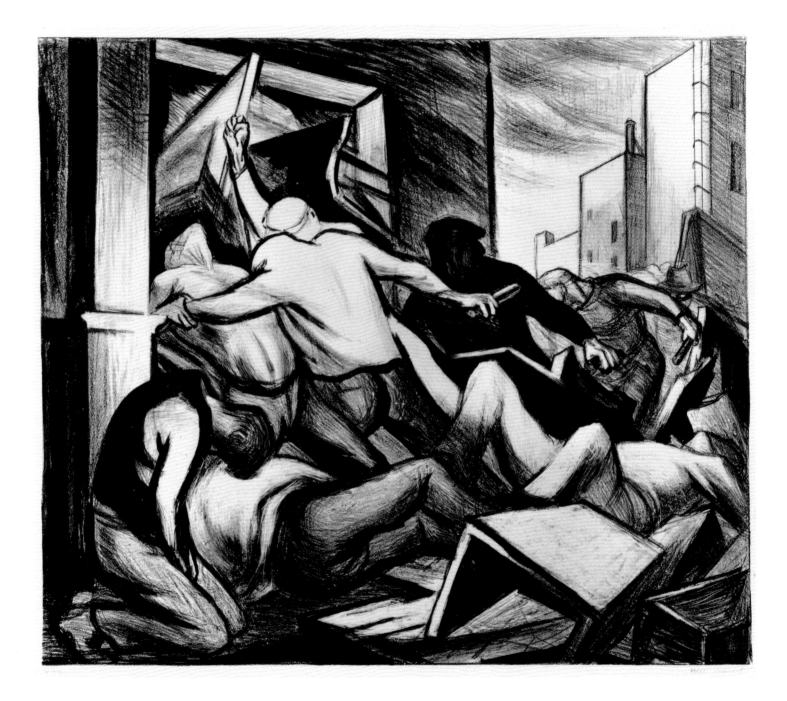

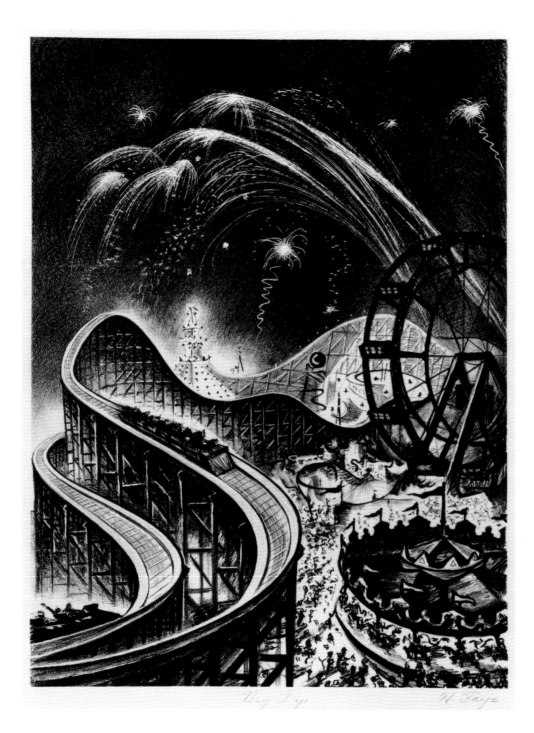

46
H A R O L D F A Y E (1910–80)
Big Dip, ca. 1935
Lithograph
Sheet: 21⅛ x 16⅛ in.
Image: 15¼ x 11¾ in.
Signed below image, right: "H. Faye";
inscribed below image, center: "Big Dip"

47

EVERETT GEE JACKSON

(b. 1900)

The Fishing Barge, ca. 1935

Lithograph

Sheet: 14½ x 11 in.

Image: 13½ x 10⅛ in.

Signed below image, right: "Everett Gee Jackson";
inscribed below image, left: "P. Roeher Imp.
The Fishing Barge"; signed in stone, lower left
of center: "Everett Gee Jackson"

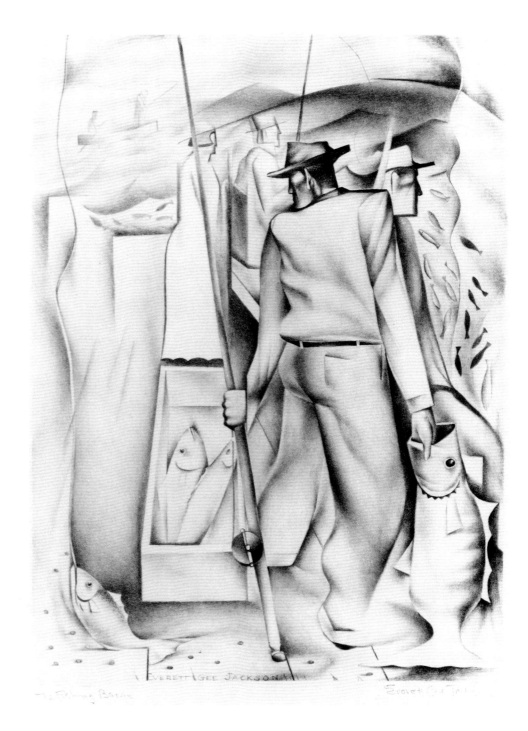

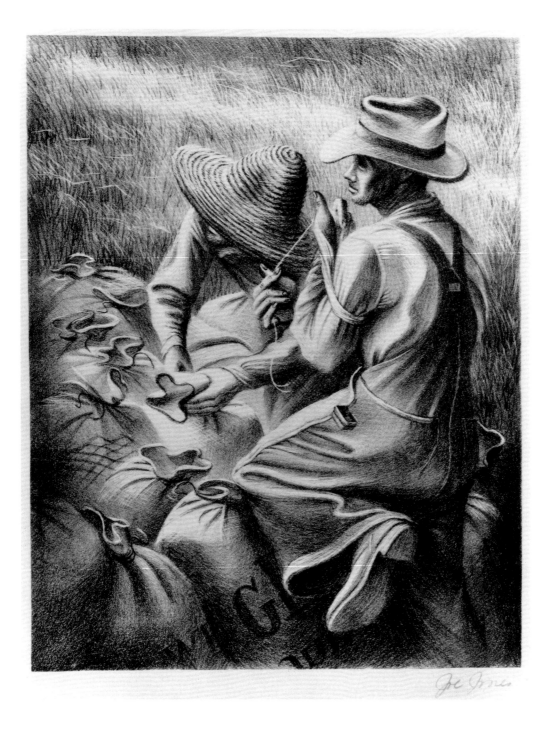

48
JOE JONES (1909–63)
Sacking Grain, ca. 1935
Lithograph
Sheet: 15⅛ x 12¾ in.
Image: 9⅞ x 7¹⁵⁄₁₆ in.
Signed below image, right: "Joe Jones"

49

PAUL LANDACRE (1893–1963)

Coachella Valley, ca. 1935

Wood engraving Sheet: 10⅝ x 15⅛ in. Image: 6 x 12¼ in.

Signed below image, right: "Paul Landacre"; inscribed below image, left:
"36/60 Coachella Valley"; stamped on verso, lower right: "Origins of Art"

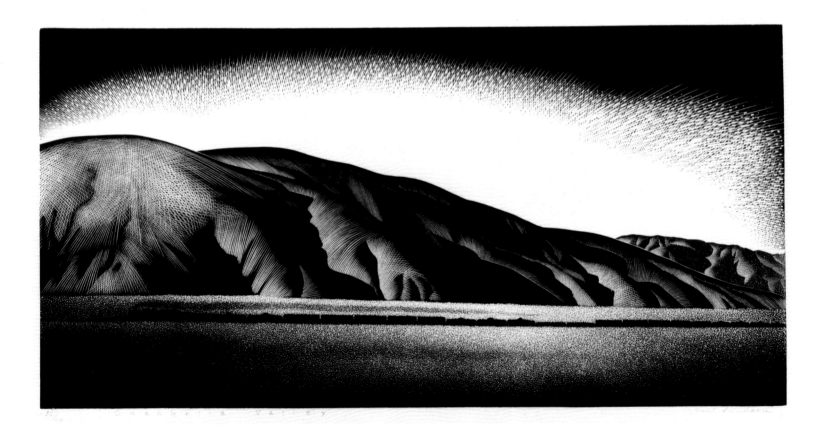

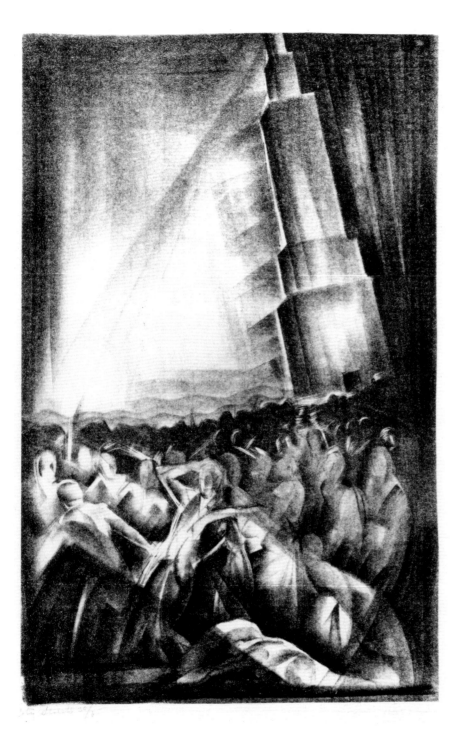

50

I. IVER ROSE (1899–1972)
City Streets, ca. 1935
Lithograph
Sheet: 21¹⁵⁄₁₆ x 16¹³⁄₁₆ in.
Image: 17⁹⁄₁₆ x 11⅜ in.
Signed below image, right: "I. Iver Rose";
inscribed below image, left: "City Streets 30/85"

51

EDGAR DORSEY TAYLOR
(1904–78)
The UVX, Jerome, ca. 1935
Lithograph
Sheet: 17¼ x 11⅞ in.
Image: 11 x 9 in.
Signed below image, right:
"Edgar Dorsey Taylor";
inscribed below image, left:
"The U.V.X, Jerome 121/150"

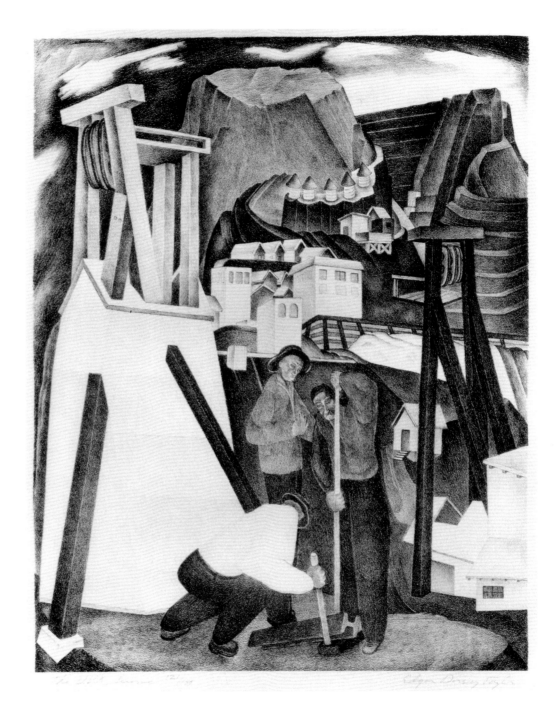

52
BEATRICE WOOD (b. 1895)
Helen Lloyd Wright, ca. 1935
Lithograph Sheet: 12⅜ x 14⅞ in. Image: 9½ x 12⅝ in.
Inscribed below image, center: "Helen Lloyd Wright"; inscribed below image, left: "[monogram] 7/20"; signed below image, right: "Bea"

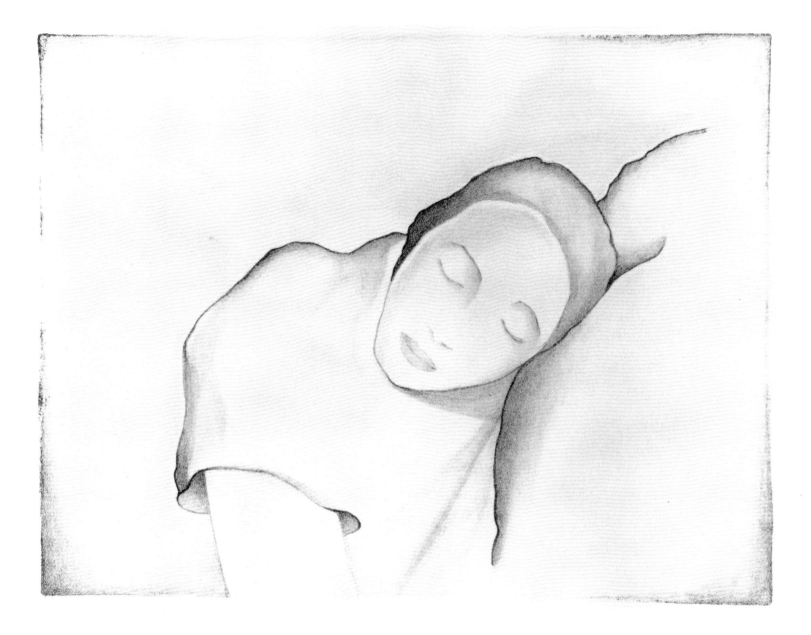

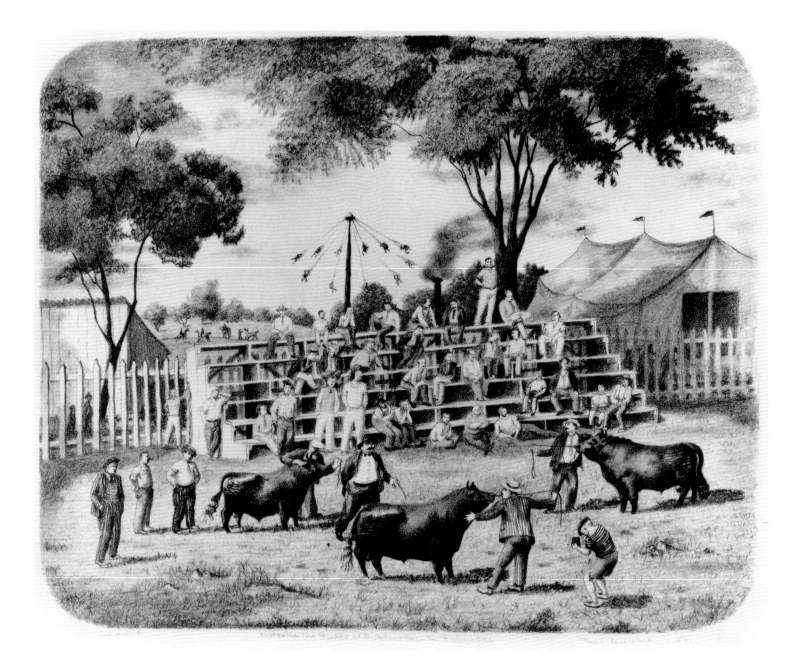

53

LUCILE BLANCH (1895–1983)

Judging the Bulls, 1935

Lithograph

Sheet: 13½ x 17 in.

Image: 13 x 16⁷⁄₁₆ in.

Inscribed below image, right: "Much love to
Wilma and Nan—Lucile Blanch"; inscribed
below image, left: "20 prints"; inscribed below
image, center: "Judging the Bulls at Dutchess
County Fair, 1935"

54

JACOB BURCK (1907–82)

Coffee and ——, 1935

Lithograph

Sheet: 19⅛ x 12⅝ in.

Image: 14⅛ x 9¾ in.

Inscribed below image, right:
"To Alex from Jake Burck";
inscribed below image, left: "4/25 1935";
inscribed below image, center:
"'Coffee and ——'";
signed in stone, lower left: "Burck"

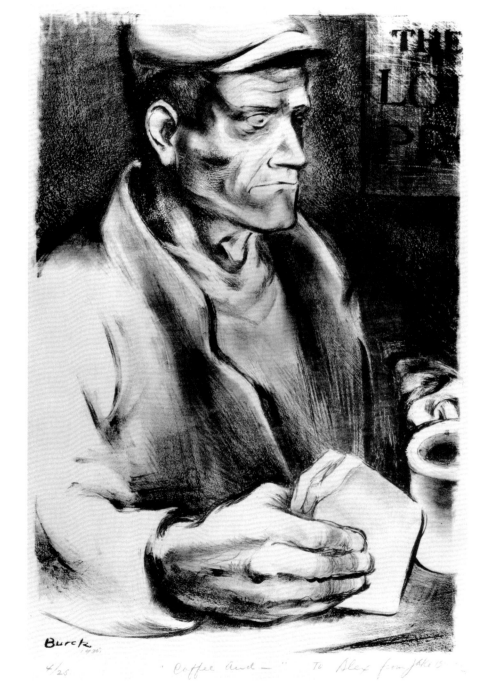

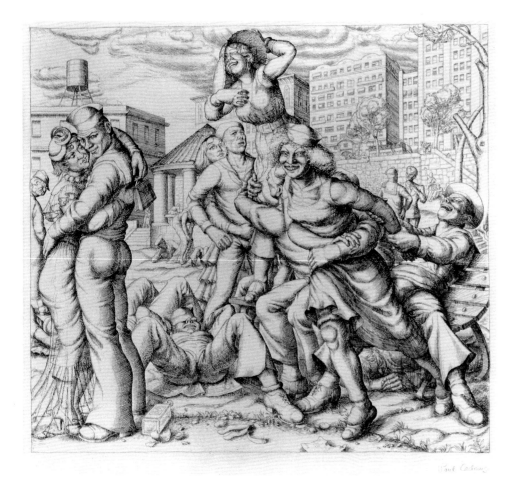

Paul Cadmus

55
PAUL CADMUS (b. 1904)
Shore Leave, 1935
Etching
Sheet: 14⅞ x 13⁵⁄₁₆ in.
Image: 10⅜ x 11⁹⁄₁₆ in.
Signed below plate, right: "Paul Cadmus";
signed in plate, lower center: "P. C."

56
JOHN FERREN (1905–69)
Expressive, 1935
Softground etching, aquatint, and drypoint Sheet: 11 x 13½ in. Image: 7⅛ x 9¼ in.
Signed below plate, right: "Ferren 35"; inscribed below plate, left: "Epreuve d'essais"

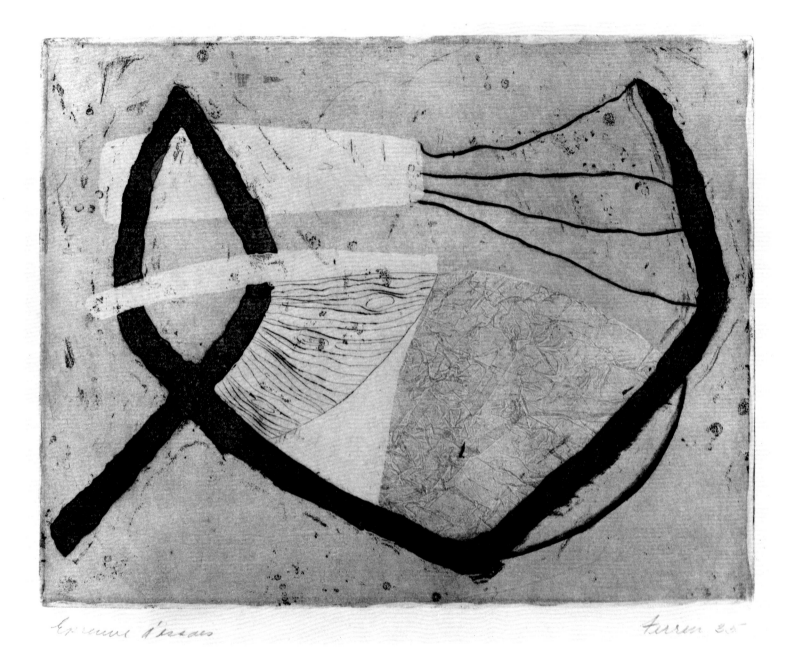

Épreuve d'essais Turin 95

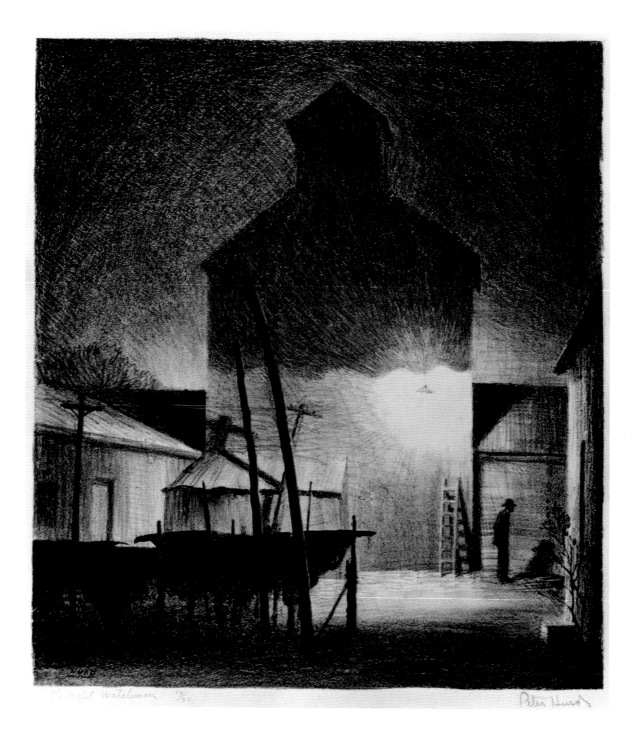

57
PETER HURD
(1904–84)
The Night Watchman, 1935
Lithograph
Sheet: 14½ x 13½ in.
Image: 11⅞ x 10⅞ in.
Signed below image, right:
"Peter Hurd"; inscribed
below image, left:
"The Night Watchman 19/36";
signed in stone, lower left:
"HURD"

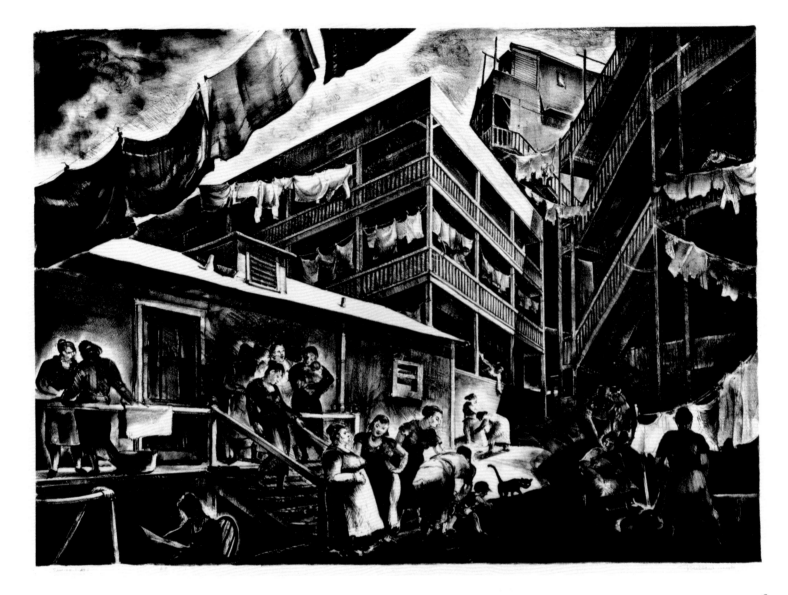

58

MILLARD SHEETS (1907–89)
Family Flats, 1935
Lithograph Sheet: 18 x 24¾ in. Image: 15⁹⁄₁₆ x 21⅞ in.
Signed below image, right: "Millard Sheets";
inscribed below image, left: "FAMILY FLATS/A. P."

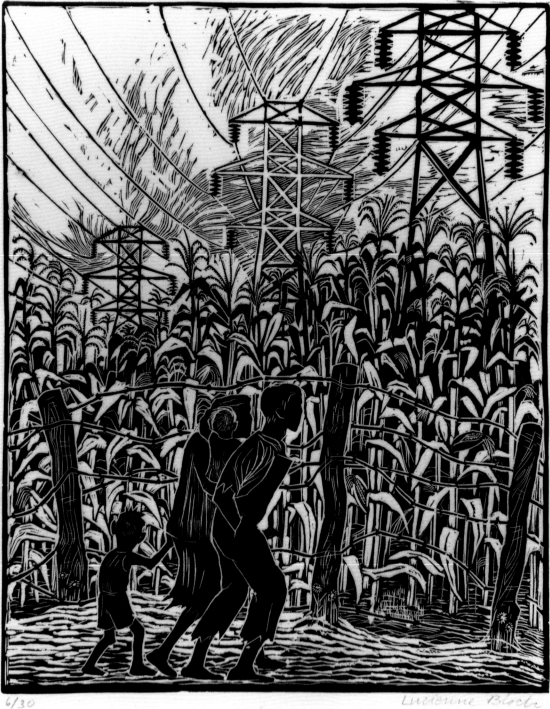

6/30 Lucienne Bloch

59
LUCIENNE BLOCH
(b. 1909)
Land of Plenty, ca. 1936
Woodcut
Sheet: 15⅞ x 12 in.
Image: 10⅝ x 8¹³/₁₆ in.
Signed below image, right:
"Lucienne Bloch";
inscribed below image, left: "6/30"

60

WILLIAM LeROY FLINT (b. 1909)

Sun and Dust, ca. 1936

Etching Sheet: 9¹⁵⁄₁₆ x 13 in. Image: 6¹⁵⁄₁₆ x 8⅞ in.

Signed below plate, right: "W LeRoy Flint"; inscribed below plate, left: "Sun and dust"

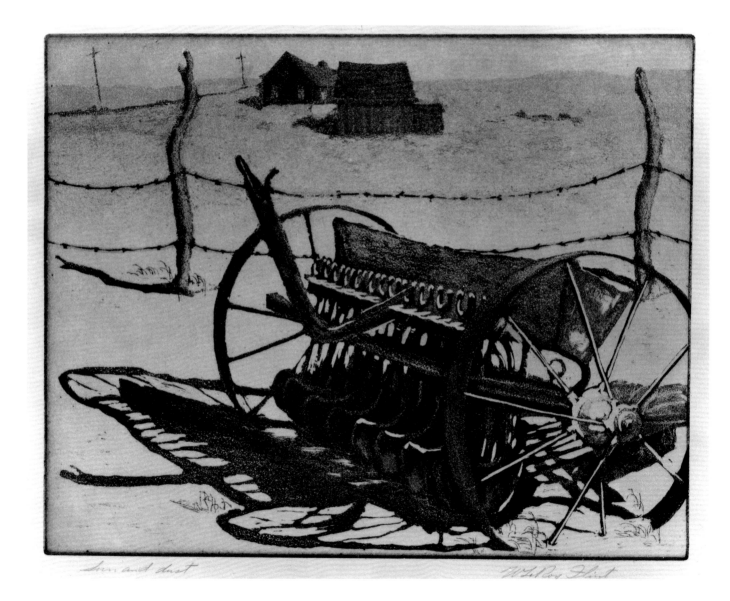

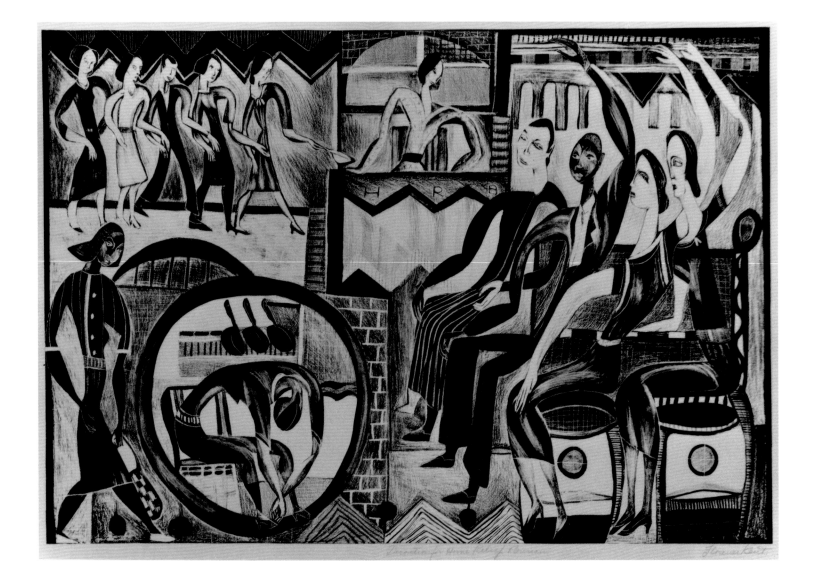

61

FLORENCE KENT HUNTER (1917–89)

Decoration for Home Relief Bureau, ca. 1936–39

Lithograph Sheet: 16 x 22⅞ in. Image: 13⅜ x 19⅝ in.

Signed below image, right: "Florence Kent"; inscribed below image, center: "Decoration for Home Relief Bureau";
inscribed on sheet, lower right: "13"; signed in stone, lower right: "F. KENT"

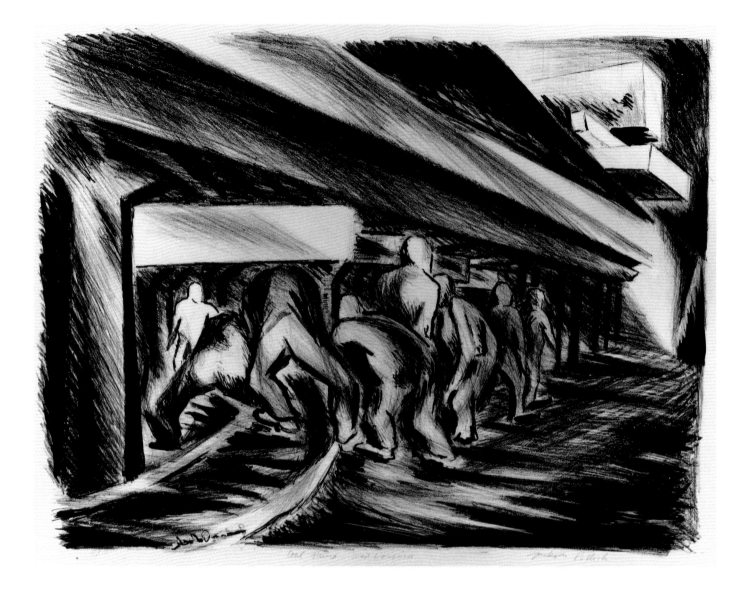

62

JACKSON POLLOCK (1912–56)

Coal Miners—West Virginia, ca. 1936

Lithograph Sheet: 14³/₁₆ x 17⁷/₁₆ in. Image: 11½ x 15½ in.

Signed below image, right: "Jackson Pollock"; inscribed below image, left: "E/10"; inscribed below image, center: "Coal Mine. West Virginia"; signed in stone, in mirror image, lower left: "Jackson Pollock"

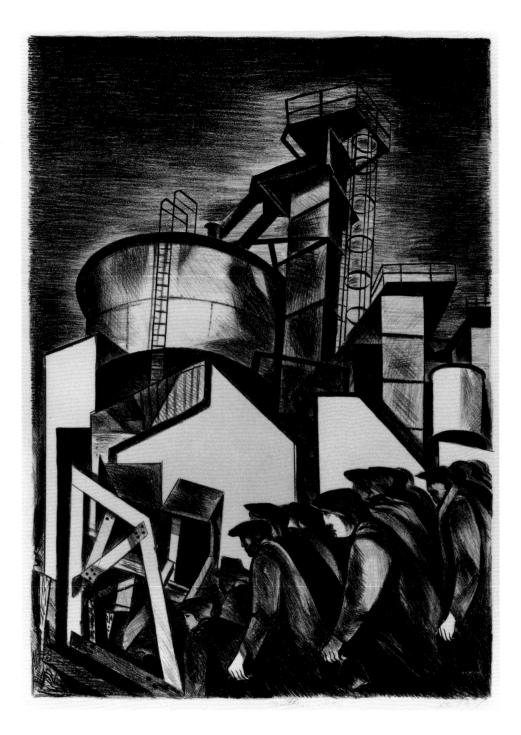

63

JOSEPH VOGEL (b. 1911)
Another Day, ca. 1936–39
Lithograph
Sheet: 23 x 16 in.
Image: 14¾ x 10⅞ in.
Signed below image, right: "Joe Vogel";
inscribed below image, right of center:
"Another Day"

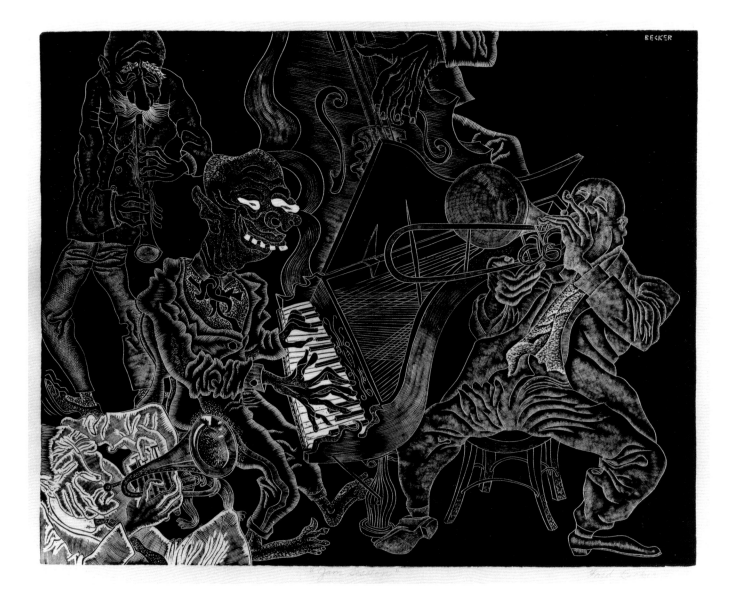

64

FRED BECKER (b. 1913)

Jam Session, Clambake, At the Jazzband Ball, 1936

Wood engraving Sheet: 9⅞ x 12¹¹⁄₁₆ in. Image: 7¾ x 9¹⁵⁄₁₆ in.

Signed below image, right: "Fred Becker '36"; inscribed below image, center: "'Jam Session'"; signed in block, upper right: "Becker"

65

JOHN LANGLEY HOWARD (b. 1902)

The Union Meeting, 1936

Lithograph

Sheet: 14¹¹/₁₆ x 18¾ in.

Image: 10⅛ x 14¼ in.

Signed below image, right: "John L. Howard—1936"; inscribed below image, left: "The Union Meeting";
signed in stone, in mirror image, lower left: "John L. Howard—1936"

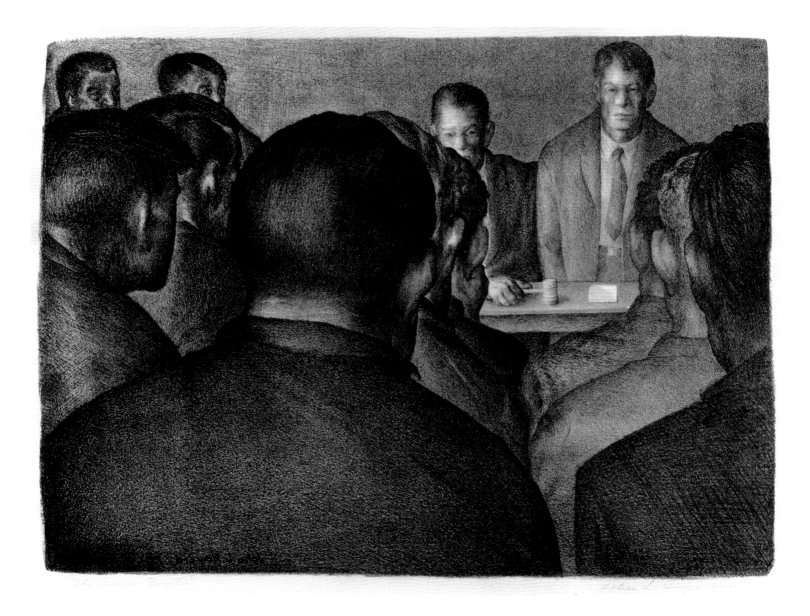

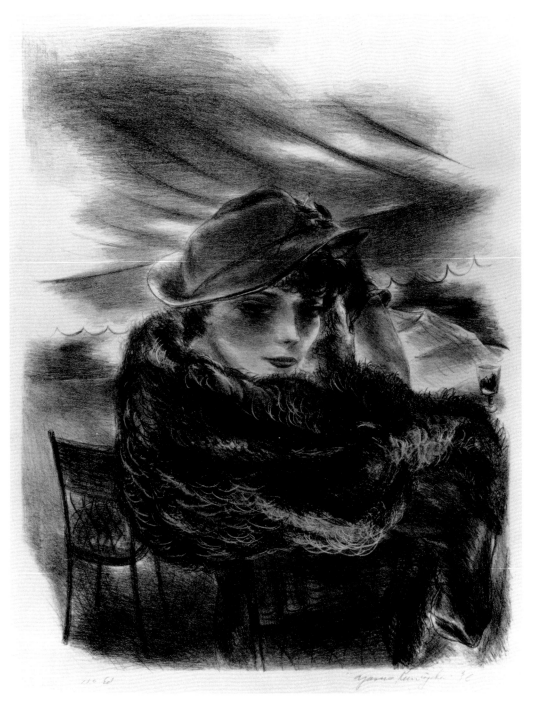

66

YASUO KUNIYOSHI (1893–1953)

Cafe 2, 1936

Lithograph

Sheet: 16 x 11½ in.

Image: 12½ x 9⅞ in.

Signed below image, right: "Yasuo Kuniyoshi 36"; inscribed below image, left: "100 Ed"

67

ROBERT RIGGS (1896–1970)

Tumblers, 1936–37

Lithograph

Sheet: 20⅛ x 22¾ in.

Image: 14¼ x 18¹⁵⁄₁₆ in.

Signed below image, right: "Robert Riggs"; inscribed below image, left: "30 Tumblers"; signed in plate, lower left: "Robert Riggs"

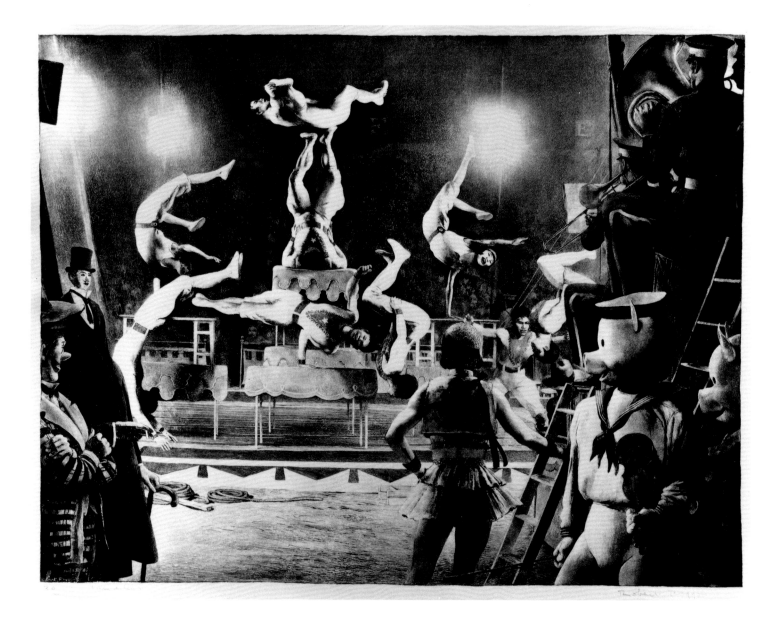

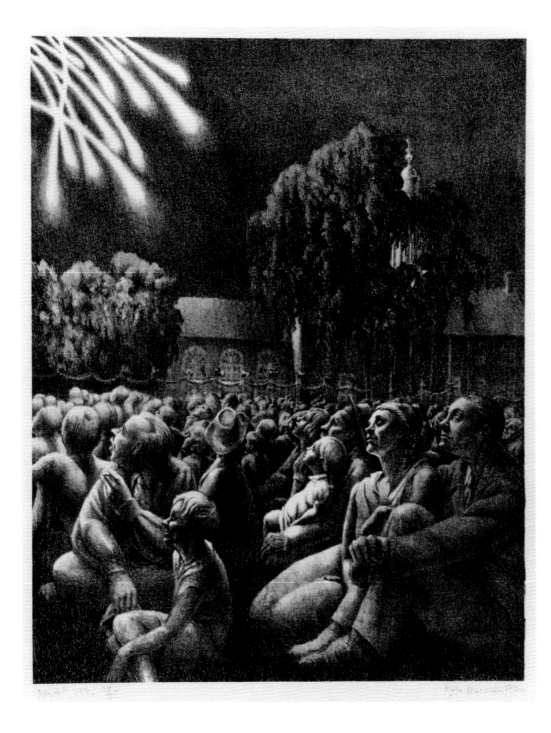

68

KYRA MARKHAM (1891–1967)
Fourth of July, 1936
Lithograph
Sheet: 19⅞ x 15¹⁵⁄₁₆ in.
Image: 12¹¹⁄₁₆ x 15¹⁵⁄₁₆ in.
Signed below image, right:
"Kyra Markham, 1936";
inscribed below image, left:
"July 4th, 1936 20/25"

69
FREDERICK WHITEMAN
(active ca. 1930s–1940s)
Elevated, 1936
Etching
Sheet: 8⅜ x 12¼ in.
Image: 5¹⁵⁄₁₆ x 7⅞ in.
Signed below plate, right:
"F. J. Whiteman '36";
inscribed below plate, left: "Elevated"

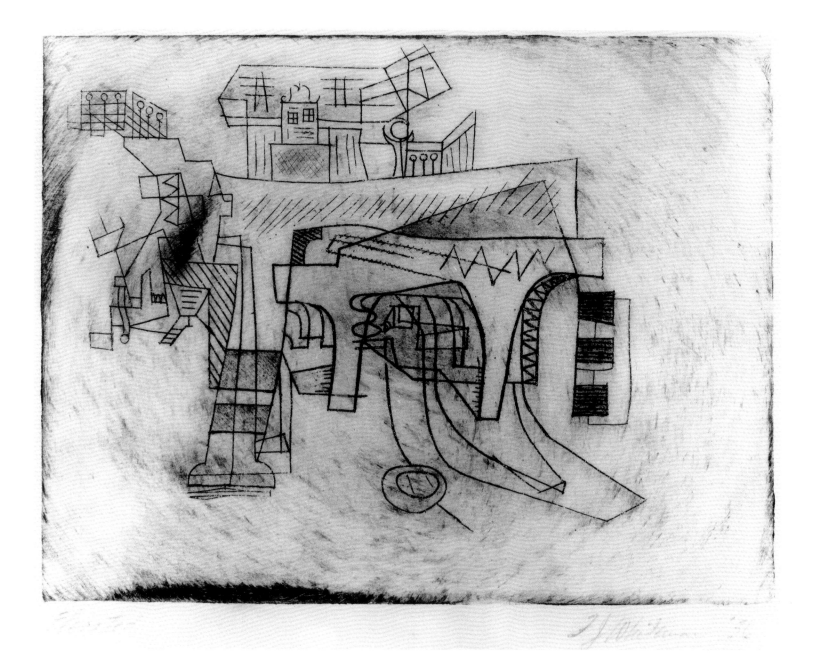

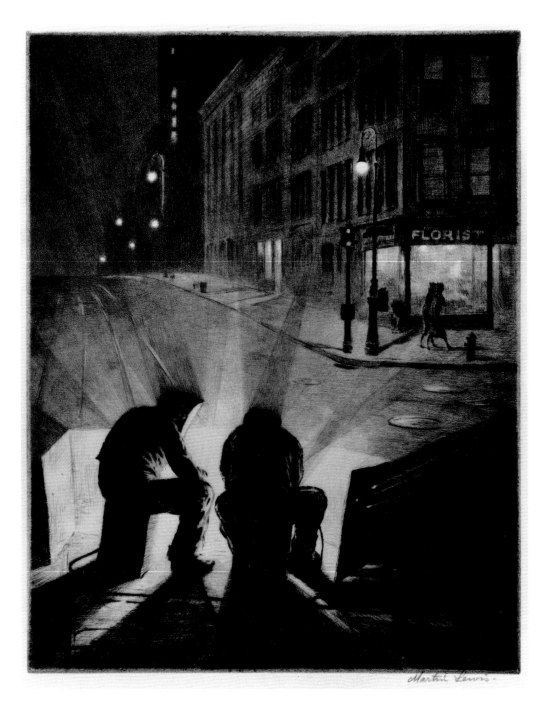

70
MARTIN LEWIS (1881–1962)
The Arc Welders, 1937
Drypoint
Sheet: 14³/₁₆ x 10¹³/₁₆ in.
Image: 10 x 7¹⁵/₁₆ in.
Signed below plate, right: "Martin Lewis"

71
PAUL WELLER (b. 1912)
Lumber Car, ca. 1938
Lithograph
Sheet: 13½ x 17½ in.
Image: 11 x 14⁷/₁₆ in.
Signed below image, right: "Paul Weller";
inscribed below image, left: "Lumber Car";
signed in stone, lower left: "P. WELLER"

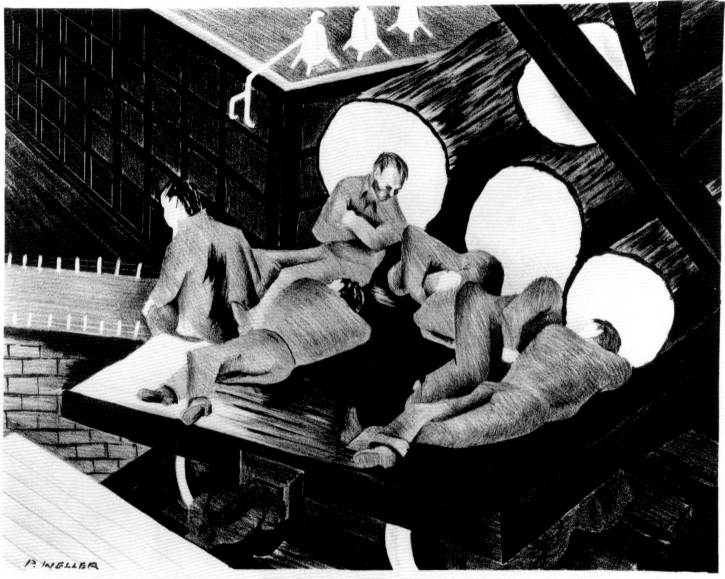

P. WELLER

72

O T I S D O Z I E R (b. 1904)

Grasshopper and Farmer, 1938

Lithograph

Sheet: 13 x 19⅝ in.

Image: 9¼ x 12⅞ in.

Signed below image, right: "Dozier '38"; inscribed below image, left:
"'Grasshopper and Farmer'"; inscribed below image, center: "Ed 10/14"

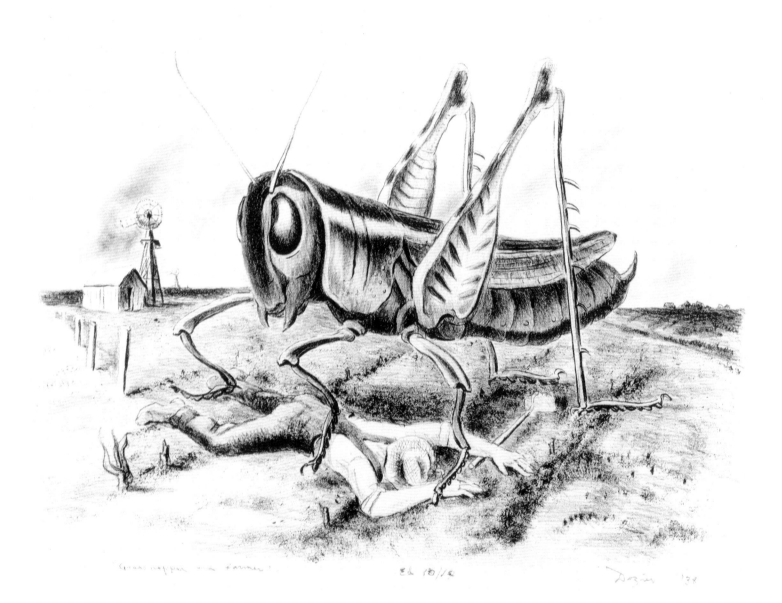

Grasshopper and Farmer Ed 10/10 Dozier '38

Weather Signals — 3–50 — Harari 38

73
HANANIAH HARARI (b. 1912)
Weather Signals, 1938
Etching
Sheet: 11⅜ x 7¹⁵⁄₁₆ in.
Image: 6⅞ x 5½ in.
Signed below plate, right: "Harari 38";
inscribed below plate, left: "Weather Signals";
inscribed below plate, center: "3–50"

74

HELEN LUNDEBERG (b. 1908)

Planets, 1938

Lithograph

Sheet: 16 x 12¼ in.

Image: 12 x 9 in.

Signed below image, right: "Lundeberg";
stamped on sheet, lower left: "FEDERAL
ART PROJECT"

75

HUGH (aka HERBERT) MESIBOV (b. 1916)

The Shed—Provincetown, 1938

Etching Sheet: 10¹¹⁄₁₆ x 15³⁄₁₆ in. Image: 8¹³⁄₁₆ x 13¾ in.

Signed below plate, right: "Herbert Mesibov '38"; inscribed below plate, left: "'The Shed'"

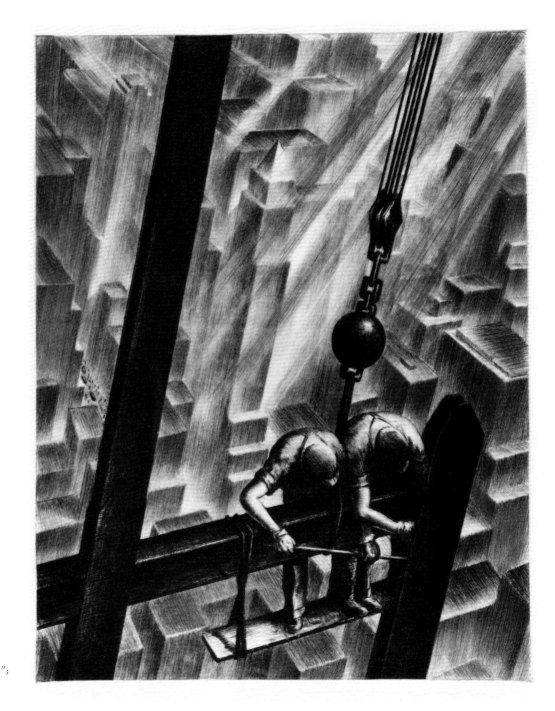

76

SAMUEL L. MARGOLIES
(1898–1974)

Men of Steel, ca. 1939

Drypoint

Sheet: 18⅞ x 14⅞ in.

Image: 14⅞ x 11¹³/₁₆ in.

Signed below plate, right: "SL Margolies/ S.A.E.";
inscribed below plate, left: "Men of Steel"

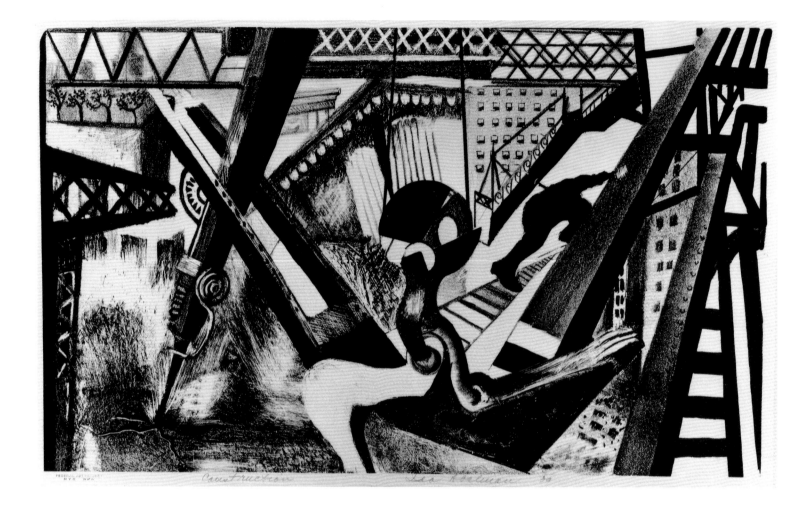

77

IDA ABELMAN (b. 1910)

Construction, 1939

Lithograph Sheet: 15⁹⁄₁₆ x 23 in. Image: 10¹⁄₁₆ x 16⁷⁄₈ in.

Signed below image, right of center: "Ida Abelman '39"; inscribed below image, left of center: "Construction";
stamped below image, left: "FEDERAL ART PROJECT NYC WPA"

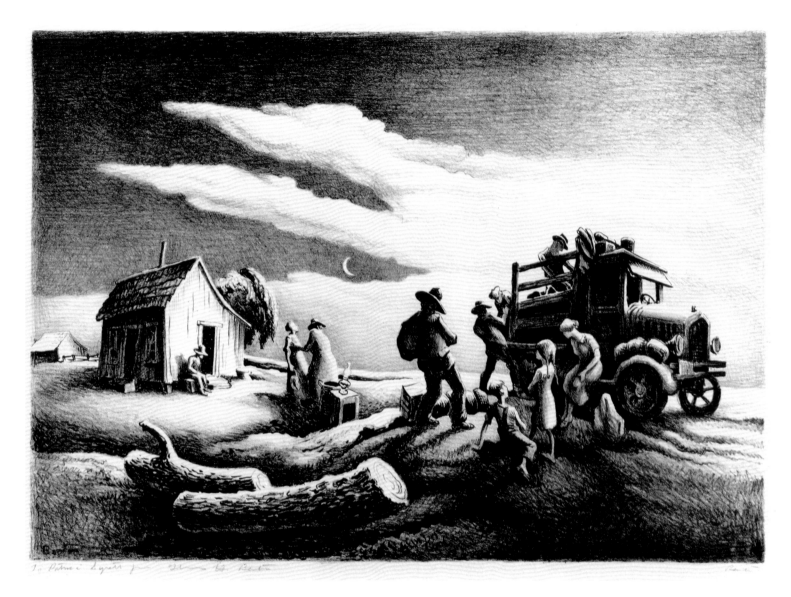

78

THOMAS HART BENTON (1889–1975)

Departure of the Joads, 1939

Lithograph Sheet: 14⁹/₁₆ x 20 in. Image: 13 x 18½ in.

Signed below image, right: "Benton"; inscribed below image, left: "To Patricia Syrett from Thomas H. Benton"; signed in stone, lower left: "Benton"

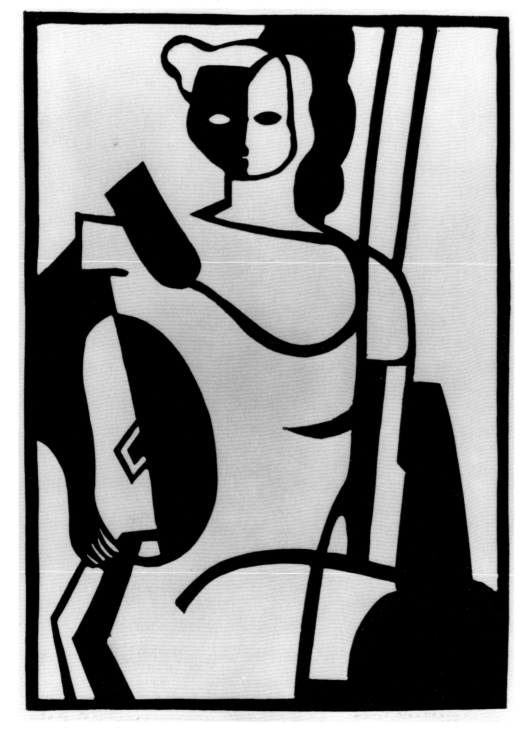

79

MORRIS BLACKBURN (1902–79)

Sally Jo, 1939

Linoleum cut

Sheet: 11¹⁄₁₆ x 8½ in.

Image: 9⁷⁄₈ x 7¹⁄₁₆ in.

Signed below image, right: "Morris Blackburn '39";
inscribed below image, left: "Sally Jo Jump 5/30"

80

JACOB KAINEN (b. 1900)

Convalescent, 1939–40

Lithograph Sheet: 11⅜ x 15¾ in. Image: 10¹/₁₆ x 13⅞ in.

Signed below image, right: "Jacob Kainen"; inscribed below image, left of center: "Convalescent";
stamped below image, left: "NEW YORK CITY WPA ART PROJECT"; inscribed on sheet, lower right: "B"

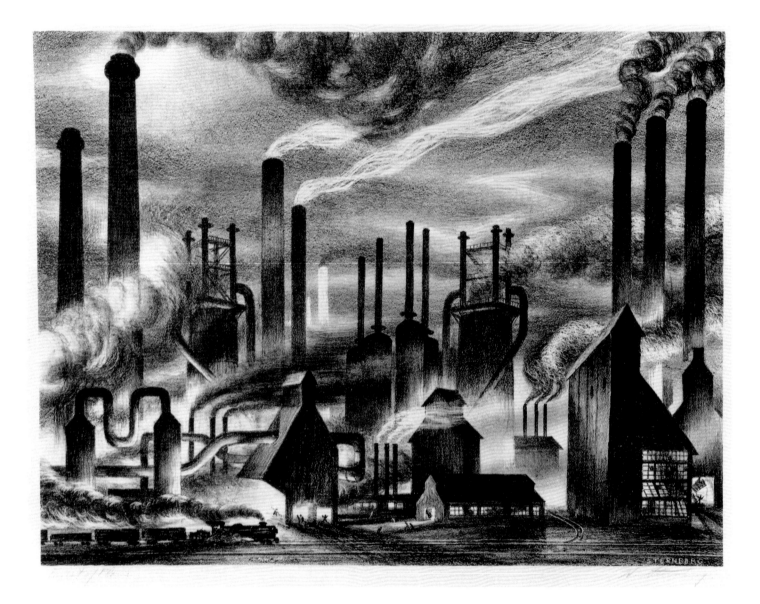

81

HARRY STERNBERG (b. 1904)

Forest of Flame, 1939

Lithograph Sheet: 15½ x 19⅞ in. Image: 12½ x 16⅝ in.

Signed below image, right: "H. Sternberg"; inscribed below image, left: "Forest of Flame"; signed
in stone, lower right: "STERNBERG"; inscribed on verso, lower left: "#158 FOREST OF FLAME $750"

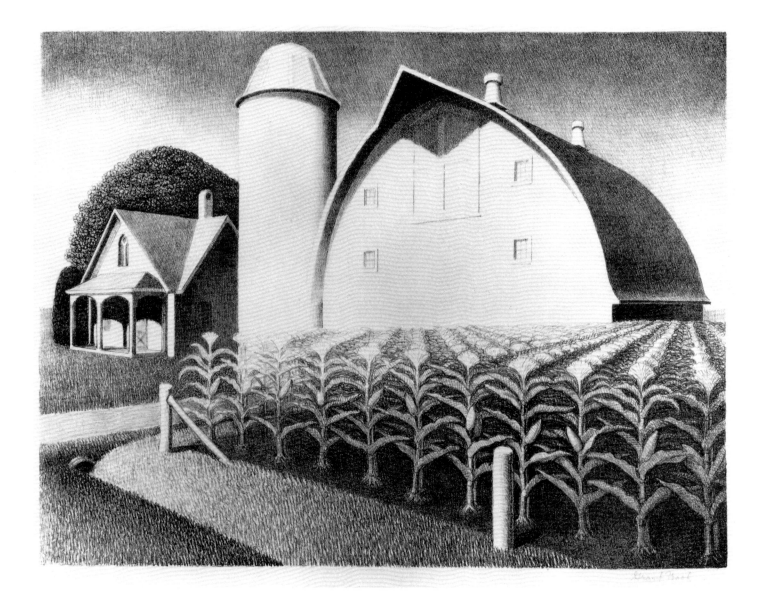

82

GRANT WOOD (1892–1942)
Fertility, 1939
Lithograph Sheet: 12½ x 18 in. Image: 9 x 11¹⁵/₁₆ in.
Signed below image, right: "Grant Wood"

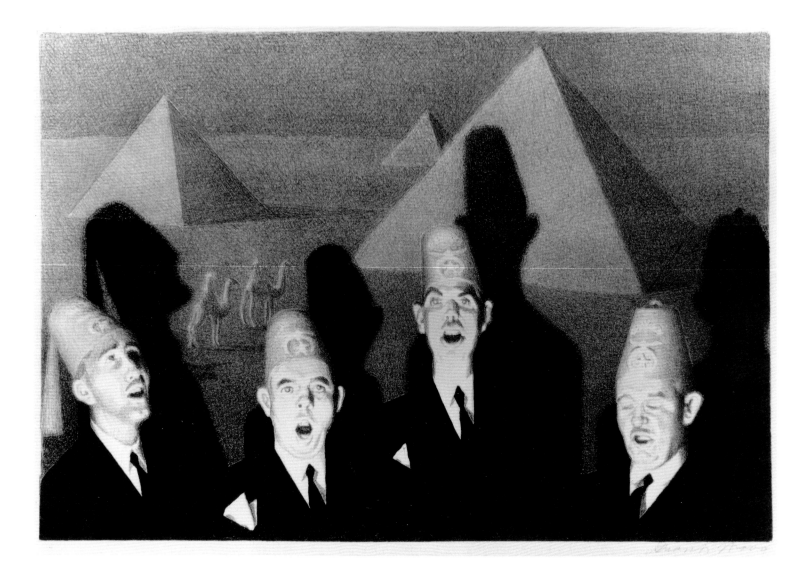

83
GRANT WOOD (1892–1942)
Shrine Quartet, 1939
Lithograph Sheet: 12 x 16 in. Image: 8 x 11⅞ in.
Signed below image, right: "Grant Wood"

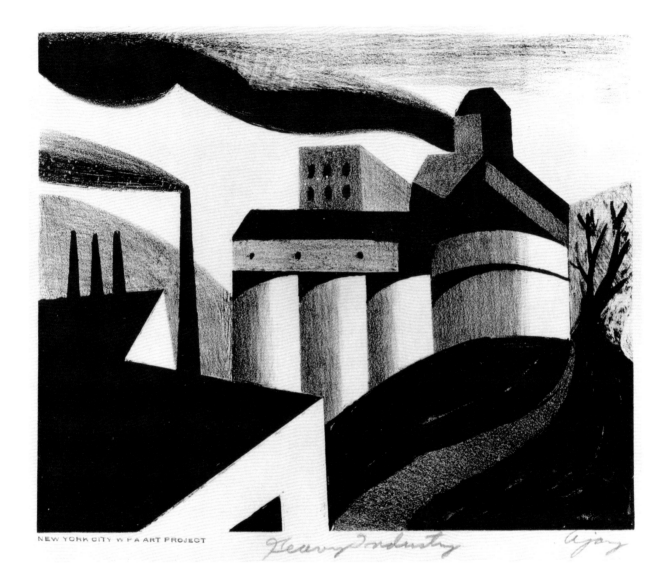

NEW YORK CITY W P A ART PROJECT *Heavy Industry* Ajay

84

A B E A J A Y (b. 1919)

Heavy Industry, ca. 1940

Lithograph Sheet: 11¼ x 15 in. Image: 7⅛ x 8⅞ in.

Signed below image, right: "Ajay"; inscribed below image, center: "Heavy Industry";
stamped below image, left: "NEW YORK CITY WPA ART PROJECT"

85
LOU BARLOW (b. 1908)
Jitterbugs, ca. 1940
Wood engraving
Sheet: 16¾ x 13¾ in.
Image: 13½ x 11⅜ in.
Signed below image, right: "Lou Barlow";
inscribed below image, left: "42/50";
inscribed below image, center:
"Jitterbugs"; signed in block, lower
right: "L. B."

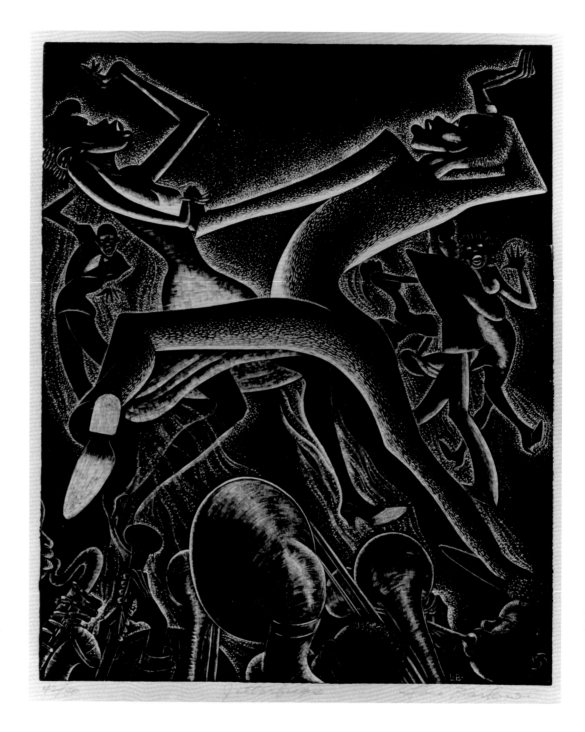

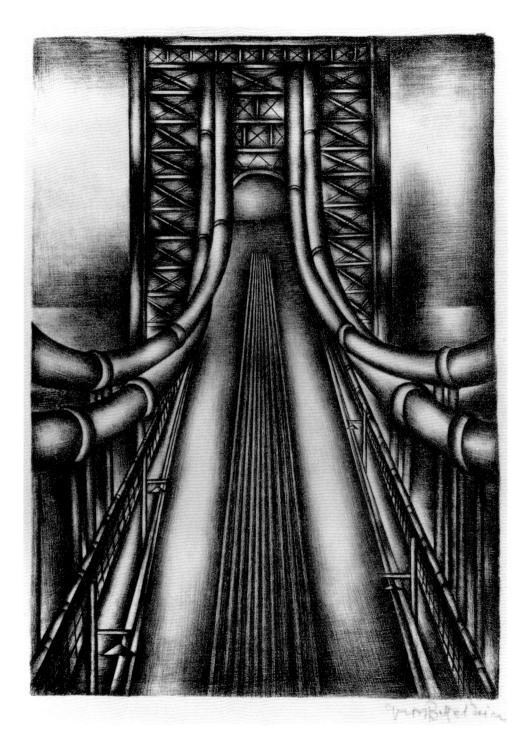

86

JOLAN GROSS BETTELHEIM
(1900–72)
Untitled (Bridge), ca. 1940
Lithograph
Sheet: 17⅛ x 11⅞ in.
Image: 14¼ x 10⁷⁄₁₆ in.
Signed below image, right: "Gross Bettelheim"

87
ERNEST BOYER (1884–1949)
Bridges, ca. 1940
Aquatint Sheet: 14 x 15 in. Image: 8 x 9⅜ in.
Signed below image, right: "E.W. Boyer Dup."; inscribed below image, left: "29/50 Bridges"

88
MARION GREENWOOD (1909–70)
Untitled, ca. 1940
Lithograph Sheet: 13⅛ x 18¼ in. Image: 10¼ x 14⅜ in.
Signed below plate, right: "Marion Greenwood"

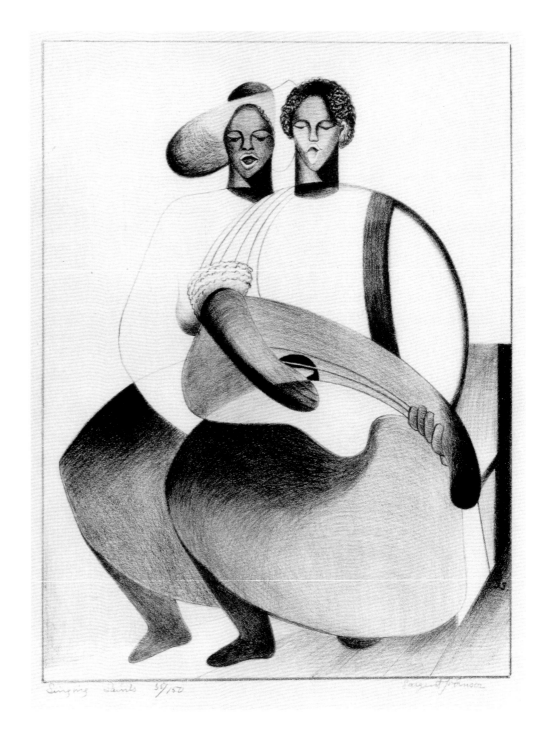

89

SARGENT JOHNSON

(1888–1967)

Singing Saints, 1940

Lithograph

Sheet: 16⅝ x 12 in.

Image: 12⅛ x 9¼ in.

Signed below plate, right: "Sargent Johnson";
inscribed below plate, left: "Singing Saints
35/150"; signed in plate, lower right: "SJ."

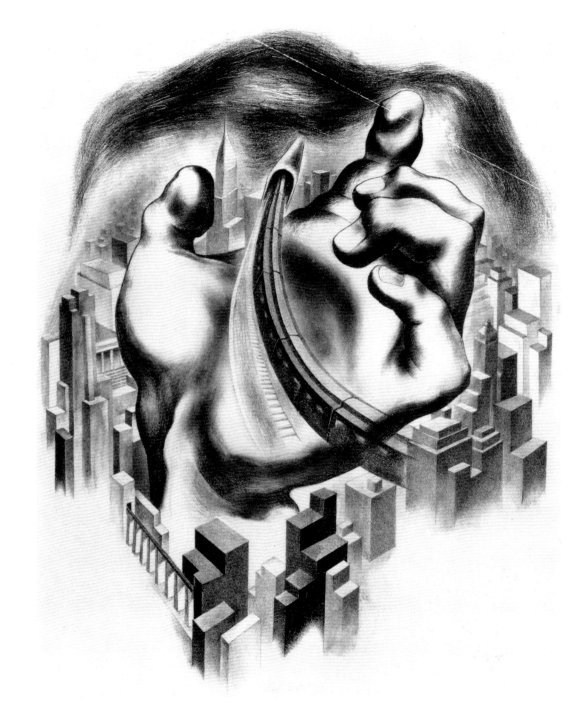

90
CLAIRE MAHL MOORE
(aka MILLMAN or
MAHLMAN) (1910–88)

Modern Times, 1940

Lithograph

Sheet: 19⅜ x 14⁷⁄₁₆ in.

Image: 17⅛ x 13½ in.

Signed below image, right: "CM '40";
inscribed below image, left: "Modern
Times"; inscribed below image, center:
"Ed. 25"

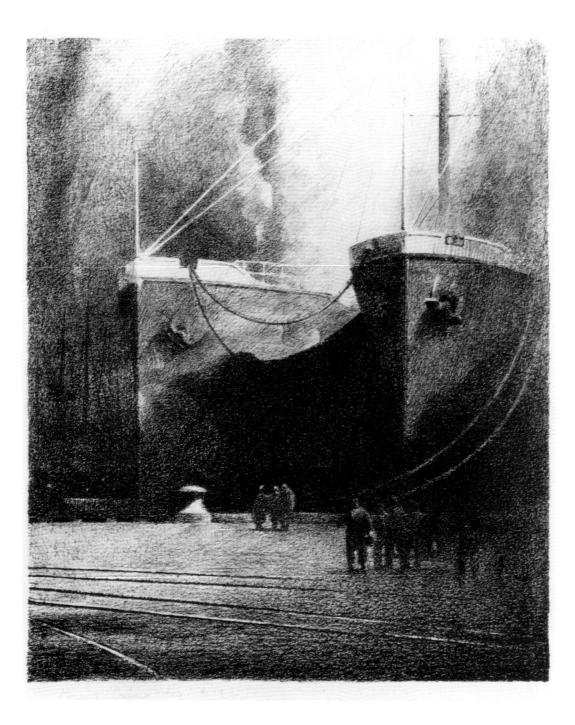

91

GRANT SIMON (b. 1887)

Ships, 1940

Lithograph

Sheet: 15¾ x 14 in.

Image: 11⁹⁄₁₆ x 9¹¹⁄₁₆ in.

Signed below image, left: "Grant Simon 1940 #18 Ed 30"; inscribed below image, right: "Ships"

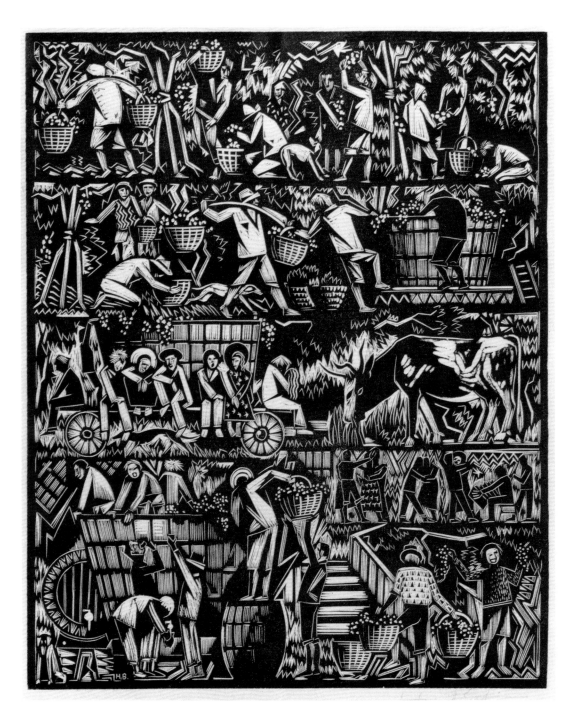

92

HARRY BERTOIA

(1915–78)

Grape Harvesters, 1941

Wood engraving

Sheet: 14³⁄₁₆ x 10⅛ in.

Image: 10³⁄₁₆ x 8⁵⁄₁₆ in.

Signed below image, right:
"Harry Bertoia"; inscribed
in block, lower left: "H. B."

93

HENRY BILLINGS (b. 1901)

Men and Machines, 1941

Lithograph Sheet: 17 x 19⅛ in. Image: 14⅛ x 15¾ in.

Signed below image, right: "Henry Billings—41—"

94

ALEXANDRE HOGUE (b. 1898)

Spindletop, 1941

Lithograph Sheet: 16⅛ x 19½ in. Image: 12 x 16¹/₁₆ in.

Signed below image, right: "Alexandre Hogue—1941"; inscribed below image, left: "Spindletop—1901 49/50"; signed in plate, lower right: "AH"

95
JOSEPH S. TROVATO
(1912–85)
Notice from the Draft Board, ca. 1942
Woodcut
Sheet: 19¼ x 16½ in.
Image: 11⅜ x 14 in.
Signed below image, right: "Joseph Trovato";
inscribed below image, left: "Notice
From The Draft Board"

96

JACQUES LIPCHITZ
(1891–1973)
Theseus, 1943
Etching, engraving,
and liquid-ground aquatint
Sheet: 18¾ x 14½ in.
Image: 13⅝ x 11½ in.
Inscribed below image, right:
"à Curt Valentin bien amicalement
J. Lipchitz"; inscribed below
image, left: "Epreuve L'Etat"

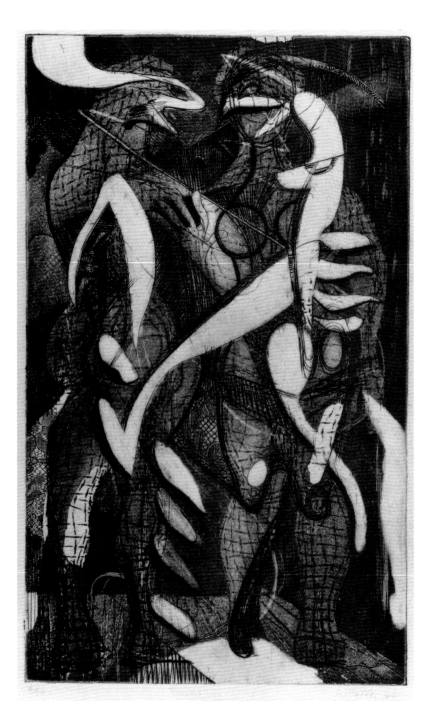

97

SUE FULLER (b. 1914)

Rumor, 1944

Softground etching and engraving

Sheet: 13⅛ x 9⅞ in.

Image: 9¾ x 6 in.

Signed below plate, right: "Sue Fuller 1944";
inscribed below plate, left: "2/20";
inscribed below plate, center: "Rumor"

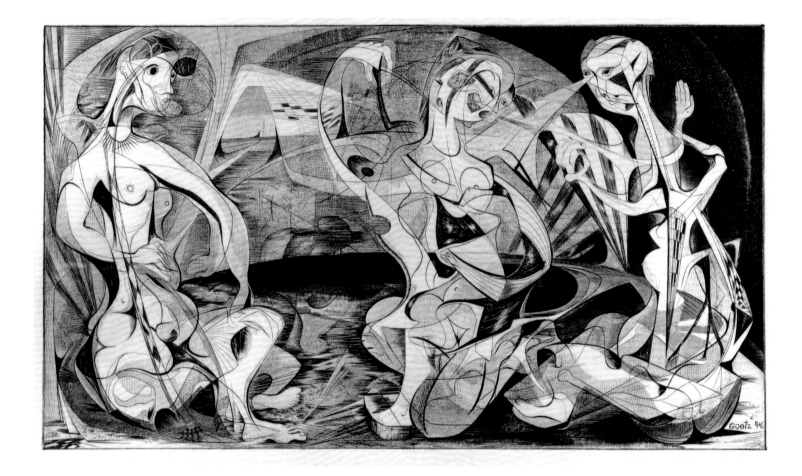

98

JAMES R. GOETZ (1915–46)

Untitled Abstract, 1946

Engraving

Sheet: 13⅛ x 17⅞ in.

Image: 8⅞ x 14⅞ in.

Signed below plate, right: "James Goetz";
signed in plate, lower right: "Goetz 46"

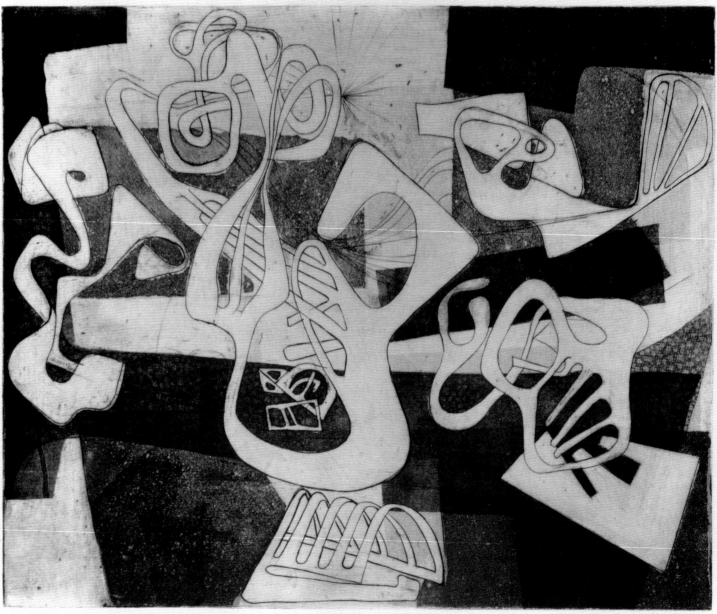

Alfred Russell 1951

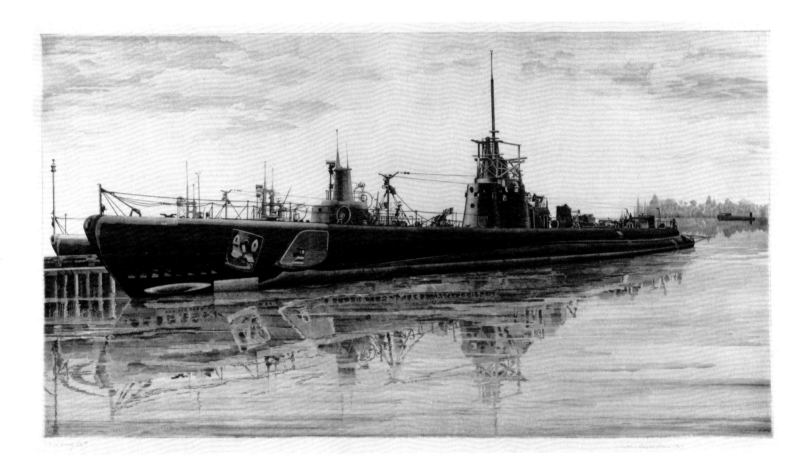

99
ALFRED RUSSELL (b. 1920)
Untitled 63, 1946
Engraving and aquatint
Sheet: 11¼ x 13¼ in.
Image: 8 x 9¾ in.
Signed below plate, right: "Alfred Russell 1946"

100
JOHN TAYLOR ARMS (1887–1953)
U.S. Navy Series, U.S.S. Haddo, 1947
Etching and aquatint
Sheet: 13⁷⁄₁₆ x 21½ in.
Image: 9⅝ x 18¼ in.
Signed below plate, right: "John Taylor Arms 1947";
inscribed below plate, left: "Trial proof IXIII"; chop
mark in image, lower center

101

ALICE TRUMBULL MASON (1895–1971)
Indicative Displacement, 1947
Softground etching Sheet: 13 1/16 x 19 1/2 in. Image: 10 1/8 x 15 13/16 in.
Signed below plate, right: "Alice Trumbull Mason"; inscribed below plate, left: "1/25 Indicative Displacement, 1947 SGE"

102

ROCKWELL KENT (1882–1974)

Fire!, 1948

Lithograph

Sheet: 16 x 12 in.

Image: 13¹¹⁄₁₆ x 9¹³⁄₁₆ in.

Signed below image, right: "Rockwell Kent";
inscribed below image, left: "'Fire!'";
inscribed on verso, lower left: "Rockwell
Kent: 'Fire' 1948—edition of 100 printed by
Geo. Miller—Burne Jones cat #143"

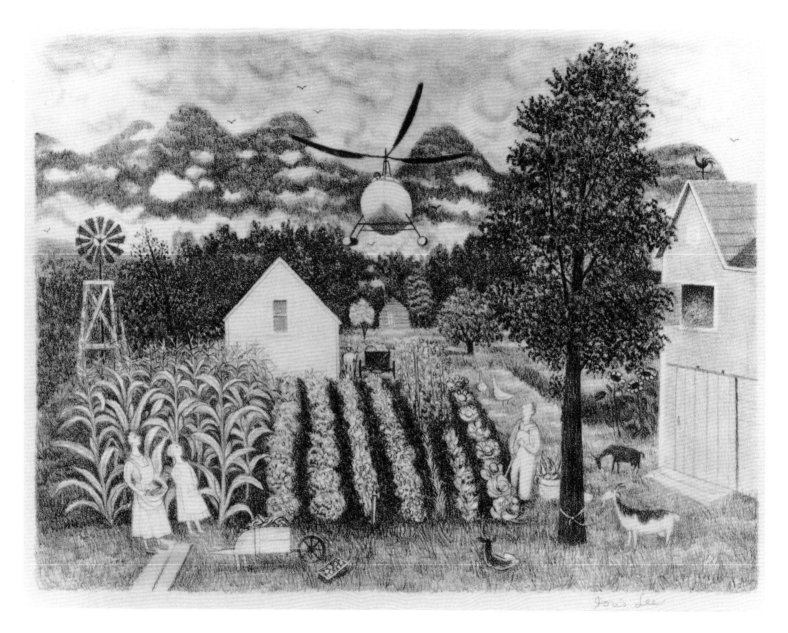

103

DORIS LEE (1905–83)

Helicopter, 1948

Lithograph Sheet: 12⁷⁄₁₆ x 14¾ in. Image: 9 x 12 in.

Signed below image, right: "Doris Lee"

104
LEON GOLUB (b. 1922)
Workers, 1949
Lithograph
Sheet: 12⁹/₁₆ x 11¼ in.
Image: 10¾ x 9¼ in.
Signed below image, right: "GOLUB";
inscribed below image, left: "WORKERS"

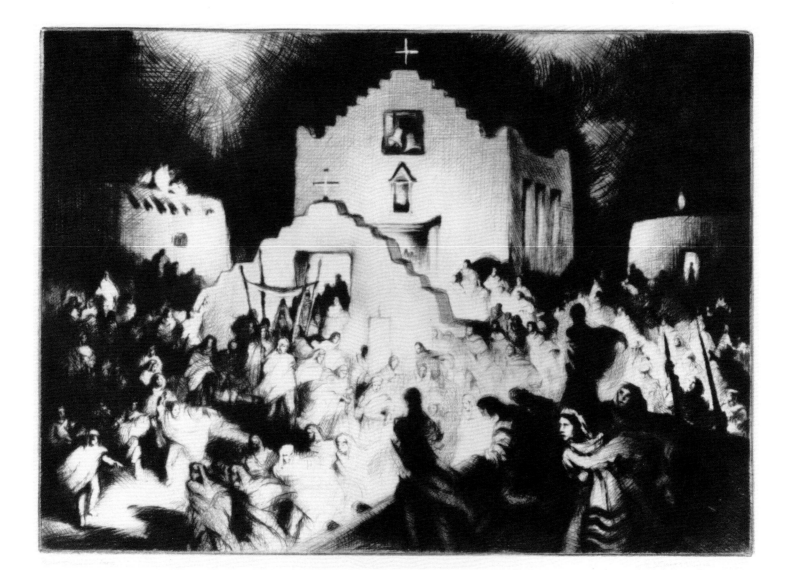

105

GENE KLOSS (ALICE GENEVA GLASIER) (b. 1904)
Processional, Taos, 1949
Drypoint Sheet: 12⅛ x 16⅝₁₆ in. Image: 9⅞ x 13¹⁵⁄₁₆ in.
Signed below plate, right: "Gene Kloss"; inscribed below plate, left: "Processional—Taos"

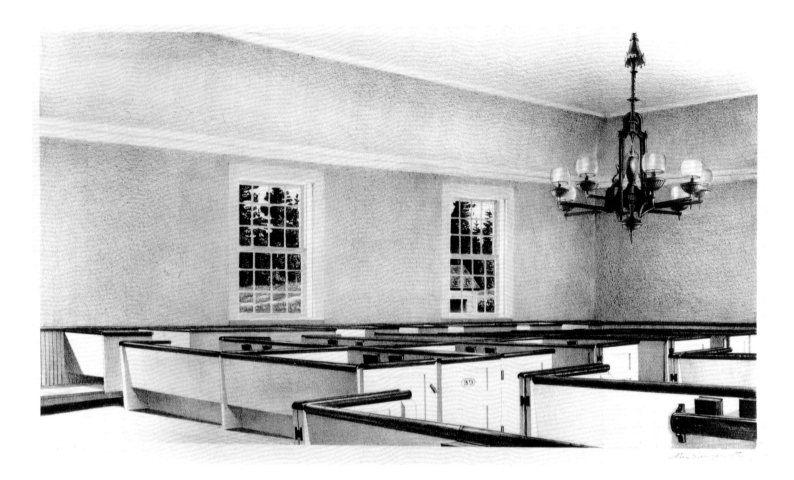

106

STOW WENGENROTH (1906–78)

Meeting House, 1949

Lithograph Sheet: 14⅞ x 20¾ in. Image: 9¼ x 16¾ in.

Signed below image, right: "Stow Wengenroth"; inscribed below image, left: "First state"; stamped in sheet: "[artist's monogram]"

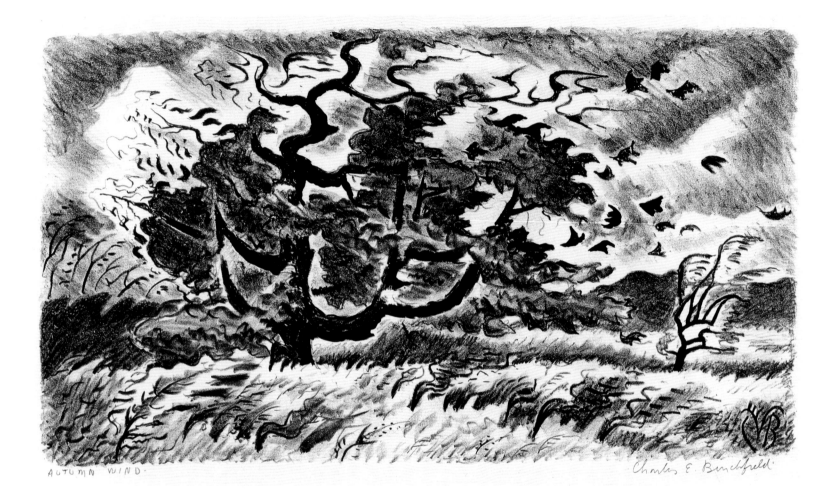

107
CHARLES BURCHFIELD (1893–1967)
Autumn Wind, 1951
Lithograph Sheet: 12 x 16 in. Image: 7⅝ x 13½ in.
Signed below image, right: "Charles E. Burchfield"; inscribed below image, left: "Autumn Wind"

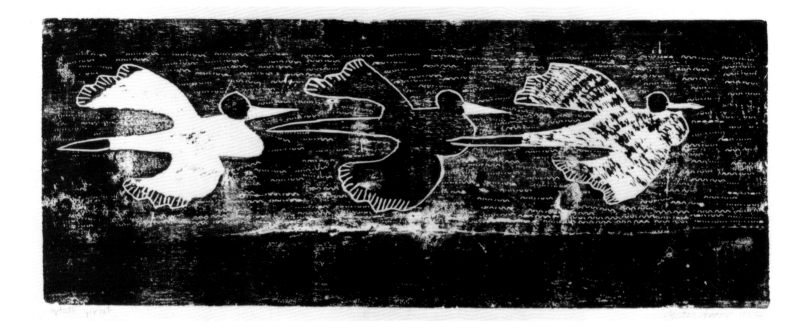

108

MILTON AVERY (1893–1965)

Three Birds, 1952

Woodcut Sheet: 12⅛ x 28⅞ in. Image: 9⅝ x 25 in.

Signed below image, right: "Milton Avery 1952"; inscribed below image, left: "artists proof"

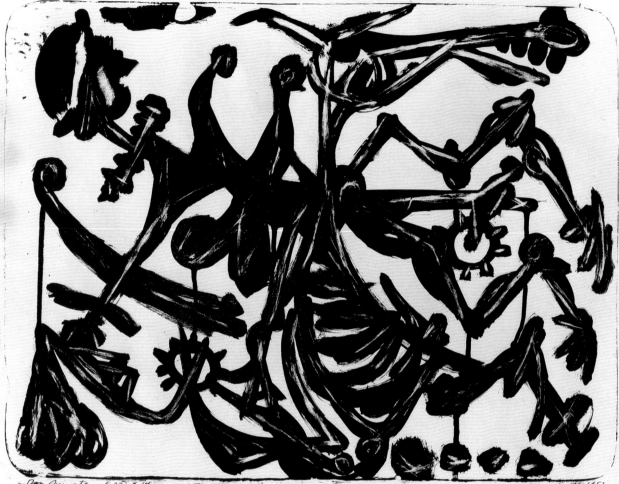

109

DAVID SMITH (1906–65)

Don Quixote, 1952

Lithograph Sheet: 22⅛ x 27½ in. Image: 18¼ x 24 in.

Signed below image, right: "David Smith 1952"; inscribed below image, left: "Don Quixote E 27 5/4"

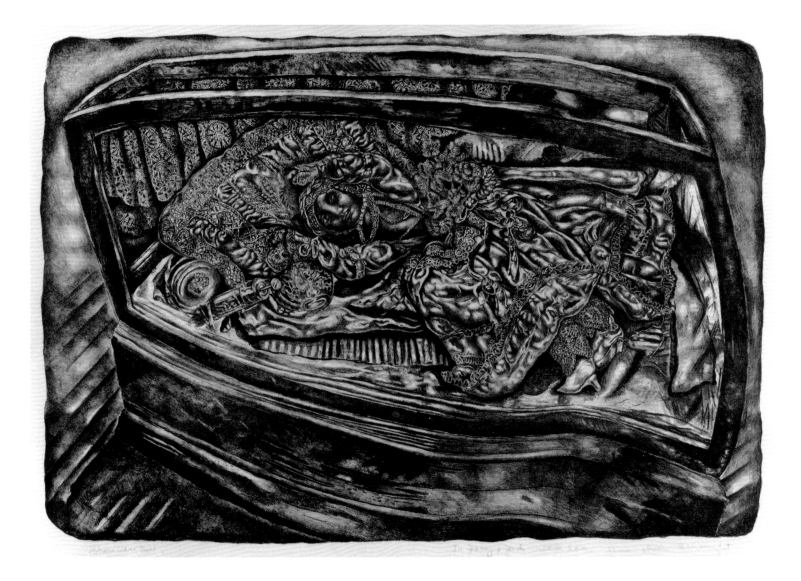

110

IVAN LE LORRAINE ALBRIGHT (1897–1980)

Show Case Doll, 1954

Lithograph Sheet: 20¼ x 27⅞ in. Image: 17⅛ x 25½ in.

Inscribed below image, right: "To Jenny & Judi with love from Ivan Albright"; inscribed below image, left: "Show Case Doll"

Biographies of the Artists

Margaret W. Doole

Ida Abelman (b. 1910) was born and educated in New York City, where she attended the National Academy School of Fine Arts, City College of New York, and Hunter College. She studied lithography with George Miller and was an active printer in the New York City Federal Art Project in the 1930s. Her work combines elements of constructivist style with social realism and expressionism. Some of her prints reflect a keen observation of human beings and make a biting statement about economic conditions during the depression. Others are strictly concerned with the more abstract design of large-scale construction projects.

Abe Ajay (b. 1919) reflects the influence of twentieth-century modernism from the beginning of his career in printmaking to his mature expressions in polyester resin. In 1937, at age eighteen, he won an Art Students League scholarship to study in New York. From 1938 to 1940 he also experimented in graphic arts for the Federal Art Project. Ajay was employed as a commercial artist from 1941 until 1963, when he built a home in Bethel, Pennsylvania, and began to devote himself entirely to his career in the fine arts. Ajay's early work in graphics reflects the influence of Matisse in its simplification of line and content. His later explorations of three-dimensionality began with the discovery that the compartments in cigar boxes could be used as modular forms for wall sculpture. These structures were later made by a polyester resin casting process with an overlay of colored Plexiglas. In his work Ajay has run the gamut of modern expression, including both the found object and machine-made sculpture in his repertoire.

Ivan Le Lorraine Albright (1897–1980), considered one of America's master printmakers, was a Chicago surrealist whose intricate images of man and nature seem to decompose before the viewer's eye. Originally inspired by his father, a student of Thomas Eakins, Albright studied in Philadelphia and Paris and learned lithography from Francis Chapin at the School of the Art Institute of Chicago. His clinical depiction of human anatomy and macabre preoccupation with surface detail may have been stimulated by his work as a medical draftsman in World War I. In the 1930s and 1940s his prints were circulated by the Associated American Artists.

James E. Allen (1894–1964) was a skilled craftsman whose detailed prints provide a panoramic view of the urban scene. The realistic depictions of men building huge bridges, skyscrapers, and tunnels are an ode to the great engineering feats of America. Allen was educated in Chicago and New York and learned etching from Joseph Pennell and William Auerbach-Levy. He studied sculpture to learn modeling for his figures and usually executed numerous drawings before he undertook an etching. Allen spent seven years experimenting with copper and acid before he exhibited his etchings. Unlike many of the "modernists" of the 1930s, he did not position his figures on a shallow stage. His space extends deep into the picture plane and provides a vast background for the gigantic building projects. After the late 1940s, Allen no longer produced prints but turned to a more abstract style under the tutelage of Hans Hofmann.

John Taylor Arms (1887–1953) trained as an architect at the Massachusetts Institute of Technology but was attracted to etching soon after receiving his Master of Science degree in 1914. After serving in the navy in World War I, he decided to devote his career to the graphic arts and in the 1920s began experimenting with aquatint. Through meticulous renderings of European and American structures, Arms became known as a leader in the American school of architectural etchers with a special interest in Gothic buildings. In 1940 Arms demonstrated making an etching on television—perhaps the first graphic arts event in the history of the newly popular medium. Arms's navy background and engineering drawing skills led to a commission by the United States Navy to produce a series of prints of World War II navy ships. President of the American Society of Graphic Arts for many years, Arms was the author and illustrator of numerous books.

Milton Avery (1893–1965) was born in Altmar, New York, and spent his youth in Hartford, Connecticut. He studied briefly with Charles Noel Flagg at the Connecticut League of Art Students, but was largely self-taught. After moving to New York City in 1925, he gained his first one-man show at the Opportunity Gallery that same year. Avery's graphics, which he began producing in 1933, are independent expressions of his artistic thinking, separate from his paintings but related in their emphasis on simplification. Avery worked in both drypoint and woodcut over a period of twenty years, executing about fifty prints. His drypoints are primarily portraits that capture the essence of the sitter with minimal detail. The woodcuts, which Avery printed himself, depict whimsical evocations of nature in abbreviated form.

Lou Barlow (b. 1908) [known as Louis Breslow until 1951] received his early art training at the National Academy School of Art in New York and later worked as a jewelry designer to finance a trip to Europe. In 1931 Barlow and Ilya Bolotowsky, a fellow artist, bicycled through

Europe visiting art museums and private galleries. Returning to the United States in 1932, Barlow became involved with the Public Works of Art Project and then worked under the Federal Art Project. While he was employed by these government agencies, Barlow became a skilled wood engraver. A large body of his work from this period is at Fort Sam Houston, San Antonio, Texas. During World War II he served as a medical illustrator, a profession he continued after the war. Barlow's highly stylized white-line engravings have a finely tuned sense of design and evoke the mood of the action with a rhythmic sensation.

Will Barnet (b. 1911) was born in Beverly, Massachusetts, and received his early art education at the School of the Museum of Fine Arts, Boston. His art studies were continued at the Art Students League of New York, where he worked with Charles Locke in the 1930s. Barnet taught at many universities and art schools throughout the United States from 1940 through 1969 but continued to explore his own interests in both painting and graphics. His career as a graphic artist began with a job on a Public Works of Art Project, which led to full-time work as a lithographic printer. Barnet's mastery of the graphic arts included skills in woodcuts, lithographs, and etchings. Until the 1960s Barnet printed all of his own works, and he still supervises their production. Some of his earlier graphics project a violent imagery of faceless figures that are pressed against the picture plane and engaged in explosive action; others depict poverty-stricken tenement districts. Barnet's most well-known image is a contemplative, passive woman, clothed in black, seen as a simplified shape against an architectural backdrop.

Fred Becker (b. 1913) entered the world of graphic arts during a time of experimentation in both technique and content. He was able to assimilate and expand the new vocabulary, employing American idioms in a fantasy-like surrealistic mode. Becker was born in Oakland, California, but moved to New York for most of his art training, which he received at the Beaux Arts Institute and at Atelier 17 under the surrealist Stanley William Hayter. Becker's wood engraving *Jam Session* (1936) reflects his own experience with the clarinet, and its pulsating, rhythmic forms provide an interesting contrast to the biomorphic surrealism of the 1940s. Becker's best-known wood engraving series *Life of John Henry* is a compelling combination of folk art and fanciful invention.

George Bellows (1882–1925) was born in Columbus, Ohio, and studied art at Ohio State University. In 1901 he moved to New York City to work with Robert Henri. Bellows taught at the Art Students League of New York (1910–11, 1917–19) and contributed to *The Masses*, a left-wing political magazine. Some of Bellows's best-known graphic works are dynamic and powerful sports prints, which reflect his earlier occupations as a professional basketball and baseball player. In 1916 Bellows purchased a press, hoping to pull his own prints, but decided soon after to enlist the help of George C. Miller, a printer who was beginning to establish himself among artists. In 1919 Bellows began what proved to be a fruitful collaboration with the printer Bolton Brown. Evoking the experiences of his youth in Ohio, Bellows produced his best graphic work when he focused on midwestern family life. Although he made some etchings, lithography proved to be his most dramatic medium. This is most clearly illustrated in his powerful lithographs

of Billy Sunday, the barnstorming evangelist, whom Bellows considered a demagogue and a charlatan.

Thomas Hart Benton (1889–1975) celebrated American regionalism in prints, paintings, and murals. Born in Neosho, Missouri, he was descended from a prominent political family. His early education began at the School of the Art Institute of Chicago and continued at the Académie Julian in Paris. Although Benton early espoused the twentieth-century trends of cubism and the synchromist movement, he later vigorously rejected abstract art and the influence of contemporary European painters. In 1926 Benton began teaching at the Art Students League in New York and took the first of many drawing trips to the Midwest, in which he absorbed the color and vigor of his native region. Benton's national prominence began with his mural painting of American scenes in the 1930s. Some of his graphic works recreate a variety of American myths; others illustrate the everyday lives of migrant threshers, sharecroppers, and oil roustabouts.

Harry Bertoia (1915–78) was born in San Lorenzo, Undine, Italy, and moved to the United States in 1930. Bertoia studied at the Society of Arts and Crafts in Detroit in 1936 and then at the Cranbrook Academy of Art from 1937 to 1942. During World War II Bertoia worked with molded plywood products at the Evans Products Company in Venice, California, and in 1947–49 was employed in graphics work at the Point Loma Naval Electronics Laboratory. These experiences, together with his studies at Cranbrook, influenced his work in wood engraving. In his later years Bertoia crafted wooden and metal sculpture that produced musical sounds when struck by hand or moved by the wind.

Jolan Gross Bettelheim (1900–72) was an immigrant who visualized the United States in terms of modernist abstraction. To her eye the majestic bridges, huge mechanized factories, and gigantic power plants seemed better suited to geometric shapes than to the realistic, detailed architectural interpretations of the previous generation. Bettelheim was born in Nyitra, Hungary, and received her education in several European institutions—the Academy of Fine Arts in Budapest, Kunstgewerbeschule in Vienna, and the Academie für bildende Kunst in Berlin. Arriving in the United States in 1925, she studied at the Cleveland Institute of Art School and participated in the Federal Art Project in Ohio. In 1938 Bettelheim moved to New York City. She worked in several media—lithography, drypoint, and pastels—but her most memorable imagery is in lithography. Her robotlike figures fill the page and project an Orwellian scenario. Bettelheim returned to Hungary in 1956.

Henry Billings (b. 1901) brought a keen sense of modeling to all his work, both animate and inanimate. He is known primarily for his paintings and murals of the 1930s, which have a robust architectonic quality and display a meticulous penchant for details that extends to the last fingernail and steel girder. Like other artists of the 1930s, he seemed to view his era as being determined by the machines. In his lithograph series *Men and Machines* the portrait of a worker is framed by the machine with which he works. Billings's precisionist style encompasses both man and machine, giving equal status to both. During the 1930s Billings was appointed by President Franklin Roosevelt as chairman of the New York City Exhibition Committee for a national art week to encourage the sale of American art. He was also active with the New York World's Fair of 1939, for which he painted three murals. His mobile mural in the Ford Building had both moving parts and changing lights—a marvel of the machine age. In 1956 Billings combined his graphic skills and interest in structure in a book on bridges, which he wrote and illustrated.

Morris Blackburn (1902–79) had a lifetime affiliation with Philadelphia, where he was born, and the Pennsylvania Academy of the Fine Arts, where he studied and later taught. Introduced to cubism and abstract concepts by his teacher, Arthur B. Carles, Jr., Blackburn used simple shapes in a cubistic format that is defined by black and white contrasts. His figures project a certain monumentality and stark angularity that is somewhat reminiscent of Picasso's still-life imagery of the 1930s. A mask motif is frequently found in Blackburn's prints and paintings.

Lucile Blanch (1895–1983) combined teaching and painting during a lifetime of work in the arts. Lucile Lundquist was born in Warren, Minnesota, and studied art at the Minneapolis Art Institute. Winning a scholarship to the Art Students League of New York in 1918 offered the young woman an opportunity to explore the vibrant postwar art world of the East Coast. After her marriage to the artist Arnold Blanch in 1920, she spent nine months in Europe developing her painting skills and personal expression. In 1923 she and her husband returned to the United States and settled in Woodstock, New York, which was fast becoming an artists' colony and a center for lithography; she produced a number of rather satirical lithographs during this period. Although Blanch later taught at several colleges in the southern United States, she always returned to Woodstock. During the 1930s Blanch separated from her husband. She became active in several federal art projects and, with George Picken and Philip Evergood, administered the easel division of the New York City Works Progress Administration. In addition she painted murals for four post offices in Florida, Virginia, Kentucky, and Mississippi. Blanch's work is primarily figurative; she frequently depicts animals, ranging from circus animals to domesticated cats to animals at a country fair. In 1974 Blanch donated thirty-four of her art works to the Edwin A. Ulrich Museum of Art located at Wichita State University in Wichita, Kansas.

Lucienne Bloch (b. 1909), the daughter of composer Ernest Bloch, was born in Geneva, Switzerland. Bloch studied in Europe at the Ecole des Beaux-Arts and also worked with Antoine Bourdelle and Andrew Wright. One of her most fruitful associations was with Diego Rivera, the muralist, with whom she studied fresco painting for two years. She and her husband-to-be, Stephen Diamitroff, were assistants to Rivera when he painted murals in Detroit and New York. Bloch's own mural commissions were the *Cycle on Woman's Life*, created for the House of Detention for Women in New York City, and the *Evolution of Music* for George Washington High School. In her woodcuts and lithographs, as in her murals, Bloch employs a mathematical system of symmetry in which formalistic elements are more important than naturalistic representation. Pattern repetition is a significant element of her artistic expression.

Ernest Boyer (1884–1949), born in Tamaqua, Pennsylvania, was one of Pittsburgh's finest architects and a skilled printmaker. Boyer graduated from Pittsburgh's Carnegie Institute of Technology in 1913 with a degree in architecture. A year later he married Louise Miller, who also became an important graphic artist. Together they explored the field of printmaking. In 1918 they purchased a huge etching machine that had been made in the late 1600s. The dearth of architectural commissions during the depression led Boyer (nicknamed "Arch") back to Carnegie Tech to study printmaking. He experimented with innovative techniques, including the use of the lithographic pencil stopout. Boyer's work reflects his architectural expertise and interest in structural designs. His daughter, Helen King Boyer, also became an active printmaker. The prints and drawings of the Boyer family are in the "Boyer Family of Printmakers Collection" in the National Museum of American History.

Ross Braught (b. 1898) traveled throughout the western United States and the British West Indies seeking artistic inspiration. Born in Carlisle, Pennsylvania, he first studied art at the Philadelphia Academy of the Fine Arts. He was

introduced to lithography during the 1920s when he lived in the artists' colony at Woodstock. In 1931 he traveled to Kansas City to teach at the Art Institute, where he stimulated interest in the graphic arts. Braught's imagery was influenced by his move west, and in 1936 he published his first book of lithographs. He developed an interest in large-scale earthmoving equipment, which he later enlarged and simplified until the machine occupied the entire frame of the print and became a nearly abstract shape.

Charles Burchfield (1893–1967) portrayed nature in mystical terms and created an almost independent imaginary world. His watercolors, oil paintings, and prints have a quivering, electrifying quality that suggests a pantheistic force energizing the landscape or townscape. Burchfield was born in Ashtabula Harbor, Ohio, and studied art at the Cleveland School of Art with Henry G. Keller. In 1916 he received a scholarship to the National Academy of Design in New York City. Five years later he settled near Buffalo, New York, which was to remain his permanent home. Here Burchfield worked as a designer in a wallpaper factory and painted his own visions in his spare time. Not until he was forty-two did Burchfield have the luxury of devoting himself full-time to his painting and printmaking. Although he lived during a period of experimentation and innovation in art, Burchfield practically never participated in the contemporary trends in American art.

Jacob Burck (1907–82) was a successful cartoonist who was also an active printmaker in the 1930s. Burck frequently used his art in the service of social and political reform. Born in Poland, Burck immigrated to the United States in 1914. As a struggling artist in the 1930s, he joined the Communist Party for two weeks in the hope that the *Daily Worker*, a Communist magazine published in New York, would commission him to draw cartoons. Because of this short stint in the Communist Party, Burck faced deportation in the 1950s. By this time, however, he was a Pulitzer Prize–winning cartoonist who had worked for the *Chicago Sun-Times* for twenty years.

Paul Cadmus (b. 1904) has focused on the human figure throughout his long artistic career. Something of a child prodigy in art, Cadmus is the son of two artists: Egbert Cadmus, a watercolorist who was a student of Robert Henri, and Maria Latasa Cadmus, an illustrator of children's books. Paul Cadmus entered the National Academy of Design at age fifteen as a preparatory student but was soon elevated to full status. Life drawing and printmaking quickly became his focus. After completing coursework at the Academy, Cadmus transferred to the Art Students League in New York, where he studied with Joseph Pennell. His first exhibition of prints was at the Blue Mask Gallery in New Hope, Pennsylvania, in 1927. After spending several years in Europe, Cadmus returned to the United States and in 1934 was among the first participants in the Public Works of Art Project. It was during this time that he produced the etching *The Fleet's In*, based on a painting of his that was rejected by the government agency. This painting had caused a scandal and focused national attention on Cadmus. In 1937 his one-man show at Midtown Galleries in New York City broke attendance records and prompted articles about him in *Life* and *Esquire*. Cadmus has sometimes been labeled a satirist of the American scene and at other times a magic realist, but his distinctive style has another dimension. His meticulously modeled figures have a sexuality and an inner tension that vibrate within the picture. While the men leer at them, the women flaunt their femininity in scenes set in urban America. Cadmus's people are reminiscent of Albrecht Dürer's sixteenth-century figures, but are clothed in twentieth-century brashness.

Howard Cook (1901–80) achieved national recognition as a muralist and lithographer. He was born in Springfield, Massachusetts, and received his early art education at the Art Students League of New York. During the 1930s Cook painted numerous murals throughout the United States for the Works Progress Administration. He was also active as a graphic artist. Cook developed highly expressive and technically expert prints in etching, woodcut, aqua-

tint, and lithograph. Some of his most memorable prints are architectonic scenes of New York City from the Empire State Building, where he had a rent-free studio in the early 1940s. Later that decade he moved to New Mexico, where he taught at the University of New Mexico until 1960. The influence of New Mexico resulted in stylized Mexican imagery in his graphics.

John Steuart Curry (1897–1946), a painter of the American scene, was born on a farm in northeastern Kansas. His early art education began at the School of the Art Institute of Chicago and continued during a trip to Paris in 1926. Returning to the United States, he became an illustrator for popular magazines. The regionalist movement of the 1920s and 1930s stirred Curry's memories of his Kansas youth and led him to paint *Baptism in Kansas*, with which he gained recognition in New York City. This prompted mural commissions in Kansas and in Wisconsin, where he was an artist-in-residence. His lithographic work addresses the social issues of his times, particularly the need for anti-lynching legislation, and also continues his exploration of American regional themes. Many of Curry's prints recreate scenes from his oil paintings or murals, and some illustrate his boyhood experiences with natural disasters. His print of John Brown, the abolitionist, inspired by the statehouse mural in Topeka, Kansas, is one of his most powerful graphic images.

Charles W. Dahlgreen (1864–1955) was born in Chicago but received his first formal art training in Düsseldorf, Germany, in 1886–88. Upon returning to Chicago with his young German wife, Dahlgreen supported himself by both painting and embroidering flags and banners. At age forty Dahlgreen was financially secure enough to return to his true vocation—art. He studied painting and etching at the Chicago Academy of Fine Arts and in 1909 returned to Europe to study the Old Masters in the museums of England, Belgium, Holland, France, and Italy. He exhibited in the Paris Salon of 1910 and subsequently became successful as a landscape painter and printer. His print *A Note in Pattern* was chosen as one of fifty etchings

to circulate on a tour of the United States in 1934.

Arthur B. Davies (1862–1928) encouraged modern art in America by promoting the Armory Show of 1913, but his own work concentrates on depictions of idealized, delicate nudes. Davies was born in Utica, New York, and studied at the Chicago Academy of Design and the School of the Art Institute of Chicago. His stint at the Art Students League in 1887 introduced him to the New York artistic community and led to a trip to Italy in 1893 under the sponsorship of Benjamin Altman. The classical Italian influence, together with an art nouveau style, are reflected in the lyricism of Davies's graphic work. Allegorical imagery predominates in his visions of a remote, ageless land. His great admiration for Odilon Redon reverberates through his work, particularly in the dreamy setting and delicate female figures. Davies experimented with many types of graphics, including lithography, etching, drypoint, mezzotint, aquatint, and woodcut.

Stuart Davis (1894–1964) was an abstract artist who used letters, numbers, and symbols in his prints and paintings to convey images of jazz-age America. Davis was the son of the art director for the *Philadelphia Press* and was tutored by Robert Henri, who had worked for the *Press*. As a teenager he exhibited in the Armory Show of 1913; that exhibition awakened him to the new trends in European artistic thinking. Davis acknowledged the cubist painter Fernand Léger as his most important influence among the European modernists. In his hard-edged, primary-color compositions, he, like Léger, used twentieth-century industrial and commercial imagery to capture the dynamics of contemporary life. Davis was active in the Federal Art Project in the 1930s, working in both the graphic arts and mural painting.

Adolf Dehn (1895–1968) was an innovator in the graphic arts who brought many new European techniques and concepts to the American printmaking community. Dehn produced his first prints in the United States but traveled to Europe in the early 1920s to study lithography with the French printer Edmond Desjobert. This association expanded Dehn's graphic vocabulary and enabled him to achieve greater nuances of tone in his prints. Upon returning to the United States in the 1930s, Dehn organized several groups of printmakers and actively encouraged the graphic arts among such artists as Thomas Hart Benton, Reginald Marsh, and George Grosz.

Burgoyne Diller (1906–65) was born in New York City and attended the Art Students League. He studied with Hans Hofmann and George Grosz and was influenced by the work of Piet Mondrian, who had arrived in New York in 1940. In addition to geometrically abstract oil paintings, he created wood constructions on masonite in a bas-relief sculptural mode. The few prints Diller executed are reminiscent of the still-life arrangements Cézanne painted at the turn of the century.

Otis Dozier (b. 1904) creates western images that frequently view nature and animals as powerful beyond man's control. Dozier was born in Forney, Texas, and grew up on a cotton farm. In 1921 he moved to Dallas, where he studied art and taught at the Dallas School of Creative Arts. From 1939 to 1945 he taught with Boardman Robinson at the Colorado Springs Fine Arts Center. Moving back to Texas, Dozier was active in the Lone Star Printmakers Group. His realistic prints display a subtle humor that sometimes masks the underlying concern for the hardships and difficulties that men meet in their confrontation with raw nature in the West. Though Dozier now lives in the city, his prints still display an empathy with the problems of rural life.

Werner Drewes (1899–1985) was born in Germany and studied there extensively before he immigrated to the United States. He attended technical architectural schools in Germany from 1919 to 1921 and then transferred to the Bauhaus, where he studied under Paul Klee and Wassily Kandinsky. After moving to the United States in 1930, Drewes was attracted to the Art Students League of New York, where he learned lithography from Eugene Fitsch. His association with European modernists helped him rather quickly to become a leader in establishing abstract art in America, and in 1937 he was a founding member of the American Abstract Artists in New York. From the beginning of his teaching career, Drewes was drawn to the graphic arts, as well as to painting and drawing. He taught printmaking at the Brooklyn Museum School, Columbia University, and at the Master Institute of the Riverside Museum, New York City. From 1940 to 1941 Drewes acted as technical supervisor in the Graphic Arts Division of the Federal Art Project in New York City. Like many modernists of the 1940s, Drewes was drawn to the New York studio of Stanley William Hayter. Here he improved his intaglio techniques and produced surrealist prints that clearly show Hayter's influence. Woodcuts were his preferred medium. Drewes's distinguished artistic career culminated in his appointment in 1946 as a professor of design at the School of Fine Arts at Washington University in Saint Louis, where he stayed until his retirement in 1965.

Harold Faye (1910–80) was the son of a wealthy New York railroad executive. His father's position permitted him to take extensive railroad trips, which prompted the love for trains, ships, and bridges that became important themes in his work. From 1929 to 1937 Faye studied at the Art Students League in New York, where he learned etching from George Picken. During this time he also participated in the Federal Art Project of the Works Progress Administration. Despite his wealthy beginnings, Faye developed a concern for the vagrant people living in New York City during the depression. Estranged from his father and desperately poor himself, Faye could identify with the downtrodden. He portrayed these people in a realistic style related to the Ashcan School of a decade earlier. Other prints by Faye employ a more streamlined, precisionist style in which the imagery focuses on industrial America—its bridges, railroad yards, generating plants, and gas stations. Faye spent the major part of his career as a successful cartographer.

John Ferren (1905–69) was a geometric abstractionist who was highly respected by the Parisian art world in the 1930s and often exhibited in group shows with Miró, Giacometti, and Kandinsky. He was born in Pendleton, Oregon, and grew up in Los Angeles and San Francisco. During his teenage years Ferren developed skills in sculpting and carved portrait heads and tombstones. In 1929, when he moved to Paris to study at the Sorbonne, he met many members of the avant-garde. During this period he began to incorporate abstract modernist styles into his own sculptural forms. These forms were later transferred into the lithographic medium.

Ernest Fiene (1894–1965) was born in Elberfeld, Germany, and immigrated to the United States in 1912. He attended the National Academy of Design School in New York and in 1923 enrolled at the Art Students League. One year later his exhibition at the New Gallery in New York sold all of the fifty-two works in the show. His early popularity may be attributed to the clear sense of design that shapes his architectural vistas. Fiene recorded New York City in an abstract manner that has a precisionist quality; his unusual angles of perspective are strikingly original. Fiene taught at the Art Students League for more than twenty-five years and bequeathed a sense of the importance of craftsmanship in printing and painting.

William LeRoy Flint (b. 1909) is an Ohio artist whose work reflects his midwestern heritage. Born in Ashtabula, Ohio, Flint received most of his education at Ohio institutions. He studied at the Cleveland Art Institute, Cleveland College, Western Reserve University, and the University of Minnesota. Like many other artists of his era, he worked in the Public Works of Art Project and the Federal Art Project in the 1930s. In addition to executing numerous murals for Ohio institutions, he produced graphics and easel paintings. Beginning in 1950 he served as instructor and gallery director at several Ohio art and educational institutions, including the Cleveland Museum of Art, Akron Art Institute, and Kent State University Gallery.

Isaac Friedlander (1890–1968) was born in Latvia and studied art in Rome. His entire career was devoted to the graphic arts. Friedlander's prints reflect his fascination with his adopted country, America, whose industrial complex and urban environment appear larger than life in his vision. In some of his etchings the tanks and pipes of the oil refining industry take on the monumentality of the castles and cathedrals of the Old World. Friedlander's woodcuts, however, have a simple expressionistic quality reminiscent of the German prints of the early twentieth century.

Sue Fuller (b. 1914) emphasizes textures in her prints and string compositions. An interest in new techniques and different media has always directed her artistic expression. Born in Pittsburgh, Fuller received her bachelor's degree from the Carnegie Institute of Technology in 1936 and her master's from Columbia Teachers' College in 1939. While at Columbia, Fuller learned graphic-art techniques from Arthur Young. She has also studied with Hans Hofmann, Josef Albers, and Stanley William Hayter. Working with Hayter she rediscovered a method for obtaining direct-blacks aquatints that had been practiced by Thomas Gainsborough and Georges Rouault. Attempting a better use of textures in printing, Fuller next completed a series of plates using laces; she perfected a technique for retaining inner tension within materials while applying them to the plate. In addition, Fuller initiated a revival of color etchings. In her later work, Fuller has devised string compositions and worked in plastics.

Gerald Geerlings (b. 1897) trained as an architect at the University of Pennsylvania and used this knowledge in his prints. Between 1924 and 1929 Geerlings studied architecture at the American Academy in Rome and the Royal College of Art in London. It was in London that he learned etching from Malcolm Osborne and Robert S. Austin. After his return to the United States, Geerlings produced a series of etchings and lithographs on American women's colleges. This popular series also included notations about the architecture he illustrated. In 1934 Geerlings participated in a contest sponsored by the Chicago World's Fair. His drypoint *Grand Canal America*, which won first prize, employs fascinating light effects on water, buildings, and sky. In his aquatints Geerlings developed a feathery quality with subtle gradations of blacks and grays.

Henry Glintenkamp (1887–1946) was born in Augusta, New Jersey, and spent his early career in the New York City area. He studied with Robert Henri and was included in the 1910 Exhibition of Independent Artists and in the Armory Show of 1913. During the next four years Glintenkamp was associated with *The Masses* (a left-wing political magazine). In 1917 he moved to Mexico and remained there for ten years. During the next two decades Glintenkamp's work became increasingly political and radical. His graphic work frequently contains groups of figures whose features are generalized but who illustrate intense political aspirations. Glintenkamp's interest in social issues and love of travel are reflected in a book of prints he compiled entitled *A Wanderer in Woodcuts* (1932). Other prints depict intimate scenes of Manhattan backyards and the New York skyline without any ideological overtones.

James R. Goetz (1915–46) was born in Indianapolis and studied at Westminster College and Colgate University. After college, Goetz worked in Atelier 17, the workshop of Stanley William Hayter. His graphic work shows Hayter's surrealist influence, particularly in the practice of allowing the subconscious to guide the burin across the plate. Afterwards, the artist reinforced the lines and added details and tonal shading. In this last step Goetz departed from the work of his mentor and added many humanistic details and creative elements, including beams shining forth from the eyes of his figures. These new directions were endorsed by Hayter, who saw a great potential in Goetz's work.

Leon Golub (b. 1922) is a figurative artist whose primary themes are stress and violence.

His gigantic figures with classical sources are set against contemporary references to war and aggression. Golub was born in Chicago and acquired his art education at the University of Chicago and at the School of the Art Institute of Chicago, where he received his Master of Fine Arts degree in 1950. Golub's World War II experience with the 942nd Engineers, Aviation Torpedo Battalion, has influenced his graphic work. He has taught at several universities, among them Temple University in Philadelphia, and Livingston College, Rutgers University, in New Brunswick, New Jersey.

Arshile Gorky (1904–48) bridged the gulf between the Old World and America, between surrealism of the 1930s and abstract expressionism of the 1950s. His early life in Turkish Armenia was filled with dramatic events. He was mentally scarred by the atrocities of the Turks and the tragic death of his mother. When he entered the United States in 1920, Gorky's name was Vosdanig Manoog Adoian. Around 1930 he adopted the surname of the famous Russian author Maxim Gorky, whom he jokingly declared was his cousin. The Russian translation of "Gorky" means "bitter"—a prophetic forecast of Gorky's own future. Gorky began his artistic career at the New School of Design in Boston in 1925 and then moved to New York, where he studied and taught at the Grand Central School of Art. Gorky was influenced by many of the early modernist trends, but Cézanne, Picasso, and Miró were the dominant forces in his early work. The arrival of the surrealists, fleeing from Hitler's Nazi Germany, was the last formative influence in Gorky's painting and printmaking. Acting as a catalyst for the American experimentalists of the 1940s, Gorky combined surrealism with a powerful, expressive brushwork to create paintings that anticipated abstract expressionism.

Blanche Grambs (b. 1916) was born in China and came to New York City in the 1930s on an Art Students League scholarship. Later she worked on the New York City Federal Art Project, where she enlivened the scene of the WPA artists. Her highly expressive graphics employ a gradation of gloomy blacks together with stark white to convey a somber world of poverty-stricken workers, their homes, and their workplaces. Her compositions have a monumentality and weightiness that reflect the defeat, pain, and depression of laborers, particularly miners in the 1930s.

Marion Greenwood (1909–70) traveled to Mexico in 1931 and met the American expatriate artist Paul (Pablo) O'Higgins, who encouraged her to try fresco painting. Greenwood won a commission from the Mexican government and became the first American woman to paint a mural in Mexico—at the University of San Nicholas Hidalgo. Greenwood studied at the Art Students League and in Paris; she also worked with Diego Rivera and José Clemente Orozco. With her sister Grace, and under the direction of Pablo O'Higgins, she painted her finest mural at the Ablejarbo Rodriguez market in Mexico City. She also painted murals in the United States and exhibited at the 1939 New York World's Fair.

Hananiah Harari (b. 1912) was born in Rochester, New York, and studied art at the College of Fine Arts at Syracuse University. During the 1930s Harari traveled to Europe to work in the studios of Fernand Léger, Andre Lhote, and Marcel Gromaire. Harari's work reflects a variety of styles, from realistic portraiture to surrealistic still life. He has transmitted this diversity of stylistic modes to his students at the School of Visual Arts in New York City.

George "Pop" Hart (1868–1933) expressed in his art a certain *joie de vivre* that reflected his attitude toward life. Hart was born in Cairo, Illinois, but left home at an early age to explore the world from South and Central America to the Near East and the South Seas. Returning to the United States, he supported himself by painting signs for amusement parks and stage sets for a movie studio in Fort Lee, New Jersey. In 1921 he began producing graphics, which became the major portion of his artistic oeuvre. Hart experimented with many graphic media, including etching, lithography, and aquatint.

Some of his early prints illustrate scenes of maidens and centaurs cavorting in an Arcadian setting; others depict everyday life in Latin America.

Alexandre Hogue (b. 1898) was born in Memphis, Missouri, but moved to Denton, Texas, when he was six years old. Much of his life was spent in the Texas Panhandle. Hogue's artistic inspiration was his mother, a capable artist who knew she had no opportunities but was determined that her son would have his chance. When Hogue was nine years old, he spent his Saturdays in the art classes of Elizabeth Hilyar, a progressive art teacher at the Teachers College (now North Texas University) in Denton. These classes were the only formal art training that Hogue received. He followed them up with four years of self-study (from 1921 to 1925) in New York City, where he immersed himself in the art galleries and museums. His later college teaching career included summers at the Texas State College for Women (1932–43), Hockaday Junior College, Dallas (1936–45), and the University of Tulsa (1945–68). Hogue's realistic graphic oeuvre concentrates on western themes, including oil derricks and equipment, dust bowl landscapes, and animals of the Texas plains. Some of his western landscapes of the 1930s become metaphors for man's misuse of the land.

Edward Hopper (1882–1967) articulated his vision of America in realistic scenes of lonely men and women in architectural settings. Whether indoors or outside, these figures are frequently surrounded by an aura of light that emphasizes their isolation. Hopper was born in Nyack, New York, and first studied art at the Correspondence School of Illustrating, a commercial art school in New York City. In 1900 he transferred to the New York School of Art, where his teachers were Robert Henri, William Merritt Chase, and Kenneth Hayes Miller. During two trips to Paris between 1906 and 1910, Hopper absorbed the French atmosphere but apparently was little affected by the modernist trends. The trips left him with a nostalgia for Paris that was to remain with him always.

Back in the United States, Hopper began to support himself as a commercial artist and illustrator. In 1915 he learned etching techniques from Martin Lewis, and he continued with etchings and drypoint until 1928. His graphics of this period, in which he experimented with many kinds of inks and papers in an attempt to obtain the greatest contrast and brilliance, are considered among the finest in American printmaking. The two motifs that appear frequently in his prints are the isolated figure and the open window. The latter Hopper learned from Henri, who saw the window symbolically as an opening to the world from a restricted interior space. In his choice of subject matter—interior scenes, rooftop views, and urban life—Hopper seems most clearly related to John Sloan.

John Langley Howard (b. 1902) was born in Montclair, New Jersey, but his family moved to Berkeley, California, soon after his birth. In 1920 he entered the University of California, Berkeley, where he studied engineering and then English. Leaving the university in 1922, he spent one semester at the Berkeley School of Arts and Crafts. Still looking for a vocational direction, Howard traveled to France, where he sketched and meditated. After six months, Howard returned to the United States and enrolled in the Art Students League of New York. His most influential teacher at the League was Kenneth Hayes Miller, who stressed the cultivation of a more intuitive and less analytical approach to art. In 1928 Howard and his two brothers staged an exhibition of their works in San Francisco. Moving to Monterey in the 1930s led to a significant thematic change in Howard's work. He and his wife joined the John Reed Club and became more involved in social and economic issues. Howard's painting took on a more industrial, urban look, and he began including members of the labor movement in his figurative paintings and graphics. Returning to the San Francisco area in 1934, Howard joined the Public Works of Art Project, which was commissioned to paint a mural in Colt Tower on Telegraph Hill. Although dissension arose over leftist references in the mural, Howard enjoyed the actual production of the mural and the interaction with other artists. He has remained in California throughout most of his career.

Florence Kent Hunter (1917–89) was the daughter of Polish Jews who had arrived in New York shortly after the turn of the century. Florence Goldman grew up in the Bronx and was educated at the Cooper Union and New School for Social Research. Around 1936 she married fellow artist Theodore Herzl Emanuel, and together they helped organize the Artists' Union. For several years they participated in the WPA project, and it was at this time that she adopted the name Florence Kent to get around the illegality of both members of a married couple working for the project. For the WPA she taught art in settlement houses and produced etchings and lithographs with a passionate social reformist content. Her study for a wall in the Home Relief Bureau shows a relief worker presiding over the vicious cycle of poverty, supplication, and despair. She and Emanuel were divorced in 1946; in 1950 she married Paul Hunter, a chemist, and moved with him to Bern, Switzerland, where he was to pursue medical studies. She continued her art training at the University of Bern. They returned to the States in 1956, and until her husband's death in 1975 Hunter worked as his receptionist and bookkeeper, able to continue her art only in her spare time. Her paintings of this time are both influenced by Picasso and recognizably representational. She was concerned about the lack of spontaneity and emotion in her work and in the 1970s sought additional instruction from the painter Anthony Toney. After Paul's death her art, and especially her prints, reclaimed her Jewish heritage, as she rendered images of her parents and other elderly Jewish people. That was not to last, as she joined the Unitarian Church, the faith of her third husband, Morton Pollack. Her late paintings and prints reveal her newfound interest in nature and environmental issues.

Peter Hurd (1904–84) was born in New Mexico, which remained his primary artistic focal point. Although Hurd studied at several colleges and the Pennsylvania Academy of Art, his greatest inspiration was N. C. Wyeth, with whom he studied in 1924–26. He married Wyeth's daughter, Henrietta, and returned to New Mexico, where he lived until his death. Working in a realistic style, Hurd projects familiar images of everyday ranch life using muted earth colors to depict the vast expanse of earth and sky.

Everett Gee Jackson (b. 1900) was born in Mexia, Texas. He studied at Texas A & M University and the Chicago Art Institute, received a bachelor's degree from San Diego State University and a master's from the University of Southern California, and pursued further studies in Mexico. Jackson spent most of his career teaching at California State University in San Diego. He was active in San Diego as a member of the board of trustees of the Fine Arts Society and chairman of the Latin-American Arts Committee. Publications he illustrated include *The Wonderful Adventures of Paul Bunyan* (1973), *Romona* (1959), and *American Indian Legends* (1968).

Sargent Johnson (1888–1967) was born in Boston and studied at the Boston School of Fine Arts. About 1915 he moved to San Francisco and continued his art education at the California School of Fine Arts, studying under Ralph Stackpole and Benjamin Bufano. Johnson was primarily a sculptor and ceramist, but he learned lithography through the WPA. In 1935 he told an interviewer from the *San Francisco Chronicle* (publishers of a series of lithographs in the early 1940s, including *Singing Saints*): "It is the pure American Negro I am concerned with, aiming to show the natural beauty and dignity in that characteristic hair, bearing and manner; and I wish to show that beauty not so much to the white man as to the Negro himself."

Joe Jones (1909–63) was a self-taught artist who painted his midwestern world with intense and expressive realism. Jones was born in Saint Louis and lived in one of the worst slums of the city. At the age of ten he was sent to reform school for defacing a building. Although

his stay lasted a little less than a year, the harsh experience made an indelible impression. Jones returned to Saint Louis to complete grammar school in 1923. After hoboing around the country, he decided to become a house painter like his father. He went to night school to learn decorating and gradually became attracted to painting as an art form. He would meet with a group of artists in Saint Louis and paint until the early hours of the morning. Jones won a prize in the first exhibition he entered and success followed. He traveled to the artists' colony in Provincetown, Massachusetts, to gain a wider perspective on the art world. The liberalism of the Provincetown artists awakened Jones to new social concerns that could be expressed in art. From 1934 on, the theme of the laborer revolting against management appears frequently in his work. In the middle of 1934, Jones went to New York to find a gallery that would exhibit his work. The A.C.A. Gallery agreed to show his paintings of workers on strike, and the exhibition was a hit, according Jones instant acclaim. In the following years Jones pursued other themes associated with the Midwest, including scenes of threshing in wheat fields and somewhat allegorical views of dust bowl farms amid the highly eroded land.

Jacob Kainen (b. 1900) has spent fifty years in the graphic arts, during which he has been a printmaker, curator of the Smithsonian's collection of graphic arts, and a collector of prints, particularly those of the German expressionists. Kainen was born in Waterbury, Connecticut, and grew up in New York. He studied at the Art Students League, the Pratt Institute of Art and Design, and George Washington University. During the 1930s Kainen became a social realist and an influential member of the New York Graphic Arts Project, part of the Federal Art Project. Moving to the Washington, D.C., area, he also assumed a leadership role in the Washington Color School, encouraging the career of Morris Louis and teaching Gene Davis. During this time Kainen experimented with his own color lithographs, which were primarily abstract. As a celebration of his eightieth birth-day, Kainen was commissioned to create for the Smithsonian a color lithograph with woodcut overlay.

Rockwell Kent (1882–1974) sought adventure in remote parts of Alaska, Greenland, and New-foundland and even sailed alone around Cape Horn. His art reflects this attraction to the un-spoiled nature of remote places. Kent was born in Tarrytown Heights, New York, and studied at Columbia University with William Merritt Chase, Robert Henri, and Kenneth Hayes Miller. During the 1920s and 1930s Kent was one of the leaders among American printmak-ers creating expressive landscapes in wood en-gravings. In other prints, his art deco image of man is symbolic and highly idealized, a possi-ble precursor to many of the figures in large posters and paintings that are seen today in the Soviet Union. Kent's prints were reproduced extensively in many books, periodicals, and ad-vertisements and may have circulated in the Soviet Union. Kent also wrote books about ad-ventures in remote lands and illustrated these with his own woodcuts and wood engravings. Although he was involved in left-wing causes throughout his life, Kent rarely used his art for political propaganda.

Gene Kloss (Alice Geneva Glasier) (b. 1904) was born in Oakland, California, and studied in sev-eral California schools—the University of Cali-fornia at Berkeley, the California School of Fine Arts, and the California School of Arts and Crafts. Beginning in 1925 she developed an in-terest in the Southwest and since 1930 she and her husband, the poet Phillips Kloss, have lived at least part of each year in Taos, New Mexico. She is best known for her depictions of South-west Indians, their ceremonies, and their land. An early success was her series of nine etchings of the Pueblo country, which were widely cir-culated by the federal government as part of the Public Works of Art Project. Although Kloss is concerned with design, color, and technique in her art, the central focus of her work is the in-terpretation of the culture of the Southwest In-dians as they live in harmony with nature. Kloss has stated that the art of etching, with its limited black and white nuances, expresses most clearly the values of Indian culture.

Walter Francis Kuhn (1880–1949) displayed a multitude of talents during his lifetime—orga-nizer of the Armory Show, cartoonist, art advi-sor to John Quinn (director of musical revues on Broadway), architect, designer of railroad cars, teacher, and artist. He was a leading pro-ponent of twentieth-century modernism; yet his own paintings and prints seem firmly rooted in late-nineteenth-century realism. Kuhn was born in Brooklyn, New York, and educated at the Brooklyn Polytechnic Institute. From 1901 to 1903 he studied in Paris and Munich, where he absorbed influences from contempo-rary artists like Paul Cézanne, Georges Rou-ault, and the German expressionists. Upon re-turning to the United States, Kuhn worked as a cartoonist in San Francisco and New York. Through his work in organizing the 1913 Ar-mory Show, Kuhn became a recognized artistic leader in New York City. Although he exhib-ited regularly during the 1920s, 1930s, and 1940s, his best-known images—the tragic clown and stoic acrobat—were first created in 1929. Kuhn's little-known graphic work of the 1930s reflects his struggle with the modernist idiom, which was frequently not suited to his artistic statements. He destroyed much of his earlier work.

Yasuo Kuniyoshi (1893–1953) combines in his work a subtle blend of his native Japanese heri-tage with western modernist vocabulary and folk art idioms. Born in Okayama, Japan, Kuni-yoshi immigrated to Los Angeles in 1906 and moved to New York four years later. He stud-ied at the Art Students League, where his most influential teacher was Kenneth Hayes Miller. Trips to Europe in 1925 and 1928 stimulated Kuniyoshi's interest in the graphic arts. He worked in the Paris print shop of Edmond Des-jobert, where he experimented with new tech-niques then current in Europe. Although Kuni-yoshi produced drypoint and etchings, his most common choice was lithography, a medium he found both subtle and expressive. Kuniyoshi fo-cuses primarily on women in his prints and

paintings. A delicate line and quiet, somber mood are basic elements of his style.

Paul Landacre (1893–1963) was born in Ohio but moved to California as a young man. He began his career as a commercial artist in the Los Angeles area. Between 1923 and 1925 Landacre attended the Ortis Institute in Los Angeles, where he experimented with etching, drypoint, lithography, and wood engraving, which became his primary medium of expression. In 1927 Landacre first exhibited his work—three wood engravings—at the Second Annual Exhibition of Artists of California in San Diego. In 1930 he had his first one-man show in a suburban California bookstore owned by Jake Zetlin; it inaugurated Landacre's most productive decade, during which images of nature—the mountains, trees, and birds of California—dominated his graphic work. The stormy petrel became Landacre's monogram after he rescued a wounded bird and made it his pet. Landacre's stylized prints are characterized by strong contrasts of light and dark that evoke an expressive quality. Landacre is also known as an illustrator of nature books.

Armin Landeck (1905–84) was a printmaker whose architectural training formed his imagery. Although he was born in Wisconsin, Landeck was educated in New York at Columbia University School of Architecture and remained on the East Coast all his life. In 1927 he made his first etching and from that time on seems to have been absorbed by the graphic arts. A trip to Europe in 1928–29 broadened his knowledge of graphic techniques. After his return to New York City, Landeck joined with Martin Lewis and George Miller to found the School for Printmakers at Miller's Fourteenth Street Studio. It was during the 1930s that Landeck executed a panoramic scene of New York City that was the largest lithograph made between the wars. The architectural scenes of New York that dominated Landeck's graphics during this period have a soft, almost painterly quality and a wonderful sense of space and light. Landeck's superb draftsmanship evokes the precisionist quality of Charles Sheeler's drawings, but his style underwent a change in the 1940s after his association with Stanley William Hayter at Atelier 17. Unlike many artists, Landeck did not change his subject matter radically, but his techniques did undergo a revision. From Hayter he learned the use of the graver, expanded his expertise in depicting texture and color, and began to concentrate on engraving. A darker richness resulted from these techniques.

Doris Lee (1905–83) was a painter, illustrator, and lithographer whose roots were in the Midwest. Born in Aledo, Illinois, she studied under Ernest Lawson at the Kansas Art Institute. She also worked with Arnold Blanch at the California School of Fine Arts in San Francisco and in 1927 traveled to Paris. In the 1930s Lee was commissioned to execute a mural for the post office in Washington, D.C. Though primarily a realist painter, she sometimes inserted modern incongruities into the typical American Scene painting. Lee was active in the graphic arts community on the East Coast and also taught at the Colorado Springs Fine Arts Center. She participated in the Association of American Artists exhibition and sale of prints in department stores in the 1930s. Her book illustrations include James Thurber's *The Great Quillow* (1944) and a Rodgers and Hart songbook.

Martin Lewis (1881–1962) was born in Castlemaine, Australia, and spent the early years of his adult life traveling around the world. While in London in 1910, Lewis was introduced to printmaking, which became a lifelong occupation. After moving to the United States, Lewis sparked Edward Hopper's interest in graphics and continued his own experiments with etchings, aquatints, lithographs, mezzotints, and drypoint. In 1934 Lewis, together with Armin Landeck and George Miller, organized the School for Printmakers on Fourteenth Street in New York City. Lewis's amazing ability in drypoint enabled him to capture remarkable gradations and qualities of light. He is an expert in nighttime scenes.

Jacques Lipchitz (1891–1973) was born in Lithuania of Orthodox Jewish parents. His early life was under the shadow of persecution, and this darkness followed him as he escaped the struggles of two world wars. In his work, however, Lipchitz usually avoids reference to war. He began his artistic career by moving to Paris in 1908. Here, he studied at the Ecole des Beaux-Arts and the Académie Julian but found his greatest inspiration among the cubists. In 1913 Diego Rivera introduced him to Picasso and two years later Lipchitz began producing cubist sculpture. He later became known as the definitive cubist sculptor. Lipchitz continued in the cubist style until the 1930s, when he sought another means of expression in broadly modeled baroque figures. These sculptures reflect Lipchitz's new interest in the basic themes of love, death, conflict, and metamorphosis as illustrated in Greek mythology. These are the ideas that he pursued after his arrival in the United States in 1940. Here Lipchitz also worked in printmaking, exploring motifs that he had previously modeled in sculpture.

Louis Lozowick (1892–1973) was born in a small village near Kiev, Russia, and was one of six children. With the help of an older brother, at age eleven he entered the Kiev Art School, where he studied for two years. At fourteen, without passport or other documents, Lozowick followed his brother in an illegal immigration to America, arriving at Ellis Island in 1906. He quickly learned English and enrolled in Newark High School. He then studied art at the National Academy of Design and graduated Phi Beta Kappa from Ohio State University. Lozowick returned to Europe in 1920 and in his four years there became acquainted with artists and their work in Paris, Moscow, and Berlin; he was particularly influenced by Léger, cubism, and Russian constructivism. His fascination with structures and machinery informs the essay he wrote for the catalogue of the *Machine Age Exposition* (1925–27), in which he extols the machine and industrialization as a benefit to mankind.

Adriaan Lubbers (1892–1954) discovered American skyscrapers on a trip to New York City from his native Netherlands and continued to

paint the New York skyline for the remainder of his life. Although Lubbers never settled permanently in the United States, his unusual perspectives of Manhattan architecture earned him fame in America and Europe. Lubbers first trained as an engineer, and he continued to focus on structures rather than the human aspect of cities. His unusual viewpoints—frequently over rooftops, under bridges, or across water—distinguish both his paintings and lithographs.

Helen Lundeberg (b. 1908) has explored the realms of surrealism and abstraction in a calm, introspective style. The feminine presence in her work—perhaps just a hand or shadow—adds a note of gentle sensibility that contrasts with the work of many American and European surrealists, whose imagery is filled with torture and nightmarish visions. Born in Chicago, Lundeberg studied art in California with Lorser Feitelson, who was later to become her husband. Although she began exhibiting in 1931, Lundeberg's reputation was well enough established three years later that she was asked to participate in the exhibition *Fantastic Art, Dada, and Surrealism* at the Museum of Modern Art in New York. Lundeberg's style changed in the 1950s, passing into a more abstract phase that still retained a suggestion of reality. The implied landscapes of her later style employ curvilinear forms that are modeled in soft color tones. Throughout her career, Lundeberg has focused on the themes of creativity and illusion, using images of plants, mirrors, shells, planets, and her own self-portrait to create an introspective world.

Samuel L. Margolies (1898–1974) focused on the construction of skyscrapers in New York City during the 1930s, and his prints reflect a sense of optimism that the United States could recover from the Great Depression. Although the workers remain anonymous, their central place in the print implies a belief in the power of people to construct their own future. The workers are placed high over the city on the structures created with the engineering ingenuity of American builders. Margolies (known as S.L.) was born in New York and studied at the National Academy of Design, Cooper Union Art School, and the Beaux-Arts Institute. He ended his graphics career in 1939 after exhibiting at the New York World's Fair.

John Marin (1870–1953) was one of the first artists to exhibit a semi-abstract imagery in the United States during the first decade of the twentieth century. He continued that same style throughout a lifetime of working in etching, watercolor, and oils. He is best known for his work in watercolor, in which he concentrates on naturalistic subject matter frequently related to sea imagery. Marin was born in Rutherford, New Jersey, and lived most of his life on the East Coast. He studied at the Pennsylvania Academy of the Fine Arts and the Art Students League of New York. From 1905 to 1911 Marin lived in Europe, at a time when the exciting new cubistic and expressionistic styles were being explored. After his return to the United States, Marin and his work were promoted extensively by Arthur Stieglitz in his photo-secession gallery "291" in New York City. Marin found his greatest inspiration in Manhattan's architecture and the wild, rocky coast of Maine, where he spent his summers.

Kyra Markham (1891–1967) sought theatricality in her life and art. Elaine Hyman (her given name) was born in Chicago and left high school about 1907 to study drawing at the Art Institute. When she was discovered as an actress in 1909, she left the Art Institute and began working at Chicago's Little Theater. There she met Theodore Dreiser, the American novelist, and they developed an intense relationship. She left him in 1916 and continued her stage career with the Provincetown Players in Massachusetts. During the 1920s her artistic abilities helped supplement her income, and she supported herself by drawing illustrations for book jackets and painting murals in houses and restaurants. In 1930 Markham returned to the study of art at the Art Students League in New York and four years later began to work in lithography. Markham's participation in the Federal Art Project began in 1936. This association stimulated her finest body of lithographs, whose themes vary from fantasy to realistic views of a crowd enjoying fireworks. Her prints are characterized by a highly effective use of light and shadow to mold or dramatize her images.

Reginald Marsh (1898–1954) was born in Paris, but his work reveals the quintessential New Yorker—bold, brassy, and filled with life. Little in his early years could have foretold that he would spend his artistic life painting Bowery bums, burlesque queens, and sunbathers at Coney Island. He came from a financially comfortable family of artists and began his art study at Yale University, continuing at the Art Students League in New York. Employed as an illustrator by several New York newspapers and magazines, Marsh began to seek out the most picturesque elements of depression-era New York. His work was influenced immensely by the explosion of mass media during this time—advertising, movies, and billboards fill his canvases. Marsh's drawing abilities are powerfully revealed in his graphic work, particularly in the burlesque scenes in which leering men gaze intently at the well-developed "Queen" about to step on stage. One of America's foremost printmakers, Marsh produced approximately 236 graphic works, including lithographs, etchings, drypoint, and engravings.

Alice Trumbull Mason (1895–1971) experimented with the modernist trends of the 1920s through 1940s as she sought her own definitive abstract vocabulary. She is less well known today because she was part of the generation of artists working between Alfred Stieglitz's modernist group and the abstract expressionist movement of the 1950s. Mason, nevertheless, was one of the most gifted early abstract artists. She was born in Chicago and received a Bachelor of Science degree from Northwestern University. After studying at the School of the Art Institute of Chicago, Mason went abroad to study in Vienna and Paris. She worked with Arshile Gorky when she returned to the United States in the late 1920s and watched his dilemmas as he absorbed different modernist trends. Fifteen years later Mason began making prints

that reflected the influences of Mondrian and Miró. Perhaps one of the most significant experiences of the 1940s was her work at Stanley William Hayter's Atelier 17. There she learned new possibilities and concepts in the intaglio print. Out of the experience came her soft-ground etchings which Mason made by introducing different materials into the ground. When the ground interacted with the acid, it assumed a translucent overlay of textures. This textural effect produced an etching of remarkable underlying pattern and structure.

Jan Matulka (1890–1972) immigrated to the United States from Czechoslovakia and became an influential teacher at the Art Students League in New York. His work ranged in style from cubist still-life arrangements to precisionist cityscapes to realistic genre scenes. Matulka began his art studies in the United States at the National Academy of Design in New York City. In 1917, after several years at the academy, Matulka was awarded the first Joseph Pulitzer Traveling Scholarship. He spent the early 1920s in Europe but returned to the United States, where he received support and encouragement from Katherine Dreier, organizer of the Société Anonyme, and Gertrude Whitney, founder of the Whitney Museum of American Art. In some of his lithographs, spotlight effects play over the surface of the print. Matulka played an important role in the early art education of David Smith, Dorothy Dehner, and Burgoyne Diller, among others.

Mildred ("Dolly") McMillen (1884–ca. 1940) was one of the printmakers who made Provincetown, Massachusetts, a thriving artists' colony between the world wars. McMillen's views of Provincetown exhibit a simple charm that does not depend on picture-postcard attractiveness. McMillen was born in Chicago and attended the School of the Art Institute of Chicago from 1906 to 1913. Traveling to Europe the following year, she became a part-time student of Ethel Mars in Paris and later worked at the Académie Colarossi. The outbreak of World War I brought many artists back to the United States; McMillen was among them. She settled

in Provincetown and absorbed influences from the many active artists there. She exhibited a block print in the First Annual Exhibition of the Provincetown Art Association and continued to be active for many years.

Hugh (aka Herbert) Mesibov (b. 1916) is the inventor of carborundum color etching, a technical innovation that altered the course of printmaking. Born and educated in Pennsylvania, Mesibov attended the Fletcher Memorial Art School, the Pennsylvania Academy of the Fine Arts, and the Barnes Foundation. In the 1930s Mesibov first began making prints at a press set up in the family kitchen. Later he participated in the Works Progress Administration program in New York City. His expressionist prints of the period are filled with crowds of people packed together in a shallow space; not fully individualized, the faces in the crowd are preoccupied and intense. In some prints a fractured light streams down from the ceiling fixtures. Mesibov's later work evolved into a more painterly abstract style.

William Meyerowitz (1898–1981) was born in the Ukraine, Russia, and immigrated to the United States when he was a young boy. His art training was at the National Academy of Design, where he received awards in painting, drawing, and etching. At the age of twenty he etched a scene of Fifth Avenue in New York during the armistice celebration in 1918. The scene is highly reminiscent of the impressionistic flag paintings of Childe Hassam executed during the same period. Later in his career, Meyerowitz became a highly successful portrait painter.

Kenneth Hayes Miller (1897–1952) taught some of the most renowned painters of the mid-twentieth century, including Edward Hopper, Reginald Marsh, and Philip Evergood. His long association with the Art Students League in New York (from 1911 to 1951) spanned a fertile period in art during which American artists struggled to assimilate the rapid changes in European art and to establish their own identities. Miller participated in this struggle as he tried

to reconcile abstract ideas with figurative verisimilitude. His best-known etchings are realistic scenes of women shoppers, whom he encountered near his studio on Fourteenth Street in New York City. From 1918 through the 1930s Miller produced both etchings and drypoint prints.

Claire Mahl Moore (aka Millman or Mahlman) (1910–88) received her art training at the National Academy of Design, the Grand Central School of Art, and the Art Students League. Moore's early work with the Federal Art Project focused on expressionistic faces of women seen in front of architectural backdrops. Her detailed draftsmanship is central to her artistic style. Moore's prints and drawings of the 1960s frequently include words, either as a part of the work or as illustrations for significant verbal messages. Moore also produced a series of paintings based on the poems of Max Jacob, whose black humor and spiritual mood she found fascinating. She participated in a number of one-person and group exhibitions in the 1970s and 1980s.

Joseph Pennell (1860–1926) was a leader of graphics studies in the United States and an influential teacher at the Art Students League in New York. Pennell was born and educated in Philadelphia. He learned etching from Stephen Ferris while he was enrolled at the Pennsylvania Academy of the Fine Arts from 1879 to 1880. In 1880 he cofounded the Philadelphia Society of Etchers. Pennell's first major assignment was to illustrate a series of articles on Tuscany by William Dean Howells. This job so stimulated his interest in foreign places that he spent the next thirty years traveling all over the world. In 1883 Pennell traveled to London where he met and befriended James A. McNeill Whistler. In 1912 he visited the Panama Canal, the construction of which was the subject of a series of lithographs. Pennell was fascinated with the colossal cranes and steam shovels that were building a monument to American engineering skill. During this time Pennell began using the transfer method of lithography, which enabled him to draw his images on paper and

later have them transferred to stone by a professional printer. This method had its detractors, among them Bolton Brown, a master lithography printer, who did not think the transfer method had the integrity of a lithograph produced by drawing with crayon on a stone.

Jackson Pollock (1912–56) produced some of the most controversial abstract expressionist paintings of the 1950s and became a symbol of the American break with European pictorial conventions. Probably the most American of the abstract expressionists, Pollock was born in Cody, Wyoming, and as a young man traveled extensively across the country. While he is best known for his "drip" paintings, these were executed in the last four years of his career. His earlier works, particularly his graphics, owe a debt to one of his first teachers, Thomas Hart Benton, and to the Mexican muralists Diego Rivera, José Clemente Orozco, and David Alfaro Siqueiros. In his early lithographs Pollock frequently employed specifically local American imagery—West Virginia coal mines, western ranches, and motifs from American Indian art. During 1944–45, he worked at Stanley William Hayter's Atelier 17, where he became familiar with Hayter's large etchings and theory of automatism. Guided by this theory, the artist allowed his subconscious freely to direct the movements of the burin across the plate while simultaneously moving the plate. Most of Pollock's plates, executed while he worked at Atelier 17, were not printed until after his death.

Robert Riggs (1896–1970) was a successful commercial illustrator and graphic artist whose work mirrored his avid interests in American Indians, primitive peoples, and circus performers. Born in Decatur, Illinois, Riggs first studied art at James Millikin University in Illinois and later transferred to the Art Students League in New York. After two years in the army in World War I, Riggs enrolled at the Académie Julien in Paris. Seeking wider experience as a basis for his art, Riggs traveled extensively in North Africa, China, Thailand, and the West Indies, collecting artifacts and making record-

ings. During the 1930s Riggs returned to the United States and began to establish himself as a leader in American graphic arts. In his lithographs of this period Riggs focuses primarily on the circus, prizefighting, and crowded street scenes. His realistic interpretations of physical action have a dynamic, energizing force that is enhanced by strong lights and darks.

I. Iver Rose (1899–1972) was born in Chicago and studied at Hull House, the Art Institute of Chicago, and the Cincinnati Academy of Art. Rose was a modern expressionist whose themes varied from industrial America to clowns, children, and Gloucester fishermen. Using color to model his forms, Rose created strikingly vivid figures. In the latter part of his career, Rose spent his summers working along the Massachusetts coast.

James N. Rosenberg (1874–1970) combined careers as a lawyer, artist, conservationist, and author, and found success in all he undertook. Rosenberg was born near Pittsburgh and began his collegiate career at Columbia University in 1891. Seven years later he graduated from the Columbia Law School and was admitted to the New York Bar. During these early years painting was a hobby for him, but in 1910 he became more committed to his art and held his first one-man show. Rosenberg's graphic works focus primarily on the Adirondack landscape. They are executed in a realistic style reminiscent of the nineteenth-century artists of the Hudson River School.

Alfred Russell (b. 1920) was born in Chicago and began to study art at age fifteen. Three years later he entered the University of Michigan and graduated with a Bachelor of Arts degree in literature. He then earned a Master of Arts degree in Greek and Roman art from Columbia University and also studied at the Art Students League. A turning point in his career came in 1944 while he was working at Stanley William Hayter's Atelier 17 in New York City. Russell turned to abstract painting and developed a vocabulary of naturalistic, curvilinear forms that seemed to exist in a three-dimen-

sional space. Russell's prints and graphics of the subsequent decade gained wide acceptance in New York and abroad. In 1951 he made his debut in Paris at Michel Tapié's exhibition *Vehemences Confrontées*. In more recent years Russell has developed a more painterly, gestural style.

Birger Sandzen (1871–1954) emigrated from Sweden to Lindsborg, Kansas, in 1894 and remained there, teaching at Bethany College, for the rest of his life. Sandzen was born in Blidsberg, Sweden, to parents who encouraged his creative talents. At the age of ten Sandzen entered the Academy and College of Skara. After graduation from the college, he attended Lund University and the Technical High School of Stockholm, where he studied perspective and drawing. Later Sandzen saved enough money to travel to Paris for study with Aman-Jean. Returning to Stockholm for the summer, Sandzen read a book by Dr. Carl A. Swensson that told of Swensson's struggles in setting up a college in Kansas. Swensson invited young men from Sweden to come and help him. Sandzen accepted that invitation and arrived in Lindsborg in 1884. He began work immediately, teaching languages, painting, drawing, and art history at the college. During summers Sandzen taught in Colorado, New Mexico, and Utah. In these locales he painted and made charcoal drawings that became the basis for many of his lithographs. Over the years Sandzen's repertoire also included drypoint, woodcuts, and linoleum cuts. His style in the latter two can be recognized by the bold and dynamic strokes that he achieves with the use of a V- or U-shaped graver. Much of his graphic work has an expressionistic quality that is reminiscent of Van Gogh's landscapes and flower arrangements. The Birger Sandzen Memorial Art Gallery on the campus of Bethany College preserves his works.

William S. Schwartz (1896–1977) was born in Smorgon, Russia, and came to the United States in 1913. After several years in Omaha, Nebraska, he settled in Chicago, which became his permanent home. In order to study at the

Art Institute of Chicago, Schwartz supported himself singing with the Bohemian Opera, the Orpheum Circuit, and the Chicago Symphony Orchestra. This musical interest is reflected in the *Symphonic Form* series that he painted using abstract shapes and various color tonalities to express musical idioms. Schwartz's lithographic work lasted for a decade, from 1928 to 1938. In some instances, Schwartz based his prints on earlier drawings or paintings, but more frequently he used the medium to explore a new range of subjects and techniques. His works reflect a cubist influence in the fractured surfaces of mountains, cityscapes, and factory buildings stacked close to the sky. Schwartz's first and lasting impression of America was his feeling of awe at the great power and vitality of his adopted country. This is the mood he conveys in his graphic art.

Charles Sheeler (1883–1965) was born and educated in Philadelphia and found one of his first mentors in William Merritt Chase, under whom he studied at the Pennsylvania Academy of the Fine Arts and in Europe. Photography was Sheeler's chief occupation in the early years, and his photographs of industrial buildings provided images for his major work in oil painting. A highly developed sense of design and a precision in draftsmanship permeate his work, fittingly first shown at the National Academy of Design in 1906. Throughout his artistic career Sheeler followed closely the realist tradition and used a composite of photographs to meld scenes of industrial America into a meticulously rendered vision. His few prints reflect this precisionist quality.

Millard Sheets (1907–89) was a designer, painter, and graphic artist. Sheets was born in Pomona, California, and graduated in 1929 from the Chouinard Art Institute in Los Angeles. During World War II he worked for *Life* magazine as an artist covering Burma and India. After the war Sheets organized his own architectural firm, which designed banks, shopping centers, schools, and homes in California and Texas. In addition, during his long, diversified career, Sheets acted as chairman of the art department at Scripps, the art director at Claremont Graduate School, and director of the Otis Art Institute in Los Angeles from 1955 to 1962. His graphic work of the 1930s was executed as part of the Public Works of Art Project. Typical is his *Family Flats*, which depicts a more urban, high-density apartment complex than we usually associate with California. Sheets's design elements, using the staircases and wooden banisters, form patterns that focus our view back into the picture plane and seem to extend the environment beyond the print's border. The light in the print, which echoes the bright California sun, highlights the hanging laundry and throws some areas into deep shadow.

Grant Simon (b. 1887) was a Philadelphia artist who studied with Thomas Anshutz, a pupil of Thomas Eakins. Photographic experiments influenced these artists and are evident in Simon's graphic work. Educated at the University of Pennsylvania, Simon later studied at the Ecole des Beaux-Arts in Paris. His career encompassed the disciplines of architecture, painting, and criticism in addition to graphics. Simon's prints reflect an interest in filtered light and unusual perspectives, both of which derive from photographic sources.

John Sloan (1871–1951) was a student of Robert Henri and an influential member of The Eight, a group of artists who painted the American urban scene in the early twentieth century. Sloan's career began in graphic arts, and this interest in printmaking continued throughout his life. He is considered one of the most important graphic artists in America during the first half of the twentieth century. Sloan was born in Lockhaven, Pennsylvania, and he moved to Philadelphia with his parents in 1876. At age seventeen Sloan began working for the firm of Porter and Coates, a Philadelphia bookseller and print dealer; he produced his first etching that same year. His earliest influences in graphics were the English illustrator Walter Crane and Japanese woodblock prints. Other important early sources were the illustrations in *Punch* and depictions of lowlife in French journals. Throughout his life Sloan produced illustrations for newspapers, magazines, and books. Between 1912 and 1916 he served as art editor for *The Masses*, a socialist magazine dedicated to reform. His drawings for the magazine are considered some of his finest work. One of his most controversial prints, *Turning Out the Light*, was judged too risqué for the exhibition of the American Watercolor Society in 1906. Sloan's teaching career at the Art Students League in New York from 1906 until 1937 assured his legacy to the following generations of American artists.

David Smith (1906–65) is regarded as one of the most influential and innovative sculptors of the twentieth century. He absorbed the European concepts of cubism, constructivism, and surrealism, adding his own ideas of metal craftsmanship, technical ingenuity, and introspective intensity to produce artworks that have few precedents and many followers. Although he was born in Decatur, Indiana, Smith spent his formative artistic years (1920s and early 1930s) in New York City, studying at the Art Students League and associating with many artists of the avant-garde. In 1927 he married Dorothy Dehner, a fellow artist, and together they studied with Jan Matulka, who was an important early influence on Smith's work. Smith's first exhibited work was a block print included in a show of the Print Club of Philadelphia in 1930. At this time Smith bought Old Fox Farm in Bolton Landing on Lake George in upstate New York. This was to become his home, studio, and refuge. On a trip to Paris in 1936, Smith made etchings in the workshop of Stanley William Hayter, thereby expanding his technical knowledge of printmaking and further absorbing the principles of surrealism. Smith's work of the 1950s, his most productive period, is usually linked with the abstract expressionists. His sculpture of this period is sometimes considered figurative, despite its geometric, abstract quality. A central motif in his sculpture and graphics is the heroic, isolated figure who confronts the vastness of nature. The Don Quixote lithograph illustrates this theme and epitomizes Smith's own lonely and combative nature.

Raphael Soyer (1899–1987) focused his art on the realistic portrayal of human beings and projected a sensitivity for his subjects that was a reflection of his own personality. Soyer was born near Borisoglebsk, Russia, the son of a Hebrew scholar and teacher who encouraged Raphael and his two brothers, Isaac and Moses, in their creative ambitions. Immigrating to the United States with their parents in 1912, the brothers pursued their artistic interests; all three became successful artists. Although Raphael Soyer studied at the National Academy of Design and the Art Students League, he once declared that his greatest source of artistic stimulation was the Metropolitan Museum of Art. Here he studied drawings of the great masters, finding Degas without equal among draftsmen he knew. Soyer was interested in printmaking from an early age; he acquired his first printing press when he was a teenager and produced his first lithograph in 1920. During the depression of the 1930s, his lithographs of unemployed men depicted scenes of quiet desperation and placed his art in the realm of social realism.

Harry Sternberg (b. 1904) was born in New York City to Jewish immigrant parents who wanted him to be a doctor, not an artist. Sternberg had different ideas and in 1927 entered the Art Students League, where he learned etching from Harry Wickey. During the 1930s Sternberg was active in the American Artists Congress and also taught for the Works Progress Administration. It was in the graphics division of the WPA that he developed innovations in serigraphs and offset lithographs. This led to the organization of a silk-screen group, the nucleus that formed the Workshop School on Tenth Street in Manhattan. Sternberg has always displayed a strong social consciousness in his graphic work. In 1936 this work was recognized by a Guggenheim Fellowship, which directed him to record his impressions of the Pennsylvania coal mines and steel mills. In Sternberg's views of the steel mills, such as *Forest of Flame*, man is seen as a tiny figure dominated by his own creation, huge blast furnaces that spew forth smoke and flame. Sternberg's career after 1940 included teaching at the Art Students League from 1934 to 1968, writing numerous books on art, and continuing his exploration of painting and graphic techniques.

John Storrs (1885–1956) was a modernist sculptor and printer who spent most of his adult life in France. Storrs was born and raised in Chicago, but early fell under French influence. He studied in France with Auguste Rodin and married the French writer Marguerite Chabrol. Under the terms of his father's will, Storrs could receive his inheritance only if he was a permanent resident of the United States, so he returned periodically. It was during the 1920s and 1930s that he did his best work. Simplicity of form characterizes both his graphics and sculpture. His work is most often associated with art deco, and his figures frequently have a multifaceted cubistic style and machine-age sleekness that relate to the architecture of the time.

Edgar Dorsey Taylor (1904–78) probes the mysteries of nature in his woodcuts and concentrates on images found in California and Texas. Taylor was born in Grass Valley, California, and attended the University of California in Berkeley. He also studied with Hans Hofmann in Munich and won a fellowship for travel in southern Europe. Later in his career, Taylor taught at the University of California, the University of Texas, and the University of Southern California. Taylor's love of the California land and ocean is evident in his choice of subjects: turtles, sand lizards, and beach scenes appear frequently in his prints. He concentrates on woodcuts, finding that the resistance of the wood and the repetitious strokes of the knife suit the nature of his vision.

Joseph S. Trovato (1912–85) was born in Guardaville, Italy, and came with his parents to the United States in 1920. They settled in Utica, New York, where he received his first art training at the Utica Art Center. He later studied in New York City at the National Academy of Design and the Art Students League. Returning to Utica, Trovato taught classes at the Munson-Williams-Proctor Institute and directed an art school connected with the Utica Conservatory of Music. In 1939 he was appointed assistant to the director of the Munson-Williams-Proctor Institute, with duties as curator of art exhibitions, compiler of catalogues, and administrator of the museum. He held this position until he retired in 1982. Trovato was also a field researcher for the Archives of American Art; he taped interviews with WPA artists and administrators for a project called *The New Deal in the Arts—1966–67*. Trovato's graphic work reflects a variety of influences, including social realism and art deco. In some prints his heavily modeled figures resemble the titanesque forms embellishing the architecture at Rockefeller Center.

Joseph Vogel (b. 1911) was born in Poland and immigrated to the United States as a young boy. He studied in New York at the National Academy of Design and the John Reed Club. The 1930s were exciting years for Vogel, as he worked on the Public Works of Art Project and traveled to Spain to fight with the Loyalist army. His work during this period is surrealist in style. The images have a dreamlike quality with an overtone of discontinuity, and they seem unable to relate to one another as they move in a strangely neurotic fashion. Clearly, the subconscious world underlies Vogel's artistic vision.

Abraham Walkowitz (1880–1965) was born in Tumen, Siberia, Russia, and came to the United States in 1892. After studying at the National Academy of Design and the Art Students League in New York, he continued his education in Paris at the Académie Julian. In Paris he met Max Weber and first saw the dancer Isadora Duncan, who was to inspire a series of his paintings. Returning to the United States, Walkowitz became a member of the avant-garde group promoted by Alfred Stieglitz in his photo-secessionist "291" gallery. From 1912 until 1917 Walkowitz exhibited at the Stieglitz gallery and participated in the modern movement in New York, continuing his active involvement until 1964. Walkowitz was never as much a cubist as his friend Max Weber;

rhythm and movement play a more dominant role in his art than do form and structure.

Max Weber (1881–1961) was one of the pioneers of modern art in America, but he was not financially successful until he was sixty years old. During the last twenty years of his life he became known as a leader of modernism in this country, not only because of his style of painting, but also because of his tireless efforts to encourage Americans to accept modern art. Born in Bialystock, Russia, Weber and his family immigrated to the United States and settled in Brooklyn in 1891. It was here that Weber began his art education at the Pratt Institute, studying with Arthur Dow. At Pratt, Weber was first exposed to Asian and American Indian art and the work of Paul Gauguin. In 1906, after several years of teaching, Weber journeyed to Paris, where he met two men who directly influenced his art—Henri Matisse and Henri Rousseau. Weber was a student in the first class that Matisse taught, and the nude studies that he painted were some of the best of his early work. Weber also developed a friendship with Henri Rousseau, who encouraged his interest in primitivism. In addition, he was influenced by the directions of cubism that Braque and Picasso were exploring, and he embraced prevailing ideas of expressionism and futurism. The small gemlike woodcuts that Weber produced at this time are some of the earliest and most sensitive examples of cubism in the United States. Weber had his first one-man show in 1909 at the Haas Gallery in New York City and later exhibited at Stieglitz's photosecessionist "291" gallery. From 1912 to 1916 Weber painted numerous scenes of New York and produced lithographs based on some of these paintings. In 1928 he held his first one-man lithographic exhibition at the Downtown Gallery in New York City.

Paul Weller (b. 1912) was always intrigued by the West and adventure. His art and life reflect this fascination. Weller was born in Dorchester, Massachusetts, and as a child took art lessons at the School of the Museum of Fine Arts, Boston. In the early 1930s Weller jumped on a

freight train and traveled through the West—sometimes working on ranches in Arizona, at other times performing construction work on Boulder Dam. The memory of the trains he rode and the hobos and migrant people he met during these years remained with him always. In the late 1930s Weller settled in New York City and enrolled in classes at the National Academy of Design. During this time he learned lithography from Jacob Freelander and later taught printmaking for the Works Progress Administration at the Educational Alliance. Weller's prints of this period are figurative studies of the migrant workers and their families. The stark simplicity of the shapes echoes the mural figures that Weller was painting at the same time. After 1940 Weller gave up lithography and concentrated on photography, a medium in which he was very successful.

Stow Wengenroth (1906–78) was a master printmaker who wrote articles and a book on lithography. Wengenroth was born in Brooklyn, New York, and spent his life on the East Coast. In 1923 he enrolled in the Art Students League and later studied with Wayman Adams at the Grand Central School of Art. He produced his first print in 1931. Wengenroth's association with George Miller, the art printer, also began that year. This relationship, which lasted for thirty years, established the careers of both men. One of Wengenroth's early achievements was executing a two-stone lithograph in 1940. He continued producing prints and writing about lithography until two years before he died. His reputation as a master printmaker is based on his impeccable craftsmanship and lush tonalities that provide textural quality and luminous atmospheres for uncluttered landscapes.

Frederick Whiteman (active ca. 1930s–1940s) was born in Indiana, Pennsylvania, and received his art education at Carnegie Technical Institute in Pittsburgh. Here he was apprenticed to Alexander Kostellow, the first art instructor with a modernist point of view at Carnegie Tech. Later, Whiteman moved to New York City to study with Jan Matulka at the Art Stu-

dents League. During the 1930s Whiteman began teaching art in the settlement houses in Brooklyn and also worked for Mayor Fiorello LaGuardia's poster project. In the latter part of the 1930s Whiteman taught for the Federal Art Project in Greensboro, North Carolina, and later became director of the museum there.

Beatrice Wood (b. 1895) was a New York dadaist whose uninhibited life of free expression endeared her to Marcel Duchamp, Henri-Pierre Roche, and members of the avant-garde during the early part of the twentieth century. Wood's formal art study began with several sessions at the Académie Julian in Paris; she was also encouraged in her drawing by Duchamp. Through diary drawings and later writings, Wood recorded the people and happenings of the New York dadaists and other avant-garde members of the art world. During the 1930s Wood's style became more closely related to art deco. Although Wood moved to Los Angeles in 1928, she found her permanent home in the Ojai Valley in the late 1940s. Her most lasting artistic accomplishment has been in ceramics.

Grant Wood (1892–1942) was one of the major figures in the American regionalist movement. His gently satirical paintings and prints illustrated American life as he knew it in Iowa. Wood was born in Anamosa, Iowa, and lived for ten years on a farm in that area. When his father died in 1901, his mother sold the farm and moved to Cedar Rapids, which was to remain the center of Wood's world. Wood received his art education in a summer at the Minneapolis School of Design, Handicraft and Normal Art; two years at the University of Iowa; and in night school at the Art Institute of Chicago. He made several trips to Europe; the most influential was an excursion to Munich in 1928. At this time Wood studied the northern Renaissance masters, whose crystalline realism and work with oil glazes partially influenced his *Woman with Plants* and *American Gothic*. Wood's other sources were American folk paintings, old family tintypes, Currier and Ives prints, and nineteenth-century townscapes. The turning point in Wood's career came in 1930

when he won a bronze medal at the Art Institute of Chicago for his *American Gothic*. The painting received national recognition and Wood became famous overnight. In 1937 Wood began making lithographs for the Associated American Artists. These prints, which were sold in department stores, reflect the same humorous satire that Wood employs in his paintings. Similarly, they exhibit the careful craftsmanship and concern for detail that we see in his earlier oils.

William Zorach (1887–1967) is best known as a sculptor. His graphic work served as a springboard into three-dimensional form. Zorach was born in Eurburg, Lithuania, and moved with his parents to the United States when he was four years old. Although he studied at the Cleveland Institute of Art and the National Academy of Design, his first introduction to lithography was in 1902 through his employment with the Morgan Lithograph Company. Zorach's work before 1917 is eclectic, with numerous European influences including fauvism and orphism. His woodcuts are characterized by a profusion of detail and curvilinear patterns covering the print. Zorach's decision in 1917 to translate some woodcuts into carved relief initiated his career in sculpture.

Index of the Artists